Secrets of Life
Secrets of Death

Secrets of Life
Secrets of Death

ESSAYS ON LANGUAGE, GENDER AND SCIENCE

EVELYN FOX KELLER

Routledge
New York • London

Published in 1992 by

Routledge
An imprint of Routledge, Taylor & Francis, Inc.
270 Madison Ave,
New York NY 10016

Published in Great Britain by

Routledge
2 Park Square, Milton Park,
Abingdon, Oxon, OX14 4RN

Transferred to Digital Printing 2009

Library of Congress Cataloging-in-Publication Data

Keller, Evelyn Fox, 1936–
 Secrets of life, secrets of death : essays on science and culture / Evelyn
Fox Keller.
 p. cm.
 Includes bibliographical references.
 ISBN 0-415-90524-9. — ISBN 0-415-90525-7 (pbk.)
 1. Science—Philosophy. 2. Science—History. 3. Women in science.
4. Science—Social aspects. I. Title.
QC175.3.K45 1992
500—dc20 92-28013
 CIP

British Library Cataloguing in Publication Data also available.

Publisher's Note
The publisher has gone to great lengths to ensure the quality of this reprint
but points out that some imperfections in the original may be apparent.

For Jeffrey and Sarah

Contents

CONTENTS

Acknowledgments

♦

I welcome the opportunity this book gives me to thank the many
friends and colleagues—too many to name—who have provided me
with intellectual and personal sustenance over the years in which I
wrote these essays. I am also grateful for the institutional support
that has come my way—especially, to the Institute for Advanced
Study for a Visiting Membership in the year 1987–88, and to the
Center for Advanced Study in the Behavioral Sciences for their ex-
traordinary hospitality during the year 1991–92 in which I put this
volume together. But especially, I want to thank Jehane Kuhn who
has, once again, given so generously of her invaluable and irre-
placeable reading and editorial skills, and Bill Germano, whose en-
thusiasm and support first prompted the idea of a collection.

Most of these essays have appeared before, and I thank the pub-
lishers for permission to reprint them here—in some cases, with
modifications. In particular, large excerpts of "Gender and Science:
An Update" were taken from a similarly titled article originally pub-
lished in *The Great Ideas Today* (© 1990, Enc. Britannica, Inc.). "Se-
crets of God, Nature, and Life" first appeared in *History of the Human
Sciences* (1990); "From Secrets of Life to Secrets of Death," in *Body/
Politics* (1990); "Fractured Images . . . ," in *Poetics Today* (1991);
"Reading Cultural Norms into Natural Law," in *The Boundaries of
Humanity* (© 1991, Univ. of California Press); "The Language of
Reproductive Autonomy" under the title "Sexual Reproduction and

the Central Project of Evolutionary Theory", in *Biology and Philosophy* (© 1987 by D. Reidel); "Demarcating Public from Private Values," in *J. Hist. Biol.* (© 1988 by D. Reidel); and "Between Language and Science" in *Perspectives in Biology and Medicine* (© 1992, Univ. of Chicago Press).

Introduction

In the mid-1970s—the very early days of my shift from "doing" science to thinking about what goes into the production of scientific knowledge—the notion that both that process and its products reflect social norms seemed very radical, not only to my scientific colleagues, but even to most historians and philosophers of science. At that time, Kuhn's *The Structure of Scientific Revolutions* (1962) was still widely viewed as "revolutionary" (Wade 1977), perhaps second only to the even more subversive (and certainly more sweepingly irreverent) work of Paul Feyerabend. Whatever his role in undermining the received view of scientific knowledge, for Kuhn, "science" remained a distinctive endeavor; its internal dynamics, even if neither autonomous nor impervious, still conceptually distinguishable from social ("extrascientific") factors. Perhaps because of my own history as a scientist, I too took as a given the distinctiveness of the values and the practices responsible for the growth of scientific knowledge. From my earliest inquiries into "gender and science," even while I focused on the subjective dimensions of scientific commitments to "objectivity," I distinguished between beliefs about science I called "mythlike" and those commitments I saw as "indispensable." In the introduction to *Reflections on Gender and Science*, I wrote:

> [S]cientists' shared commitment to the possibility of reliable knowledge of nature, and to its dependence on experimental replicability and logical coherence, is an indispensable prerequisite for the effectiveness of any

1

scientific venture. What needs to be understood is how these conscious commitments (commitments we can all share) are fueled and elaborated, and sometimes also subverted, by the more parochial social, political, and emotional commitments (conscious or not) of particular individuals and groups (Keller 1985:11).

In the late 1970s, when I began my inquiry into the psychosocial (historically "masculinist") dimensions of our dominant scientific traditions, such a venture seemed (to me and to others) not only more difficult but potentially even more radical than Kuhn's, perhaps especially insofar as it was aimed at transforming these dominant traditions—as I eventually put it, at "taming [their] hegemony." But relative to the starting point of many critics writing today, it can appear quaintly conservative. My aim was neither the repudiation of science nor its replacement, but rather "the reclamation, from within . . . of science as a human instead of a masculine project, and the renunciation of the division of emotional and intellectual labor that maintains science as a male preserve." Even my critique of the ideal of objectivity was intended "to help clarify the substructure of science in order to preserve the things that science has taught us, in order to be more objective" (Keller 1985:178). In other words, though I well understood that "science" has never been a unified endeavor,[1] I nonetheless regarded it as sufficiently coherent to be distinguishable from other endeavors, and correspondingly, as distinctively valuable. Not surprisingly, the confidence and respect I continued to have for "science" was lost on those critics—mostly from the ranks of "working scientists," but sometimes also from the history and philosophy of science—who read in my work only an attack on both *science* and *objectivity*.

Over the last decade, however, the autonomy (as well as the number) of scholars who study science as observers rather than as practitioners has grown considerably, and a sea change has occurred, among those of us whose academic occupation it has come to be to think about such things, in our understanding of the growth of scientific knowledge. Increasingly, historians, philosophers, and sociologists of science writing today take the social location of the

[1] As Hacking puts it, "The sciences . . . are composed of a large number of only loosely overlapping little disciplines many of which in the course of time cannot even comprehend each other" (1983:6).

natural sciences as their starting point, exploring the influence of economic, political, and cultural factors at every stage of the production of scientific knowledge—on how questions are posed, how research programs come to be legitimated, how theoretical disputes are resolved, on "how experiments end."[2] At every level, choices can be seen to be made that are social *even as* they are cognitive and experimental. For many, especially for those who think of themselves as "post-Kuhnians," the very distinction between internal ("scientific") and external ("extrascientific") dynamics has come to be thought of as an ideological phantasm. Steven Shapin observes that "there is as much society inside science as outside"; in a similar spirit, Bruno Latour argues that the divide between human and nonhuman actors (or between Society and Nature) is itself a product of negotiations and resource networks. In such an ambience, any residual allegiance to "science" or appeal to "nature" (including my own) has come to be seen as retrograde, anachronistic, even as "foundationalist"; visions of transforming or "reclaiming" science (rather than, for example, simply dethroning it) as correspondingly innocent and naive.

Yet I am not about to recant. Along with many of my colleagues, I continue in the effort to articulate, and occupy, a "middle of the road" position. Indeed, as *science studies* has tended toward the dissolution of all distinctive boundaries demarcating the sciences, toward an ever greater focus on institutions, politics, cultural contexts, and language, I have found myself leaning more and more in an opposite direction—feeling the need for more attention to the logical and empirical constraints that make scientific claims so compelling to scientists, as well as to the technological prowess that makes them so compelling to the world at large. There is no question that the work of historians, philosophers, and sociologists of science over the last two decades has made it impossible to think of "nature" either as simply given or as available to any kind of "mirroring." What we know or claim to know about the natural world comes to us in our own constructions—constructions that are inevitably shaped by our cultural and linguistic frames. If I nonetheless continue at times to refer to something called "nature," it is for lack of a better word to denote the world of prelinguistic and pretheoretical

[2] The title of Peter Galison's recent book (1987).

phenomena, constraints, and opportunities in which we reside, and with which we, as part of that world, must negotiate our survival, our accounts and representations, and, perhaps above all, our technological achievements.

Indeed, it is precisely because of the testimony of our technological prowess, because science as we know it "works" so extraordinarily well (that is, because it so effectively meets so many of the goals set for it), that I have become increasingly uncomfortable with the limitations of my initial preoccupations with scientific representations of "nature," and correspondingly compelled to think about the force and efficacy of these representations. The concept of force, however—as I note in "Critical Silences in Scientific Discourse" (this volume)—implies directionality as well as magnitude. Accordingly, the need is not simply to account for the efficacy of scientific knowledge, but, at the same time, to examine critically what it is that knowledge works so well *at*. Inevitably, this entails a shift from thinking about science as "representing" to thinking about representations themselves as tools for "intervening." As Hacking writes, "Theories try to say how the world is. Experiment and subsequent technology change the world. *We represent in order to intervene, and we intervene in the light of representations*" (1983:31, my emphasis). And part of what it means to think about the force and efficacy of scientific knowledge is to think about the force and efficacy of language. It means to take seriously the scientist's inevitable (and usually exasperated) question: "But what does language have to do with what we actually do?"

My "linguistic turn," like Hacking's,[3] is thus toward the constitutive role of language in scientific thought and action in the practice of working scientists. As such, it represents a shift from my earlier preoccupation with the frailties of description, and in one respect at least, a departure from my initial confidence in the possibility of identifying certain beliefs as "mythlike," as distinct from other beliefs that are, by implication, "myth-free." Such a notion now seems to me suspiciously reminiscent of the old demarcation between "truth" and "ideology," or between "good science" and "value-

[3] And, also, of course, Kuhn's, Cartwright's, and that of numerous others. In addition to Hacking (1983) and Kuhn (1989), see, especially, the papers of Buchwald, Cartwright, Hacking, et al., in Kuhn's forthcoming *Festschrift*.

laden science," demarcations that are themselves residues of the copy theory of truth.

Since "nature" is only accessible to us through representations, and since representations are necessarily structured by language (and hence, by culture), no representation can ever "correspond" to reality. At the same time, however, some representations are clearly better (more effective) than others. The question that has plagued much recent philosophy of science is how to make sense of this latter statement in the absence of a copy theory of truth. But the difficulty dissolves if we search for the meaning of "better" in a comparison of the uses to which different representations can be put, that is, in the practices they facilitate. From such a perspective, scientific knowledge is value-laden (and inescapably so) just because it is shaped by our choices—first, of what to seek representations *of*, and second, of what to seek representations *for*. Since uses and practices are obviously not value-free, why should we even think of equating "good" science with the notion of "value-free"? Far from being "value-free," *good science* is science that effectively facilitates the material realization of particular goals, that does in fact enable us to change the world in particular ways. Some of the goals it enables us to realize are goals that almost all people might share, others are more restricted. (*Good science* might also enable the realization of goals that most people would reject—that is, that most people would regard as bad.)

In this sense, *good science* typically works to bring the material world in closer conformity with the stories and expectations that a particular "we" bring with us as scientists embedded in particular cultural, economic, and political frames (see, for example, Keller 1989). What distinguishes it from other successful institutions and practices is precisely its disciplined interaction with the material constraints and opportunities supplied by that which, for lack of a better word, I still call "nature." Scientific "method" is just the name we give to the assorted techniques that scientists have found effective for assessing, subverting, or exploiting those constraints and opportunities, and "disciplines" the name we give to local and institutionalized conventions about how best to proceed toward particular, more or less collectively endorsed, goals.[4]

[4] The manifest difficulty historians of science have in clearly delineating particular

We have come to recognize the *course* of science as a social product, and in that recognition, we have gained the freedom to look critically at its ends, to resist scientists' own tendency to naturalize their current habits and directions. All too well we have learned that "good science" may be efficacious, even while directed to ends we might deplore. But we cannot use our critical freedom to social effect without a clear understanding of science's virtues and strengths—above all, of the nature and conditions of its efficacy.

In brief, then, the course of science is mediated by its sources of external support, by institutional self-reinforcement, and by language. Language simultaneously reflects and guides the development of scientific models and methods. It also helps shape the ends toward which science aims, if only because we gravitate to problems we're equipped to formulate and solve. But language is hardly free. What counts as a usable, effective, and communicable representation is constrained, on the one hand, by our social, cultural, and disciplinary location, and on the other hand, by the recalcitrance of what I am left, by default, to call "nature." The language of scientists is limited by what they learn to think and say as individuals, as members of a discipline, and as members of one or, more usually, several larger communities; it is simultaneously limited by what they can do, individually and collectively, in their ongoing material interactions with the objects of their inquiry.

The essays collected in this volume are explorations within these limits. They all, in various degrees and in various ways, reflect the shifts in my concerns that have followed upon the publication of *Reflections*. Some are directly concerned with questions of gender, others are not. Before introducing them individually, let me therefore briefly review the shifting place of gender both in my own work, and in science studies more generally.

The route from the practice of science to the study of its history and philosophy is a well-traveled one, and people make that transition for all sorts of reasons. For me, involvement in the 1970s in the development of experimental, interdisciplinary college pro-

disciplines (especially, perhaps, in the life sciences—molecular biology and developmental biology are prime examples) attests to the de facto variability that persists in spite of and even between different institutional attempts to ensure consensus. (For relevant discussions of just these issues, see Soderqvist 1986 and Lenoir 1992.)

grams, in the women's movement, and in psychoanalysis were all critical. It was the intersection of these three experiences that made it possible to ask, and to take seriously, questions about the history and philosophy of science that, for me at least, were entirely new. My debt to the closely linked set of concerns that were emerging around me, soon called "feminist theory," was especially great. But "feminist theory" was at one and the same time both too broad and too narrow a label for my own questions. As I cast about for a more accurate tag for these, the term "psychosociology of scientific knowledge" seemed apt, but unwieldy. Moreover, as the work evolved, the role of gender norms—a category at once socially constructed and individually internalized—increasingly came to the fore in the arguments I was developing; "Gender and Science" emerged as the label that stuck. But what this term gained in catchiness, it lost in fidelity to my original intent, for, from the very beginning, I had seen "gender" as but one route into a far larger set of issues.

Over the last decade, the term "Gender and Science" has risen to conspicuous prominence (both in this country and abroad) as a catch-all designator for all studies in the history, philosophy, and sociology of science having to do with women, sex, or gender. Undoubtedly, both the expanded usage of this term and the growing visibility of the work it denotes attest to the positive impact contemporary feminism has begun to have on science studies. At the same time, however, and in the same process, the term itself has become increasingly problematic.[5] In large part, the problem derives from the tacit slippage between "gender" and "women" invited by this expanded usage, and the corresponding elision of the many differences in disciplinary and political interests addressed by this body of work.[6] But another problem, of particular urgency from the perspective of my own interests, has also become evident: While the label "Gender and Science" may have proven unduly expansive in relation to the needs of feminists, it has proven unduly restrictive in relation to the needs of science studies: It has tended to "ghet-

[5] The difficulty of nomenclature quickly becomes apparent if one attempts to sort through recent bibliographies in the history of science under the title "Gender and Science" and tries to distinguish the various literatures—on women in science, on scientific constructions of women, or on the role of gender ideology in science—from one another.

[6] For an elaboration of these points, see Keller (1992).

toize" inquiries about "gender" and insulate them from other pursuits in the history, philosophy, and sociology of science.

Accordingly, part of the motivation for this book is to distinguish the particular strand of "Gender and Science" studies concerned with the role of gender ideologies *in* science, and to embed it in a more general historiographic and philosophical pursuit. The essays included here were written between 1985 and 1991 and are arranged by continuities of theme rather than by chronology.

The essay that appears first, "Gender and Science: An Update," is intended as an overview of the evolution of my own thinking on this subject and inevitably reflects the thinking and writings of many others. Because it is an overview, it stands apart from the other essays as Part I. Beginning explicitly with the meaning of "gender" and the questions that the lens of gender brought into focus in feminist theory, I attempt to sketch the logic of the relation between these questions and certain more general issues in the history and philosophy of science as that logic emerged in my pursuit of the implications of the questions raised in *Reflections*.

Part II includes a series of essays that can roughly be grouped under the rubric of "secrets." The first in this section, "From Secrets of Life to Secrets of Death," was originally written for presentation at the "Kanzer Seminar in Psychoanalysis and the Humanities" (New Haven, Spring, 1986). It begins by invoking the psychoanalytic perspective that was so prominent in *Reflections*, but that is absent from the review offered in Part I, as well as from all the subsequent essays. This essay is included here, with its psychoanalytic orientation intact, partly to make a methodological/political point. Even though I have since found it strategically impossible to proceed with psychodynamic explorations of scientific postures, I stand by that earlier work; I continue to believe in the value, and perhaps even in the ultimate indispensability, of psychodynamic approaches to the study of science, notwithstanding the ill favor with which they are currently received. For both good and bad reasons, most historians, philosophers, and sociologists of science have come to regard psychoanalysis, and even the very idea of the individual subject on which it depends, as something of an embarrassment. However, as even this essay should make clear, the "subject" on which at least traditional psychoanalysis depends is in no sense either independent of or an alternative to other forms of social structure (or

8

"discourse"): Individual subjects are as much constituted by social structures as social structures are constituted by individual subjects, and the occlusion of one is as serious an error as the occlusion of the other, in science studies as elsewhere. Psychoanalysis, despite its problems and deficiencies, continues to provide some of our only tools for thinking about both individual and collective subjectivities.

But the principal point of this essay lies elsewhere, in an attempt to ground the analysis of subjectivity in its sociopolitical and material effects. Like the other essays in Part II, it reflects my growing preoccupation with the material consequences of science, nowhere more dramatically in evidence than in the successes of nuclear physics and molecular biology, that is, in the production of technologies of life and death. My starting point is the analysis of the language of "secrets," and the various uses to which this metaphor can be put.

The next essay, "Secrets of God, Nature, and Life," continues this theme by attempting to trace the historical trajectory of the trope of "secrets" from the earliest days of modern science to the present. A close rereading of Robert Boyle's classic essay, "A Free Inquiry into the Vulgarly Received Notion of Nature," illustrates the use of metaphor in the reorientation between men, women, and nature that Boyle explicitly sought to effect, and that is both reflected and facilitated by the shifting referent of "secrets" in the larger discourse of his time.

"Critical Silences in Scientific Discourse" also reflects my continuing preoccupation with technologies of life and death. It was written for presentation at the Institute for Advanced Study at Princeton during my year in residence there (1987–88). Much of that year was devoted to a search for a conceptual framework adequate to an account for the efficacy of scientific representations while at the same time acknowledging their cultural dependence—that would enable me to steer clear of the Scylla of "social relativism" and the Charybdis of "scientific realism." As the time approached for my public presentation, to an audience composed largely of physicists and social scientists, I became increasingly conscious of the extraordinary divergence between the ways in which these two groups thought about science. Accordingly, part of the purpose of this essay was to make this gap visible, on the assumption that, once visible, it would be seen as insupportable. That is, with the naivete of a new convert, I hoped to make what I had come to see as the critical problem in

science studies evident, and therefore compelling, to both groups. I surely cannot claim to have succeeded in this ambition; however, I *have* subsequently found the framework sketched out in this essay to be useful. Especially, it has provided me with a way of thinking about the intersection of cognitive, psychosocial, economic, political, and technical interests against which the efficacy of any research trajectory needs to be judged.

This framework clearly informs the next essay, "Fractured Images of Science, Language, and Power." Here I pursue the question only raised in the previous essay, namely, that of how particular social and material ambitions have helped to guide the choice of scientific theory or representation in the history of molecular genetics. More specifically, I focus first on the influence the anticipated achievements of nuclear physics had on the thinking of the geneticist, H. J. Muller, and later on the influence the actual demonstration of those achievements had on the consolidation of much of Muller's theoretical agenda in the dominant research program of molecular biology.

The essays comprising Part III of this book are more technical, and somewhat less grandiose in their ambitions. All four address the question of how language works in the specification of actual research agendas—in the first three essays, of evolutionary biology, and in the last, in molecular biology. In Part I of "Language and Ideology in Evolutionary Theory," I explore the ways in which the language of competition, with all its vicissitudes, has served as a vehicle for the importation of cultural norms into evolutionary biology—in particular and most conspicuously, of the "Hobbesian" norm of "all against all" into mathematical ecology. "Competition" is a term with both technical and colloquial meanings, and slippage between the two is both routine and consequential. It is precisely such slippage that "permits the simultaneous transfer and denial of its colloquial connotations" into technical contexts.

In Part II of the essay, my focus is on population genetics where, I argue, "The Language of Reproductive Autonomy" has critically bolstered the traditionally individualist bias of evolutionary biology. Analysis of the semipopular and technical uses of "competition" (in the first part of the essay), and of the language of reproductive autonomy (in the second), enables me to consider the extent to which animate forms of contemporary biological discourse have been "suc-

cessfully deanimated and mechanised," and the extent to which "their mechanical representations [have] themselves been inadvertently animated, subtly recast in particular images of man."[7]

The same general argument is continued in "Demarcating Public from Private Values in Evolutionary Discourse," where it is extended to an analysis of how arguments involving kinds of "individual" other than the organism (for example, the species, the group, or the gene) are constructed. Here the focus is less on definitions of "competition" and "individual" (and the inadvertent slippage between ordinary and technical usage to which these terms are prey) and more on the ways in which tacit assumptions about the necessary properties of "individual" have affected recent debates in population genetics and mathematical ecology, particularly in the implementation of the chosen methodology of evolutionary biology, "methodological individualism."

The closing essay focuses on a recent debate not in evolutionary biology, but in molecular genetics. "Between Language and Science: The Question of Directed Mutation in Molecular Genetics" returns to a question that was a leitmotif in *A Feeling for the Organism* (Keller 1983): the repeated return of the "ghost of Lamarck" in twentieth-century biology, and its relation to the "central dogma" of molecular genetics. The clear implication of McClintock's work on transposition is that "the genetic apparatus . . . is a more complex system, with more complex forms of feedback, than had been previously thought. Perhaps," I went on to suggest,

> the future will show that its internal complexity is such as to enable it not only to program the life cycle of the organism, with fidelity to past and future generations, but also to reprogram itself when exposed to sufficient stress—thereby effecting a kind of "learning" from the organism's experience. Such a picture would be radical indeed, and it would be one that would do justice to McClintock's vision: it would imply a concept of genetic variation that is neither random nor purposive—and an understanding of evolution transcending that of both Lamarck and Darwin (pp. 194–95).

In this essay, I trace the linguistic construction of the dichotomy

[7] It is the work of these essays that provided my primary incentive for *Keywords in Evolutionary Biology* (Keller and Lloyd 1992).

11

between "random" and "purposive" (and between "Lamarckism" and "Darwinism"), and the persistence of this opposition, in the exchanges initiated by John Cairns's most recent challenge to neo-Darwinian orthodoxy (1988).

The essays collected in this volume do not provide answers to the questions that occupy contemporary historians, philosophers, and sociologists of science. Instead, they reveal critical convergences between such questions and those that have grown directly out of feminist inquiries. It is my hope that, by illustrating some of the complex interconnectivities between gender, language, and science, they can contribute to our collective and ongoing efforts to understand how science works within the plenitude of sometimes converging and sometimes conflicting human desires.

Part I

1

Gender and Science:
An Update

Introduction

The Meaning of Gender

Schemes for classifying human beings are necessarily multiple and highly variable. Different cultures identify and privilege different criteria in sorting people of their own and other cultures into groups: They may stress size, age, color, occupation, wealth, sanctity, wisdom, or a host of other demarcators. All cultures, however, sort a significant fraction of the human beings that inhabit that culture by sex. What are taken to be the principal indicators of sexual difference as well as the particular importance attributed to this difference undoubtedly vary, but, for fairly obvious reasons, people everywhere engage in the basic act of distinguishing people they call male from those they call female. For the most part, they even agree about who gets called what. Give or take a few marginal cases, these basic acts of categorization do exhibit conspicuous cross-cultural consensus: Different cultures will sort any given collection of adult human beings of reproductive age into the same two groups. For this reason, we can say that there is at least a minimal sense of the term "sex" that denotes categories given to us by nature.[1] One might even say that the universal importance of the reproductive consequences of

This essay adapted from Keller (1990), with excerpts from Keller (1987).
[1] A somewhat different view is given by Tom Laqueur (1990).

sexual difference gives rise to as universal a preoccupation with the meaning of this difference.

But for all the cross-cultural consensus we may find around such a minimalist classification, we find equally remarkable cultural variability in what people have made and continue to make of this demarcation; in the significance to which they attribute it; in the properties it connotes; in the role it plays in ordering the human world beyond the immediate spheres of biological reproduction; even in the role it plays in ordering the nonhuman world. It was to underscore this cultural variability that American feminists of the 1970s introduced the distinction between sex and gender, assigning the term "gender" to the meanings of masculinity and femininity that a given culture attaches to the categories of male and female.[2]

The initial intent behind this distinction was to highlight the importance of nonbiological (that is, social and cultural) factors shaping the development of adult men and women, to emphasize the truth of Simone de Beauvoir's famous dictum, "Women are not born, rather they are made." Its function was to shift attention away from the time-honored and perhaps even ubiquitous question of the meaning of sexual difference (that is, the meanings of masculine and feminine), *to* the question of how such meanings are constructed. In Donna Haraway's words, "Gender is a concept developed to contest the naturalization of sexual difference" (1991:131).

Very quickly, however, feminists came to see, and, as quickly, began to exploit, the considerably larger range of analytic functions that the multipotent category of gender is able to serve. From an original focus on gender as a cultural norm guiding the psychosocial development of individual men and women, the attention of feminists soon turned to gender as a cultural structure organizing social (and sexual) relations between men and women,[3] and finally, to gender as the basis of a sexual division of cognitive and emotional labor that brackets women, their work, and the values associated with that work from culturally normative delineations of categories intended as "human"—objectivity, morality, citizenship, power, often even, "human nature" itself.[4] From this perspective, gender

[2] See, for example, Gayle Rubin (1975).

[3] See, for example, Rubin (1975) and Catherine MacKinnon (1988).

[4] In the most recent literature, discussions of gender have become yet more so-

and gender norms come to be seen as silent organizers of the mental and discursive maps of the social and natural worlds we simultaneously inhabit and construct—*even of those worlds that women never enter.*[5] This I call the symbolic work of gender; it remains silent precisely to the extent that norms associated with masculine culture are taken as universal.

The fact that it took the efforts of contemporary feminism to bring this symbolic work of gender into recognizable view is in itself noteworthy. In these efforts, the dual focus on women as subjects and on gender as a cultural construct was crucial. Analysis of the relevance of gender structures in conventionally male worlds only makes sense once we recognize gender not only as a bimodal term, applying symmetrically to men *and* women (that is, once we see that men too are gendered, that men too are made rather than born), but also as denoting social rather than natural kinds. Until we can begin to envisage the possibility of alternative arrangements, the symbolic work of gender remains both silent and inaccessible. And as long as gender is thought to pertain only to women, any question about its role can only be understood as a question about the presence or absence of biologically female persons.

This double shift in perception—first, from sex to gender, and second, from the force of gender in shaping the development of men and women to its force in delineating the cultural maps of the social and natural worlds these adults inhabit—constitutes the hallmark of contemporary feminist theory. Beginning in the mid 1970s, feminist historians, literary critics, sociologists, political scientists, psychologists, philosophers, and soon, natural scientists as well, sought to

phisticated as feminist scholars have begun to shift their focus away from the unifying force of gender norms within particular culturally homogeneous systems, to such inhomogeneities as class and race prevailing within ostensibly unitary cultures. But within the confines of those few worlds that can be said to be culturally homogeneous—such as, for example, the almost entirely white, upper and middle-class, predominantly Eurocentric world of modern science—analysis of the force of gender and gender norms remains relatively straightforward. Indeed, the very exclusivity of this tradition provides one of the few cases in which, precisely because of its racial and class exclusivity, the variables of race and class can be bracketed from the analysis. It must be remembered, however, that the concept of "gender" that appears in such an analysis is one that is restricted to a particular subset of "Western" culture.

[5] See, for example, Sandra Harding (1986) for a useful summary of these multiple yet interacting meanings of the term gender.

supplement earlier feminist analyses of the contribution, treatment, and representation of men and women in these various fields with an enlarged analysis of the ways in which privately held and publicly shared ideas about gender have shaped the underlying assumptions and operant categories in the intellectual history of each of these fields. Put simply, contemporary feminist theory might be described as "a form of attention, a lens that brings into focus a particular question: What does it mean to describe one aspect of human experience as 'male' and another as 'female'? How do such labels affect the ways in which we structure the world around us, assign value to its different domains, and in turn, acculturate and value actual men and women?" (Keller 1985:6).

With such questions as these, feminist scholars launched an intensive investigation of the traces of gender labels evident in many of the fundamental assumptions underlying the traditional academic disciplines. Their earliest efforts were confined to the humanities and social sciences, but by the late 1970s, the lens of feminist inquiry had extended to the natural sciences as well. Under particular scrutiny came those assumptions that posited a dichotomous (and hierarchical) structure tacitly modeled on the prior assumption of a dichotomous (and hierarchical) relation between male and female—for example, public/private; political/personal; reason/feeling; justice/care; objective/subjective; power/love, and so on. The object of this endeavor was not to reverse the conventional ordering of these relations, but to undermine the dichotomies themselves—to expose to radical critique a worldview that deploys categories of gender to rend the fabric of human life and thought along a multiplicity of mutually sanctioning, mutually supportive, and mutually defining binary oppositions.

Feminism and Science

But if the inclusion of the natural sciences under this broad analytic net posed special opportunities, it also posed special difficulties, and special dangers, each of which requires special recognition. On the one hand, the presence of gender markings in the root categories of the natural sciences and their use in the hierarchical ordering of such categories (for example, mind and nature; reason and feeling;

objective and subjective) is, if anything, more conspicuous than in the humanities and social sciences. At the same time, the central claim of the natural sciences is precisely to a methodology that transcends human particularity, that bears no imprint of individual or collective authorship. To signal this dilemma, I began my first inquiry into the relations between gender and science (Keller 1978) with a quote from George Simmel, written more than sixty years ago:

> The requirements of . . . correctness in practical judgments and objectivity in theoretical knowledge . . . belong as it were in their form and their claims to humanity in general, but in their actual historical configuration they are masculine throughout. Supposing that we describe these things, viewed as absolute ideas, by the single word "objective," we then find that in the history of our race the equation objective = masculine is a valid one (cited in Keller 1978:409).

Simmel's conclusion, while surely on the mark as a description of a cultural history, alerts us to the special danger that awaits a feminist critique of the natural sciences. Indeed, Simmel himself appears to have fallen into the very trap that we are seeking to expose: In neglecting to specify the space in which he claims "validity" for this equation as a *cultural or even ideological space*, his wording invites the reading of this space as a biological one. Indeed, by referring to its history as a "history of our race" without specifying "our race" as late-modern, northern European, he tacitly elides the existence of other cultural histories (as well as other "races") and invites the same conclusion that this cultural history has sought to establish; namely, that "objectivity" is simultaneously a universal value and a privileged possession of the male of the species.

The necessary starting point for a feminist critique of the natural sciences is thus the reframing of this equation as a conundrum: How is it that the scientific mind can be *seen* at one and the same time as both male and disembodied? How is it that thinking "objectively," that is, thinking that is defined as self-detached, impersonal, and transcendent, is also understood as "thinking like a man"? From the vantage point of our newly "enlightened" perceptions of gender, we might be tempted to say that the equation "objective = masculine," harmful though it (like that other equation woman = nature) may have been for aspiring women scientists in the past, was

simply a descriptive mistake, reflecting misguided views of women. But what about the views of "objectivity" (or "nature") that such an equation necessarily also reflected (or inspired)? What difference—for science, now, rather than for women—might such an equation have made? Or, more generally, what sorts of work in the actual production of science has been accomplished by the association of gender with virtually all of the root categories of modern science over the three hundred odd years in which such associations prevailed? How have these associations helped to shape the criteria for "good" science? For distinguishing the values deemed "scientific" from those deemed "unscientific"? In short, what particular cultural norms and values has the language of gender carried into science, and how have these norms and values contributed to its shape and growth?

These, then, are some of the questions that feminist theory brings to the study of science, and that feminist historians and philosophers of science have been trying to answer over the last fifteen years. But, for reasons I have already briefly indicated, they are questions that are strikingly difficult to hold in clear focus (to keep distinct, for example, from questions about the presence or absence of women scientists). For many working scientists, they seem not even to "make sense."

One might suppose, for example, that once such questions were properly posed (that is, cleansed of any implication about the real abilities of actual women), they would have a special urgency for all practicing scientists who are also women. But experience suggests otherwise; even my own experience suggests otherwise. Despite repeated attempts at clarification, many scientists (especially, women scientists) persist in misreading the force that feminists attribute to gender ideology as a force being attributed to sex, that is, to the claim that women, for biological reasons, would do a different kind of science. The net effect is that, where some of us see a liberating potential (both for women *and* for science) in exhibiting the historical role of gender in science, these scientists often see only a reactionary potential, fearing its use to support the exclusion of women from science.[6]

[6] Of course, scientists are not the only ones who persist in such a mistranslation;

The reasons for the divergence in perception between feminist critics and women scientists are deep and complex. Though undoubtedly fueled by political concerns, they rest finally neither on vocabulary, nor on logic, nor even on empirical evidence. Rather, they reflect a fundamental difference in mind-set between feminist critics and working scientists—a difference so radical that a "feminist scientist" appears today as much a contradiction in terms as a "woman scientist" once did.[7]

I need only recall my own trajectory from practicing scientist to feminist critic to appreciate the magnitude of difference between these two mind-sets, as well as the effort required to traverse that difference. In the hope that my experience, with its inevitable idiosyncracies, might prove helpful in furthering our understanding of the more general problem, I offer a reconstruction of that trajectory.

From Working Scientist to Feminist Critic

I begin with three vignettes, all drawn from memory.

1965. In my first few years out of graduate school, I held quite conventional beliefs about science. I believed not only in the possibility of clear and certain knowledge of the world, but also in the uniquely privileged access to this knowledge provided by science in general, and by physics in particular. I believed in the accessibility of an underlying (and unifying) "truth" about the world we live in, and I believed that the laws of physics gave us the closest possible approximation of this truth. In short, I was well trained in both the traditional realist worldviews assumed by virtually all scientists and in the conventional epistemological ordering of the sciences. I had, after all, been trained, first, by theoretical physicists, and later, by

it is also made by many others, and even by some feminists who are not themselves scientists. It is routinely made by the popular press. The significant point here is that this mistranslation persists in the minds of most women scientists even after they are alerted to the (feminist) distinction between sex and gender.

[7] Indeed, a striking number of those feminist critics who began as working scientists have either changed fields altogether or have felt obliged to at least temporarily interrupt their work as laboratory or "desk" scientists (I am thinking, for example, of [the late] Maggie Benston, Ruth Hubbard, Marian Lowe, Evelynn Hammonds, Anne Fausto-Sterling, and myself).

molecular biologists. This is not to say that I lived my life according to the teachings of physics (or molecular biology), only that when it came to questions about what "really is," I knew where, and how, to look. Although I had serious conflicts about my own ability to be part of this venture, I fully accepted science, and scientists, as arbiters of truth. Physics (and physicists) were, of course, the highest arbiters.

Somewhere around this time, I came across the proceedings of the first major conference held in the United States on "Women and the Scientific Professions" (Mattfield and Van Aiken 1965)—a subject of inevitable interest to me. I recall reading in those proceedings an argument for more women in science, made by both Erik Erikson and Bruno Bettelheim, based on the invaluable contributions a "specifically female genius" could make to science. Although earlier in their contributions both Erikson and Bettelheim had each made a number of eminently reasonable observations and recommendations, I flew to these concluding remarks as if waiting for them, indeed forgetting everything else they had said. From the vantage point I then occupied, my reaction was predictable: To put it quite bluntly, I laughed. Laws of nature are universal—how could they possibly depend on the sex of their discoverers? Obviously, I snickered, these psychoanalysts know little enough about science (and by implication, about truth).

1969. I was living in a suburban California house and found myself with time to think seriously about my own mounting conflicts (as well as those of virtually all my female cohorts) about being a scientist. I had taken a leave to accompany my husband on his sabbatical, remaining at home to care for our two small children. Weekly, I would talk to the colleague I had left back in New York and hear his growing enthusiasm as he reported the spectacular successes he was having in presenting our joint work. In between, I would try to understand why my own enthusiasm was not only not growing, but actually diminishing. How I went about seeking such an understanding is worth noting: What I did was to go to the library to gather data about the fate of women scientists in general— more truthfully, to document my own growing disenchantment (even in the face of manifest success) as part of a more general phenomenon reflecting an underlying misfit between women and

science. And I wrote to Erik Erikson for further comment on the alarming (yet somehow satisfying) attrition data I was collecting. In short, only a few years after ridiculing his thoughts on the subject, I was ready to at least entertain if not embrace an argument about women in, or out of, science based on "women's nature." Not once during that entire year did it occur to me that at least part of my disenchantment might be related to the fact that I was in fact not sharing in the *kudos* my colleague was reaping for our joint work.

1974. I had not dropped out of science, but I had moved into interdisciplinary, undergraduate teaching. And I had just finished teaching my first women's studies course when I received an invitation to give a series of "Distinguished Lectures" on my work in mathematical biology at the University of Maryland. It was a great honor, and I wanted to do it, but I had a problem. In my women's studies course, I had yielded to the pressure of my students and colleagues to talk openly about what it had been like, as a woman, to become a scientist. In other words, I had been persuaded to publicly air the exceedingly painful story of the struggle that had actually been[8]—a story I had previously only talked about in private, if at all. The effect of doing this was that I actually came to *see* that story as public, that is, of political significance, rather than as simply private, of merely personal significance. As a result, the prospect of continuing to present myself as a disembodied scientist, of talking about my work as if it had been done in a vacuum, as if the fact of my being a woman was entirely irrelevant, had come to feel actually dishonest.

I resolved the conflict by deciding to present in my last lecture a demographic model of women in science—an excuse to devote the bulk of that lecture to a review of the many barriers that worked against the survival of women as scientists, and to a discussion of possible solutions. I concluded my review with the observation that perhaps the most important barrier to success for women in science derived from the pervasive belief in the intrinsic masculinity of scientific thought. Where, I asked, does such a belief come from? What is it doing in science, reputedly the most objective, neutral, and

[8] This story was subsequently published in Ruddick and Daniels's *Working It Out* (1977).

abstract endeavor we know? And what consequences does that belief have for the actual doing of science?

In 1974 "women in science" was not a proper subject for academic or scientific discussion; I was aware of violating professional protocol. Having given the lecture—having "carried it off"—I felt profoundly liberated. I had passed an essential milestone.

Although I did not know it then, and wouldn't recognize it for another two years, this lecture marked the beginning of my work as a feminist critic of science. In it I raised three of the central questions that were to mark my research and writing over the next decade. I can now see that, with the concluding remarks of that lecture, I had also completed the basic shift in mind-set that made it possible to begin such a venture. Even though my views about gender, science, knowledge, and truth were to evolve considerably over the years to come, I had already made the two most essential steps: I had shifted attention from the question of male and female nature to that of *beliefs about* male and female nature, that is, to gender ideology. And I had admitted the possibility that such beliefs could affect science itself.

In hindsight, these two moves may seem simple enough, but when I reflect on my own history, as well as that of other women scientists, I can see that they were not. Indeed, from my earlier vantage point, they were unthinkable. In that mind-set, there was room neither for a distinction between sexual identity and beliefs about sexual identity (not even for the prior distinction between sex and gender upon which it depends), nor for the possibility that beliefs could affect science—a possibility that requires a distinction analagous to that between sex and gender, only now between nature and science. I was, of course, able to accommodate a distinction between belief and reality, but only in the sense of "false" beliefs— that is, mere illusion, or mere prejudice; "true" beliefs I took to be synonomous with the "real."

It seems to me that in that mind-set, beliefs per se were not seen as having any real force—neither the force to shape the development of men and women, nor the force to shape the development of science. Some people may "misperceive" nature, human or otherwise, but properly seen, men and women simply *are*, faithful reflections of male and female biology—just as science simply *is*, a faithful reflection of nature. Gravity has (or is) a force, DNA has

force, but beliefs do not. In other words, as scientists, we are trained to see the locus of real force in the world as physical, not mental.

There is of course a sense in which they are right: Beliefs per se cannot exert force on the world. But the people who carry such beliefs can. Furthermore, the language in which their beliefs are encoded has the force to shape what others—as men, as women, and as scientists—think, believe, and, in turn, actually do. It may have taken the lens of feminist theory to reveal the popular association of science, objectivity, and masculinity as a statement about the social rather than natural (or biological) world, referring not to the bodily and mental capacities of individual men and women, but to a collective consciousness; that is, as a set of beliefs given existence by language rather than by bodies, and by that language, granted the force to shape what individual men and women might (or might not) do. But to see how such culturally laden language could contribute to the shaping of science takes a different kind of lens. That requires, first and foremost, a recognition of the social character (and force) of the enterprise we call "science," a recognition quite separable from—and in fact, historically independent of—the insights of contemporary feminism.

The Meaning of Science

Although people everywhere, throughout history, have needed, desired, and sought reliable knowledge of the world around them, only certain forms of knowledge and certain procedures for acquiring such knowledge have come to count under the general rubric that we, in the late twentieth century, designate as science. Just as "masculine" and "feminine" are categories defined by a culture, and not by biological necessity, so too, "science" is the name we give to a set of practices and a body of knowledge delineated by a community. Even now, in part because of the great variety of practices that the label "science" continues to subsume, the term defies precise definition, obliging us to remain content with a conventional definition—as that which those people we call scientists do.

What has compelled recognition of the conventional (and hence social) character of modern science is the evidence provided over

the last three decades by historians, philosophers, and sociologists of science who have undertaken close examination of what it is that those people we call (or have called) scientists actually do (or have done).[9] Careful attention to what questions get asked, of how research programs come to be legitimated and supported, of how theoretical disputes are resolved, of "how experiments end" reveals the working of cultural and social norms at every stage.[10] Consensus is commonly achieved, but it is rarely compelled by the forces of logic and evidence alone. On every level, choices are (must be) made that are social *even as* they are cognitive and technical. The direct implication is that not only different collections of facts, different focal points of scientific attention, but also different conceptions of explanation and proof, different representations of reality, different criteria of success, are both possible and consistent with what we call science.

But if such observations have come to seem obvious to many observers of science, they continue to seem largely absurd to the men and women actually engaged in the production of science. In order to see how cultural norms and values can, indeed have, helped define the success and shape the growth of science, it is necessary to understand how language embodies and enforces such norms and values. This need far exceeds the concerns of feminism, and the questions it gives rise to have become critical for anyone currently working in the history, philosophy, or sociology of science. That it continues to elude most working scientists is precisely a consequence of the fact that their worldviews not only lack but actually preclude recognition of the force of language on what they, in their day-to-day activity as scientists, think and do. And this, I suggest, follows as much from the nature of their activity as it does from scientific ideology.

[9] In large part, stimulated by the publication of Thomas S. Kuhn's *The Structure of Scientific Revolutions*, in 1962.

[10] See, for example, Galison (1988); Pickering (1984); Shapin and Schaffer (1985); Smith and Wise (1989).

Language and the Doing of Science[11]

The reality is that the "doing" of science is, at its best, a gripping and fully absorbing activity—so much so that it is difficult for anyone so engaged to step outside the demands of the particular problems under investigation to reflect on the assumptions underlying that investigation, much less, on the language in which such assumptions can be said to "make sense." Keeping track of and following the arguments and data as they unfold, trying always to think ahead, demands total absorption; at the same time, the sense of discovering or even generating a new world yields an intoxication rarely paralleled in other academic fields. The net result is that scientists are probably less reflective of the "tacit assumptions" that guide their reasoning than any other intellectuals of the modern age.

Indeed, the success of their enterprise does not, at least in the short run, seem to require such reflectivity.[12] Some would even argue that very success demands abstaining from reflection upon matters that do not lend themselves to "clear and distinct" answers. Indeed, they might argue that what distinguishes contemporary science from the efforts of their forbears is precisely their recognition of the dual need to avoid talk *about* science, and to replace "ordinary" language by a technical discourse cleansed of the ambiguity and values that burden ordinary language, as the modern form of the scientific report requires. Let the data speak for themselves, these scientists demand. The problem is, of course, that data never do speak for themselves.

It is by now a near truism that all data presuppose interpretation. And if an interpretation is to be meaningful—if the data are to be "intelligible" to more than one person—it must be embedded in a community of common practices, shared conceptions of the meaning of terms and their relation to and interaction with the "objects" to which these terms point. In science as elsewhere, interpretation requires the sharing of a common language.

Sharing a language means sharing a conceptual universe. It means

[11] The discussion that follows begins with a recapitulation of my remarks in Keller (1985:129–32).

[12] For an especially interesting discussion of this general phenomenon, see Markus (1987).

27

more than knowing the "right" names by which to call things; it means knowing the "right" syntax in which to pose claims and questions, and even more critically it means sharing a more or less agreed-upon understanding of what questions are legitimate to ask, and what can be accepted as meaningful answers. Every explicit question carries with it a complex of tacit (unarticulated and generally unrecognized) presuppositions and expectations that limit the range of acceptable answers in ways that only a properly versed respondent will recognize. To know what kinds of explanation will "make sense," what can be expected to count as "accounting for," is already to be a member of a particular language community.

But if there is one feature that distinguishes scientific from other communities, and that is indeed special to that particular discourse, it is precisely the assumption that the universe scientists study is directly accessible, that the "nature" they name as object of inquiry is unmediated by language and can therefore be veridically represented. On this assumption, "laws of nature" are beyond the relativity of language—indeed, they are beyond language, encoded in logical structures that require only the discernment of reason and the confirmation of experiment. Also on this assumption, the descriptive language of science is transparent and neutral; it does not require examination.

Confidence in the transparency and neutrality of scientific language is certainly useful in enabling scientists to get on with their job; it is also wondrously effective in supporting their special claims to truth. It encourages the view that their own language, because neutral, is absolute, and in so doing, helps secure their disciplinary borders against criticism. Language, assumed to be transparent, becomes impervious.

It falls to others, then, less enclosed by the demands of science's own self-understanding, to disclose the "thickness" of scientific language, to scrutinize the conventions of practice, interpretation, and shared aspirations on which the truth claims of that language depend, to expose the many forks in the road to knowledge that these very conventions have worked to obscure, and, in that process, finally, to uncover alternatives for the future. Under careful scrutiny, the hypothesized contrast between ordinary and scientific language gives way to a recognition of disconcerting similarity. Even the most purely technical discourses turn out to depend on metaphor, on

ambiguity, on instabilities of meaning—indeed, on the very com-
monsense understanding of terms from which a technical discourse
is supposed to emancipate us. Scientific arguments cannot begin to
"make sense," much less be effective, without extensive recourse to
shared conventions for controlling these inevitable ambiguities and
instabilities. The very term "experimental control" needs to be
understood in a far larger sense than has been the custom—describ-
ing not only the control of variables, but also of the ways of seeing,
thinking, acting, and speaking in which an investigator must be
extensively trained before he or she can become a contributing mem-
ber of a discipline.

Even the conventional account scientists offer of their success has
been shown by recent work in the history, philosophy, and sociology
of science to be itself rooted in metaphor: The very idea, for example,
of a one-to-one correspondence between theory and reality, or of
scientific method as capable of revealing nature "as it is," is based
on metaphors of mind or science as "mirror of nature." Simple logic,
however, suggests that words are far too limited a resource, in what-
ever combinations, to permit a faithful representation of even our
own experience, much less of the vast domain of natural phenom-
ena.[13] The metaphor of science as "mirror of nature" may be both
psychologically and politically useful to scientists, but it is not par-
ticularly useful for a philosophical understanding of how science
works; indeed, it has proven to be a positive barrier to our under-
standing of the development of science in its historical and social
context. It is far more useful, and probably even more correct, to
suppose, as Mary Hesse suggests, that "[s]cience is successful only
because there are sufficient local and particular regularities between
things in space-time domains where we can test them. These do-
mains may be very large but it's an elementary piece of mathematics
that there is an infinite gap between the largest conceivable number
and infinity" (1989:E24).

In much the same sense, the idea of "laws of nature" can also
be shown to be rooted in metaphor, a metaphor indelibly marked

[13] Mary Hesse points out, "Neurons come in billions and their possible linkages
in megabillions, while the words of a language come only in thousands and sentences
cannot in a lifetime be long enough to match the antics of the neurons. There can't
be a word or a sentence to cover every particular thing" (1989, p. E24).

by its political and theological origins. Despite the insistence of philosophers that laws of nature are merely descriptive, not prescriptive, they are historically conceptualized as imposed from above and obeyed from below. "By those who first used the term, [laws of nature] were viewed as commands imposed by the deity upon matter, and even writers who do not accept this view often speak of them as 'obeyed' by the phenomena, or as agents by which the phenomena are produced."[14] In this sense, then, the metaphor of "laws of nature" carries into scientific practice the presupposition of an ontological hierarchy, ordering not only mind and matter, but theory and practice, and, of course, the normal and the aberrant. Even in the loosest (most purely descriptive) sense of the term *law*, the kinds of order in nature that laws can accommodate are restricted to those that can be expressed by the language in which laws of nature are codified. All languages are capable of describing regularity, but not all perceivable, nor even all describable, regularities can be expressed in the existing vocabularies of science. To assume, therefore, that all perceptible regularities can be represented by current (or even by future) theory is to impose a premature limit on what is "naturally" possible, as well as what is potentially understandable.

Nancy Cartwright (1990) has suggested that a better way to make sense of the theoretical successes of science (as well as its failures) would be to invoke the rather different metaphor of "Nature's Capacities." In apparent sympathy with Mary Hesse, as well as with a number of other contemporary historians and philosophers of science, she suggests that an understanding of the remarkable convergences between theory and experiment that scientists have produced requires attention not so much to the adequacy of the laws that are presumably being tested, but rather to the particular and highly local manipulation of theory and experimental procedure that is required to produce these convergences. Our usual talk of scientific laws, Cartwright suggests, belies (and elides) both the conceptual and linguistic work that is required to ground a theory, or "law," to fit a particular set of experimental circumstances and the material work required to construct an experimental apparatus to fit a the-

[14] O. E. D., s.v. "law." The discussion here is adapted from the introduction to Part III, Keller (1985).

oretical claim. Scientific laws may be "true," but what they are true of is a distillation of highly contrived and exceedingly particular circumstances, as much artifact as nature.

Turning from Gender and Science to Language and Science

The questions about gender with which I began this essay can now be reformulated in terms of two separable kinds of inquiry: The first, bearing on the historical role of public and private conceptions of gender in the framing of the root metaphors of science, belongs to feminist theory proper, whereas the second, that of the role of such metaphors in the actual development of scientific theory and practice, belongs to a more general inquiry in the history and philosophy of science. By producing abundant historical evidence pertaining to the first question, and by exhibiting the in-principle possibility of alternative metaphoric options, feminist scholars have added critical incentive to the pursuit of the second question. And by undermining the realism and univocality of scientific discourse, the philosophical groundwork laid by Kuhn, Hesse, Cartwright, and many others, now makes it possible to pursue this larger question in earnest, pointing the way to the kind of analysis needed to show how such basic acts of naming have helped to shape the actual course of scientific development, and, in so doing, have helped to obscure if not foreclose other possible courses.

The most critical resource available for such an inquiry is the de facto plurality of organizing metaphors, theories, and practices evident throughout the history of science. At any given moment, in any given discipline, abundant variability can be readily identified along the following four closely interdependent axes: the aims of scientific inquiry; the questions judged most significant to ask; the theoretical and experimental methodologies deemed most productive for addressing these questions; and, finally, what counts as an acceptable answer or a satisfying explanation. Different metaphors of mind, nature, and the relation between them, reflect different psychological stances of observer to observed; these, in turn, give rise to different cognitive perspectives—to different aims, questions, and even to different methodological and explanatory preferences.

31

Such variability is of course always subject to the forces of selection exerted by collective norms, yet there are many moments in scientific history in which alternative visions can survive for long enough to permit identification both of their distinctiveness, and of the selective pressures against which they must struggle.

The clearest and most dramatic such instance in my own research remains that provided by the life and work of the cytogeneticist, Barbara McClintock. McClintock offers a vision of science premised not on the domination of nature, but on "a feeling for the organism."[15] For her, a "feeling for the organism" is simultaneously a state of mind and a resource for knowledge: for the day-to-day work of conducting experiments, observing and interpreting their outcomes—in short, for the "doing" of science. "Nature," to McClintock, is best known for its largesse and prodigality; accordingly, her conception of the work of science is more consonant with that of exhibiting nature's "capacities" and multiple forms of order, than with pursuing the "laws of nature." Her alternative view invites the perception of nature as an active partner in a more reciprocal relation to an observer, equally active, but neither omniscient nor omnipotent; the story of her life's work (especially, her identification of genetic transposition) exhibits how that deviant perception bore fruit in equally dissident observations.

But history is strewn with such dissidents and deviants, often as persistent and perceptive but still less fortunate than McClintock. Normally, they are erased from the record, in a gesture readily justified by the conventional narrative of science. Without the validation of the dominant community, deviant claims, along with the deviant visions of science that had guided them, are dismissed as "mistakes," misguided and false steps in the history of science. What such a retrospective reading overlooks is that the ultimate value of any accomplishment in science—that which we all too casually call its "truth"—depends not on any special vision enabling some scientists to see directly into nature, but on the acceptance and pursuit of their work by the community around them, that is, on the prior existence or development of sufficient commonalities of language and adequate convergences between language and practice. Lan-

[15] McClintock's own words, as well as the title of my book on this subject, Keller (1983).

guage not only guides how we as individuals think and act; it simultaneously provides the glue enabling others to think and act along similar lines, guaranteeing that our thoughts and actions *can* "make sense."

What About "Nature"?

Still, language does not "construct reality." Whatever force it may have, that force can, after all, only be exerted on language-speaking subjects—for our concerns here, on scientists and the people who fund their work. Though language is surely instrumental in guiding the material actions of these subjects, it would be foolhardy indeed to lose sight of the force of the material, nonlinguistic, substrata of those actions, that is, of that which we loosely call "nature." Metaphors work to focus our attention in particular ways, conceptually magnifying one set of similarities and differences while dwarfing or blurring others, guiding the construction of instruments that bring certain kinds of objects into view, and eclipsing others. Yet, for any given line of inquiry, it is conspicuously clear that not all metaphors are equally effective for the production of further knowledge. Furthermore, once these instruments and objects have come into existence, they take on a life of their own, available for appropriation to other ends, to other metaphoric schemes.

Consider, for example, the fate of genetic transposition. McClintock's search for this phenomenon was stimulated by her interest in the dynamics of kinship and interdependency; it was made visible by an analytic and interpretive system premised on "a feeling for the organism," on the integrity and internal agency of the organism. To McClintock, transposition was a wedge of resistance on behalf of the organism against control from without. But neither she herself nor her analytic and interpretive framework could prevent the ultimate appropriation of this mechanism, once exhibited, to entirely opposite aims—as an instrument for external control of organic forms by genetic engineers.[16]

[16] For McClintock, there remains a very serious question about the extent to which such convergences can in fact be said to have taken place—in particular, about the extent to which the meaning she attached to "transposition" is consonant with the current use of that term. For further discussion of this point, as well as of other issues pertinent to McClintock's research, see Keller (1983).

McClintock's vision of science was unarguably productive for her, and it has been seen to have great aesthetic and emotional appeal for many scientists. But it must be granted that her success pales before that of mainstream (molecular) biology. In the last few years (in part thanks to the techniques derived from genetic transposition itself), it is the successes and technological prowess of molecular biology rather than of McClintock's vision of science that have captured the scientific and popular imagination. These successes, and this prowess, cannot be ignored.

We may be well persuaded that the domain of natural phenomena is vastly larger than the domain of scientific theory as we know it, leaving ample room for alternative conceptions of science; that the accumulated body of scientific theory represents only one of the many ways in which human beings, including the human beings we call scientists, have sought to make sense of the world; even that the successes of these theories are highly local and specific. Yet, whatever philosophical accounts we might accept, the fact remains that science as we know it works exceedingly well. The question is, Can any other vision of science be reasonably expected to work as well? Just how plastic are our criteria of success?

Feminists (and others) may have irrevocably undermined our sense of innocence about the aspiration to dominate nature, but they/we have not answered the question of just what it is that is wrong with dominating nature. We know what is wrong with dominating persons—it deprives other subjects of the right to express their own subjectivities—and we may indeed worry about the extent to which the motivation to dominate nature reflects a desire for domination of other human beings.[17] But a salient point of a feminist perspective on science derives precisely from the fact that nature is not in fact a woman. A better pronoun for nature is surely "it," rather than "she." What then could be wrong with seeking, or even achieving, dominion over things per se?

Perhaps the simplest response is to point out that nature, while surely not a woman, is also not a "thing," nor is it even an "it" that can be delineated unto itself, either separate or separable from a speaking and knowing "we." What we know about nature we know

[17] See Keller (1985), Part II.

only through our interactions with, or rather, our embeddedness in it. It is precisely because we ourselves are natural beings—beings *in* and *of* nature—that we *can* know. Thus, to represent nature as a "thing" or an "it," is itself a way of talking, undoubtedly convenient, but clearly more appropriate to some ends than to others. And just because there is no one else "out there" capable of choosing, we must acknowledge that these ends represent human choices, for which "we" alone are responsible. One question we need to ask is thus relatively straightforward: What are the particular ends to which the language of objectification, reification, and domination of nature is particularly appropriate, and perhaps even useful? And to what other ends might a different language—of kinship, embeddedness, and connectivity, of "feeling for the organism"—be equally appropriate and useful? But we also need to ask another, in many ways much harder, question: How do the properties of the natural world in which we are embedded constrain our social and technical ambitions? Just what is there in the practices and methods of science that permit the realization of certain hopes but not others?

Earlier in this essay, I attempted to describe the shift in mind-set from working scientist to feminist critic. But to make sense of the successes of science, however that success is measured, the traversal must also be charted in reverse: Feminist critics of science, along with other analysts of science, need to reclaim access to the mind-set of the working scientist, to what makes their descriptions seem so compelling.

For this, we need to redress an omission from many of our analyses to date that is especially conspicuous to any working scientist: attention to the material constraints on which scientific knowledge depends, and correlatively, to the undeniable record of technological success that science as we know it can boast. If we grant the force of belief, we must surely not neglect the even more dramatic force of scientific "know-how." Although beliefs, interests, and cultural norms surely can, and do, influence the definition of scientific goals, as well as prevailing criteria of success in meeting those goals, they cannot in themselves generate either epistemological or technological success. Only where they mesh with the opportunities and constraints afforded by material reality can they lead to the generation of effective knowledge. Our analyses began with the question of where, and how, does the force of beliefs, interests, and cultural

norms enter into the process by which effective knowledge is generated; the question that now remains is, Where, and how, does the nonlinguistic realm we call *nature* enter into that process? How do "nature" and "culture" interact in the production of scientific knowledge? Until feminist critics of science, along with other analysts of the influence of social forces on science, address this question, our accounts of science will not be recognizable to working scientists.

The question at issue is, finally, that of the meaning of science. Although we may now recognize that science neither does nor can "mirror" nature, to imply instead that it mirrors culture (or "interests") is not only to make a mockery of the commitment to the pursuit of reliable knowledge that constitutes the core of any working scientist's self-definition, but also to ignore the causal efficacy of that commitment. In other words, it is to practice an extraordinary denial of the manifest (at times even life threatening) successes of science. Until we can articulate an adequate response to the question of how "nature" interacts with "culture" in the production of scientific knowledge, until we find an adequate way of integrating the impact of multiple social and political forces, psychological predispositions, experimental constraints, and cognitive demands on the growth of science, working scientists will continue to find their more traditional mind-sets not only more comfortable, but far more adequate. And they will continue to view a mind-set that sometimes seems to grant force to beliefs and interests but not to "nature" as fundamentally incompatible, unintegrable, and laughable.

PART II

PART II

2

From Secrets of Life
to Secrets of Death

*"It is not in giving life but in risking life that man is raised above the
animal.... Superiority has been accorded in humanity not to the sex
which brings forth but to that which kills."*
<div align="right">S. de Beauvoir, p. 58</div>

*The living blind and seeing Dead together lie
As if in love ... There was no more hating then,
And no more love: Gone is the heart of Man.*
<div align="right">Edith Sitwell, "Dirge for the New Sunrise"
(Fifteen minutes past 8:00, on the morning of
Monday the 6th of August, 1945)</div>

In reminding us of the somatic substratum of our mental products,
one of Freud's greatest contributions was to restore for us the con-
nectivity between body and mind that Descartes had severed. In
much the same spirit—in the spirit of what might be called the old
psychoanalysis—I want in this paper to examine some of the cor-
poreal springs of what is generally regarded as the most purely
mental endeavor to which modern culture has given rise. I am re-
ferring, of course, to the scientific impulse. In particular, I want to
explore a perennial motif that underlies much of scientific creativ-
ity—namely, the urge to fathom the secrets of nature, and the col-
lateral hope that, in fathoming the secrets of nature, we will fathom
the ultimate secrets (and hence gain control) of our own mortality.

Originally presented as the Kanzer Seminar in Psychoanalysis and the Humanities,
New Haven (Spring 1986) and later published in *Body/Politics*, ed. M. Jacobus, E. F.
Keller, and S. Shuttleworth, 1990, pp. 177–191 (Routledge).

This motif, like mortality itself, has two sides (or perhaps I might say, this campaign proceeds on two fronts), both of which are evident throughout the history of science: They are the search for the wellspring of life, and, simultaneously, for ever more effective instruments of death. Yet more concretely (or corporeally), I want to suggest a relationship between these two subthemes and the even more intimate (and at least equally secretive) bodily counterparts of fetal and fecal productivity.

In an earlier paper (Keller 1986), I attempted a preliminary exploration of these two motifs in the language of modern science—the one concerned with the secrets of life and the other with secrets of death—in the context of two specific historical episodes: the discovery of the structure of DNA, and the making of the atomic bomb. My concern was to explore the meaning of secrecy in these two episodes, focusing in particular on the important distinction made manifest by asking, whose secrets? And secrets from whom? As background to this sequel, I would like to summarize the principal points of that other paper.

Well-kept secrets, I argued, pose a predictable challenge to those who are not privy. Secrets function to articulate a boundary: an interior not visible to outsiders, the demarcation of a separate domain, a sphere of autonomous power. And if we ask, whose secret life has historically been, and from whom has it been secret, the answer is clear: Life has traditionally been seen as the secret of women, a secret *from* men. By virtue of their ability to bear children, it is women who have been perceived as holding the secret of life. With the further identification of women with nature, it is a short step from the secrets of women to the secrets of nature. Indeed, throughout most cultural traditions, the secrets of women, like the secrets of nature, are and have traditionally been seen by men as potentially either threatening—or alluring—simply by virtue of the fact that they articulate a boundary that excludes them. Secrets of men, equally, exclude women, of course, and no doubt, may be experienced by women as equally threatening and alluring. But in most cultures, strong taboos prevent open expression of such responses, effectively protecting the boundary of secrecy. With the granting of cultural permission, however, such a boundary can come to serve less as a taboo, and more as an invitation to exposure, under some conditions even as a demand to be found out. Nobel laureate

Richard Feynman once said, perhaps by way of explaining the extraordinary facility for lock picking that had won him so much fame as a young physicist at Los Alamos: "One of my diseases, one of my things in life, is that anything that is secret, I try to undo" (Feynman 1976).

In Western culture, the threat or the allure presented by Nature's secrets has met with a definitive response. Modern science has invented a strategy for dealing with this threat, for asserting power over nature's potentially autonomous sphere. That strategy is, of course, precisely the scientific method—a *method* for "undoing" nature's secrets: for the rendering of what was previously invisible, visible—visible to the mind's eye if not to the physical eye.

The ferreting out of nature's secrets, understood as the illumination of a female interior, or the tearing of Nature's veil, may be seen as expressing one of the most unembarrassedly stereotypic impulses of the scientific project. In this interpretation, the task of scientific enlightenment—the illumination of the reality behind appearances—is an inversion of surface and interior, an interchange between visible and invisible, that effectively routs the last vestiges of archaic, subterranean female power. Like the deceptive solidity of Eddington's table, the visible surface dissolves into transparent unreality. Scientific enlightenment is in this sense a drama between visibility and invisibility, between light and dark, and also, between female procreativity and male productivity—a drama in need of constant reenactment at ever-receding recesses of nature's secrets.

The story of the rise of molecular biology can be read as a particularly vivid reenactment of this drama—a drama that in the initial phases of this reenactment was in fact quite explicitly cast in the language of light and life, its goal, equally explicitly, as the quest for the secret of life. The drama ended, once that secret was claimed to have been found, in the effective banishment of the very language of secrets, mystery, and darkness from biological discourse. With the triumph of molecular genetics, it was said that biology at long last achieved a truly scientific status.

In its classical format, the story of the rise of molecular biology is usually told as a drama taking place between science and nature. It begins with the claim of a few physicists—most notably, Erwin Schroedinger, Max Delbruck, and Leo Szilard—that the time was ripe to extend the promise of physics for clear and precise knowledge

to the last frontier: the problem of life. Emboldened by the example of these physicists, two especially brave young scientific adventurers, James Watson and Francis Crick, took up the challenge and did in fact succeed in a feat that could be described as vanquishing nature's ultimate and definitive stronghold. Just twenty years earlier, Niels Bohr had argued that one of the principal lessons taught by quantum mechanics was that "the minimal freedom we must allow the organism will be just large enough to permit it, so to say, to hide its ultimate secrets from us" (Bohr 1958). Now, as if in direct refutation of Bohr's more circumspect suggestion, Watson and Crick showed, with the discovery of the structure of DNA, and accordingly, of the mechanism of genetic replication, "that areas apparently too mysterious to be explained by physics and chemistry could in fact be so explained" (Olby 1970).

There is another story here, however—one that takes place in the realm of science itself—a drama not between science and nature, but between competing motifs in science, indeed among competing visions of what a biological science should look like. When Watson and Crick embarked on a quest that they themselves described as a "calculated assault on the secret of life," they were employing a language that was, at the time, not only grandiose and provocatively unfashionable, but, as Donald Fleming has pointed out, "in total defiance of contemporary standards of good taste in biological discourse" (Fleming 1968:155). To historians of science, the story of real interest might be said to lie in the redefinition of what a scientific biology meant; in the story of the transformation of biology from a science in which the language of mystery had a place not only legitimate but highly functional, to a different kind of science—a science more like physics, predicated on the conviction that the mysteries of life were there to be unraveled, a science that tolerated no secrets. In this retelling, the historian's focus inevitably shifts from the accomplishments of molecular biology to the representation of those accomplishments.

The subplot is in effect a story of cognitive politics. It is a story of the growing authority of physics, and physicists; an authority that drew both from the momentous achievements of quantum mechanics early in the century, as well as from the very fresh acclaim accruing to physicists for their role in winning World War II. Told in this way, we can begin to make sense of the puzzle that has long

plagued historians of contemporary biology. Despite initial claims and hopes, molecular biology gave no new laws of physics and revealed no paradoxes. What then did the physicists, described as having led the revolution of molecular biology, actually provide?

Leo Szilard said it quite clearly: It was "not any skills acquired in physics, but rather an attitude: the conviction which few biologists had at the time, that mysteries can be solved." He went on to say, "If secrets exist, they must be explainable. You see, this is something which the classical biologists did not have . . . They lacked the faith that things are explainable—and it is this faith . . . which leads to major advances in biology" (quoted in Fleming 1960:161).

And indeed, he was right. This attitude, this conviction that life's secret could be found, this view of themselves (especially Watson and Crick) as conquistadores who could and would find it—a stance that drew directly and vigorously on the authority of physicists for its license—proved to be extraordinarily productive. It permitted the conviction, and just a few years later, the sharing of that conviction, that in the decoding of the mechanism of genetic replication, life's secret *had* been found. As Max Delbruck said in his Nobel address in 1970, "Molecular genetics has taught us to spell out the connectivity of life in such palpable detail that we may say in plain words, 'the riddle of life has been solved.' " The success of molecular genetics was the culmination of a long tradition—now with the representation of life as the molecular mechanics of DNA, even the darkest recess of nature's interior seemed to have been illuminated.

For both historical and psychological reasons, it is useful to juxtapose this story with another story of secrets—a story that might be seen as the polar opposite of this one. Among the events that historically served to bolster the authority of physics, just at the time when molecular biology was coming into existence, surely one of the foremost was the development of the atomic bomb.

The making of the bomb was perhaps the biggest and best kept secret that science ever harbored. It was a secret kept from the Germans and the Japanese, from the American public, and indeed from the wives of the very men who produced the bomb.[1] Several of the

[1] As Jeremy Bernstein recollects, "Although all of us at Los Alamos had our Q Clearance, we were divided in two classes . . . The adults knew the secret . . . the rest of us were not going to know it until we became adults, that is, actually began working on weapons." (Quoted in Forman 1987:221-22.)

Los Alamos wives have remarked that Alamagordo was the first they knew of what their husbands had been doing, and indeed of what their entire community—a community fully dependent on intimacy and cooperation for its survival—had been working toward.

The Manhattan Project was a project in which the most privileged secret belonged not to the women, but to the men. It was a scientific venture predicated not on openness, but on its opposite, on absolute secrecy. Hardly an open book that anyone could read, Los Alamos had an interior. And what was produced out of this interiority was "Oppenheimer's baby"—a baby with a father, but no mother. As Brian Easlea (1983) has amply documented, the metaphor of pregnancy and birth became the prevailing metaphor surrounding the production and the testing, first, of the atomic bomb, and, later, of the hydrogen bomb. If the A-bomb was Oppenheimer's baby, the H-bomb was "Teller's baby." The metaphor of birth was used not only as a precautionary code but also as a mode of description that was fully embraced by the physicists at Los Alamos, by the government, and ultimately by the public as large.

As early as December 1942, physicists at Chicago received acknowledgment for their work on plutonium with a telegram from Ernest Lawrence that read, "Congratulations to the parents. Can hardly wait to see the new arrival." In point of fact, they had to wait another two and a half years. Finally, in July 1945, Richard Feynman was summoned back to Los Alamos with a wire announcing the day on which the birth of the "baby" was expected. Robert Oppenheimer may have been the father of the A-bomb, but Kistiakowsky tells us that "the bomb, after all, was the baby of the Laboratory, and there was little the Security Office could do to dampen parental interests."

Two days after the Alamogordo test, Secretary of War Henry Stimpson received a cable in Potsdam that read:

> Doctor has just returned most enthusiastic and confident that the little boy is as husky as his big brother. The light in his eyes discernible from here to Highhold and I could have heard his screams from here to my farm.

And, as the whole world was to learn just three weeks later, "little Boy" was indeed as husky as his brother.[2]

[2] Quotes are taken from Easlea (1983), pp. 107, 203, 90.

In this inversion of the traditional metaphor, this veritable back-firing, nature's veil is rent, maternal procreativity is effectively coopted, but the secret of life has become the secret of death. When the bomb exploded, Oppenheimer was reminded of the lines from the Bhagavad-Gita:

If the radiance of a thousand suns
 were to burst into the sky,
 that would be like
 the splendor of the Mighty One.

As the cloud rose up in the distance, he also recalled,

I am become Death, the shatterer of worlds. (quoted in Jungk; 1958:201)

Such a historical juxtaposition reveals the story of the making of the bomb as an antithesis of the successes of molecular biology—the two stories connected only by a metaphor that works to set the stories apart by its own inversion. Today, I want to return to these two themes, focusing less on the contrasts between them, and more on their connectivity; less on the question of whose secrets, and the important difference that question marks between the two stories, and more on the meanings of creativity that both stories share in common. To this end, my focus is here less on their place in the history of science, and more on their affective content. That is, I want to focus on a certain interweaving of fantasies of birth and death that, at least on a psychological level, can be seen to connect rather than distinguish the project of uncovering the secret of life with that of producing instruments of death. To assist in this effort, I want to add to the two polar stories I began with—Watson and Crick's "calculated assault on the secret of life" and the Manhattan Project's equally calculated assault on the secret of death—three other generic stories (stories of a pre- [or proto-] scientific genre) that on the surface may seem unrelated, but which, I suggest, can be read as filling in the spectrum between these two poles, perhaps even constituting its effective closure into a circle.

The first such story requires the biggest conceptual as well as cultural leap on our part (I relate it first just because it is the one that is most conspicuously remote from the culture of modern science). I am thinking of the story of the "bullroarer"—to Europeans,

just an innocent children's toy that is swung rapidly through the air to produce a whirring humming sound, but seen by some anthropologists at least as "perhaps the most ancient, widely spread, and sacred religious symbol in the world" (Haddon, 1898, quoted in Dundes 1976:220). Building on the earlier work of Bettelheim (1955), Alan Dundes offers an interpretative account of this symbol that brings it into surprising proximity to our concerns here. I therefore want to summarize for you (in some detail) the major points of his interpretation and description.

One of the first features of this curious object that was early remarked upon by anthropologists, is that, in many instances, it "is kept secret and hidden from light by the head chief, and is considered to possess some mysterious and supernatural power or influence. The women and children are not permitted to see it; if seen by a woman or shown by a man to a woman, the punishment to both is *death*" (Fisson, 1880, in Dundes 1976:221). In other words, the bullroarer is a secret belonging to men, protected both from the light of day and the knowledge of women. Upon close examination, however, it appears that, though its secrecy from women is obligatory, a number of myths suggest that "the bullroarer is something which is produced initially by a woman and is stolen by, and for, men" (Dundes 1976:225). In one such myth, originally reported by Van Baal,

> A man kills his wife. From her dead body, all the vegetables sprouted. However, the man collects them all and swallows them. Undigested, they pass through his body into his genital organ. With a new wife, he engages in sexual intercourse, but he withdraws his organ, allowing all the vegetables to scatter over the field.

Dundes continues:

> This symbolic process is paralleled in many initiation rites where a male spirit or deity is said to swallow initiates. Later he disgorges them, thereby making the boys into men (p. 224).

In another myth, also originally reported by Van Baal, the origin of the bullroarer is more explicit:

> the wife of Tiv-r . . . is pregnant of the bullroarer. Tiv-r hears a soft whining in his wife's abdomen and is highly intrigued. One bird after

46

another is sent out by him to extract the mysterious something. At last, while the woman is stooping down with legs wide apart, brooming the place, a bird manages to get hold of the protruding thing and extract it. It is the first bullroarer (p. 225).

The conclusion Dundes draws seems hard to dispute: The bullroarer "represents the male equivalent of female procreativity" (p. 225). As such, it is like other symbols used in male initiation rites—rites that assume, as Mead has written, "that men become men only by . . . taking over—as a collective group—the functions that women perform naturally" (1949:98). In this way, Mead continues, "Man has hit upon a method of compensating himself for his basic inferiority. . . . Women, it is true, make human beings, but only men can make men" (p. 103).

But why, Dundes goes on to ask, "does the [bullroarer] function in symbolic form—through the making of noise, wind, thunder, etc.?" This question he answers with an equally obvious interpretation: The bullroarer represents the particular, but nonetheless quite common attempt of males "to supplant female procreativity through the symbolic creativity of the anus." Its frequent use in male initiation rites, often in conjunction with such other fetal and fecal signifiers as blood, mud, and excrement, suggests to Dundes that the bullroarer is the symbolic representation of a widespread belief that "boys become [or are reborn as] men by means of male anal power" (p. 228).[3]

To account for the equally prominent phallic features of the bullroarer symbolism, Dundes proposes the frequently concomitant practice of homosexual intercourse as a natural link [sic] between the phallic and anal. "It may now be more clear," he concludes,

> why the initiation rites must be kept secret from women. Whether it is males attempting to emulate female procreativity by means of anal power, or homosexual intercourse in lieu of heterosexual intercourse, or ritual masturbation, the consistent element is that men seek to live without recourse to women . . . [But] engaging in acts normally carried out by women must at all cost be kept from women. The would-be supe-

[3] Note the following account of a New Guinea myth reported by Van Baal: "Finally Sosom, [the name of a deity as well as a term for bullroarer], devours all the neophytes and adolescents . . . each time he swallows one, disgorging another through his posterior parts" (quoted by Dundes, p. 230).

riority of males would be revealed as a sham if women were allowed to observe (pp. 234–5).

This explanation of the importance of secrecy—an explanation echoed by Herdt (1981) in his own, somewhat different, account of male initiation rites among the Sambia—seems to me somewhat weak. The need for secrecy, I would suggest, is fueled by more than the desire to protect a sham—even if we add the notion that such a sham can serve to evoke a counterenvy among women[4] and hence provide a new basis for male power. I suggest also, that secrecy here serves to contain the aggressive potential of this redistribution and redefinition of procreative power. Not only is maternal procreativity symbolically replaced; it is also countered by the assertion of an opposing principle. Let us ask, in particular, what is produced by anal birth that is not produced by normal birth? That is, what is it about the transformation of boys into men in the cultures that employ this symbolism that is particularly dependent on their anal rebirth? Surely one important difference that marks the emergence of the adult male in many cultures, and that might be particularly pertinent to our concerns here, is precisely his ability to assume responsibility as an effective hunter and/or warrior, that is, as a competent master of death. In this ritualized script, the boy undergoes a symbolic death in order to be reborn with a new kind of power—a form of protection against the vicissitudes of life and death that is radically different from the protection promised by maternal power. It is the power over life and death acquired not through the generation (or sustenance) of life, but through the capacity to legislate death. Fertility is countered by virility, measured now by its death-dealing prowess. Finally, secrecy functions here not simply to protect an autonomous domain. Rather, I suggest, it functions, as well, as a necessary mechanism of containment; it serves to circumscribe the domain of the destructive powers unleashed.

My second story is a little closer to home, and because it is more familiar, I can be much briefer. It is the story of the mad scientist (or alchemist) pursuing the secrets of life—not in the broad light of day, as did Watson and Crick, but in the dark recesses of a secret laboratory (usually below ground, in a basement or cellar), often

[4] See Kittay (1984) (cited in n. 5).

producing vile-smelling vapors in the process, until finally, he succeeds (and it is always a "he")—not merely in finding the secret of life, but in using that secret to produce life itself. Inevitably, however, that life form is monstrous—itself unable to procreate, only to kill. A life form that becomes an agent of death. The most famous story of this genre is of course *Frankenstein*—written, as it happened, by a woman. As a result of a number of increasingly sophisticated literary analyses in the last few years, Mary Shelley's plot has come to be seen as considerably more complex than we had earlier thought; the major point, however, remains quite simple. *Frankenstein* is a story first and foremost about the consequences of male ambitions to coopt the procreative function, an "implicit critique" simultaneously of the plot and the birth that are conceived without women. But Shelley's narrative is finally not so much a feminist critique as a remarkably compelling rendering, by a woman, of a familiar tale of male fears. In popular fiction, the ambition of male scientists to produce life almost invariably results in the unleashing of destruction, that is, in death.

The third story (or image) is even nearer to home. It is drawn not from science fiction, but from the real lives of those contemporary scientists who got their start as boy scientists, producing explosives in their kitchens, bathrooms, or, if they were lucky, in a hand-fashioned basement laboratory. (A generation ago, a common sideline of these basement laboratories used to be the production of "stink bombs"—ready to be set off by the young scientist whenever crossed by an uncooperative or angry mother.) We are all familiar with the preoccupation many boys have with explosives, and with the great affective investment some of them show in producing bigger and more spectacular explosions—often indeed, continuing beyond boyhood into student days—but perhaps those of us who have spent time around places like MIT and Cal Tech are especially familiar with such behavioral/developmental patterns.[5] We would probably even agree that these patterns are more common in the early life histories of scientists and engineers than they are in the population at large. Certainly, for the great majority of the scientists and engineers who started out life as play bomb experts, the energy

[5] To my knowledge, it is almost always young men rather than young women who exhibit these preoccupations.

invested in such primitive attempts at the resolution of early conflicts has been displaced onto mature creative endeavors that leave no trace of their precursors. But in some cases, such traces are evident, even conspicuous. As the result of a handy convergence between personal, affective interests and public, political, and economic interests, a significant number of these young men actually end up working in weapons labs (just how many would be interesting to document)—employing their creative talents to build bigger and better (real rather than play) bombs. In other cases, traces of earlier preoccupations may be evoked only by particular circumstances—for example, the collective endeavor of a Manhattan Project. The differences between these adult activities and their childhood precursors are of course enormous. Yet it seems to me that the affective and symbolic continuity between the two nonetheless warrants our attention.

Not unlike the initiation rites of the bullroarer, modern day weapons research is generally conducted in labs that are overwhelmingly (if not exclusively) male, and highly secretive; also like the bullroarer, the bombs that are produced are likely to be associated with a provocative mix of phallic and birth imagery. The phallic imagery is keyed not only by Helen Caldicott's infamous phrase, "missile envy," but more directly by talk of "penetration aids," "big bangs," and "orgasmic whumps"—talk that has by now become routine in the rhetoric of nuclear weapons. And almost equally familiar is the joining of phallic to birth imagery—as illustrated, for example, by the example already cited, where a bomb with "thrust" is identified as a boy baby, while a girl baby is clearly understood as a dud.[6]

I reiterate that the stories I cite vary dramatically in both the real and symbolic lethality of their outcomes; they also vary in their particular mixes of phallic, anal, and birth imagery. But they all share one or more elements of the familiar motif of male appropriation of female procreativity. We might attempt to characterize the commonality in these stories under the general rubric "womb envy"—a concept that some feminists have argued properly belongs at the center of psychoanalytic theory, alongside that of "penis

[6] See, for example, Robert Jungk's discussion in *Brighter than a Thousand Suns*, p. 197.

envy"[7]—but if we do, I suggest that we should place the emphasis quite centrally on the term "envy." Melanie Klein defines envy as "the angry feeling that another person possesses and enjoys something desirable—the envious impulse being to take it away or to spoil it" (Klein 1957:187). "Envy" thus can serve to capture simultaneously the stories' similarities and their differences. Whether supplanted by fantasies of anal production or by a light/life-generating activity of the mind, the real life-giving power of the woman—often indeed women themselves—is effectively absented from all five of these stories—in some cases simply denied, in others, more actively "spoiled."

A text that provides a particularly interesting view of the former (the more benign form of the absenting of female procreativity, and of women) is given to us in James Watson's classic account of his and Crick's important discovery of the mechanism of genetic replication (1968). In Mary Jacobus's (1982) elegant paper, "Is There a Woman in This Text?" the author finds *The Double Helix* notable not for a simple but for a complex elision of both the real and the symbolic woman, repeated simultaneously (or perhaps serially) on every level of Watson's own description of his endeavor. To Jacobus's own examples of such symbolic displacements—for example, the displacement of reality by a model, of real women by "popsies," of Rosalind Franklin by "Rosy"—I would add two more: the story of the double helix is first and foremost the story of the displacement and replacement of the secret of life by a molecule.[8] Gone in this representation of life are all the complex undeciphered cellular dynamics that maintain the cell as a living entity; "Life Itself"[9] has finally dissolved into the simple mechanics of a self-replicating molecule. Indeed, living organisms themselves are no longer the proper subject of biology—all but absent from the most up-to-date biology textbooks.[10] The second example I would add to Jacobus's list is perhaps more trivial, but still, I think, worth noting: With the single exception of Rosy's hypothesized "unsatisfied mother," there are,

[7] See, for example, Eva Kittay, "Womb Envy: An Explanatory Concept," in Joyce Trebilcot (1984:94–128).

[8] Ironically enough, DNA is popularly called "the mother-molecule of life."

[9] The title of a more recent book by Francis Crick (1981).

[10] This signals yet another level of displacement, in which the meaning of biology shifts from its traditionally wide-ranging subject to that of molecular biology.

in fact, no mothers present anywhere in the story of *The Double Helix*. Mothers and life, both, are absented, discounted, and by implication at least, disvalued, though not, to be sure, "spoiled" or actually hurt.

The Watson-Crick discovery was unquestionably a great discovery—if not of the secret of life, certainly of an extremely important facet of the continuity of life. It gave rise (if not birth) to an enormously productive era in biology. But my purpose here is not to review the all too familiar successes of that story, but rather to point elsewhere—to a rather more subtle (and negative) dimension of that same story. The net result of their discovery was of course in no sense an agent of death, but it did give rise to a world that has been effectively devivified. The base pairing of the double helix (perhaps, as the critic John Limon (1986) suggests, like the quasi-eroticism of Watson's own relation with Crick[11]) is not life threatening, but it *is* lifeless.

When we look at the displacement of flesh and blood reference—of life itself—that is symbolically effected in this story, we can begin to see another level of connection between Watson and Crick's apparently successful appropriation of the secret of life and the polar opposite story of the production of atomic bombs. It is with the move away from life itself that the enormous gap between the production of lifeless, devivified forms and the production of life-destroying, devivifying forms, perhaps paralleling the differences between fantasies of mental and anal production, achieves a curious kind of closure.

To see this closure, I would like to return to the metaphor of bombs as babies—a metaphor in one sense familiar and in another sense, shocking, almost horrifying—on the face of it, indeed impossible. This is a metaphor that sits comfortably with us only to the extent that we see it as a dead metaphor—that is, one in which the original reference has been lost from view. Much as the wooden supports of a piano are legs, bombs *are* babies in some circles—but only if they are no longer evocative of the flesh and blood referents that the words legs and babies originally denoted. I want to argue, though, for a significance—in the latter case at least—in the very

[11] See John Limon, *Raritan*, 1986.

deadness of the metaphor; that is, in the distancing from the flesh and blood referent that its familiarity invites.

In an important paper on the language of defense intellectuals, Carol Cohn (1987) makes an interesting argument about the use of metaphors in weapons rhetoric that are so blatantly inappropriate to outsiders, focusing less on their psychodynamic sources and rather more on their function. Describing a tour of a nuclear powered submarine, she writes,

> A few at a time, we descended into the long, dark, sleek tube in which men and a nuclear reactor are encased underwater for months at a time. We squeezed through hatches, along neon-lit passages so narrow that we had to turn and press our backs to the walls for anyone to get by. We passed the cramped "racks" where men sleep, and the red and white signs warning of radioactive materials. When we finally reached the part of the sub where the missiles are housed, the officer accompanying us turned with a grin, and asked if we wanted to stick our hands through a hole to "pat the missile." (p. 695)

"Pat the missile"? In an attempt to make sense of what turns out to be a frequently recurring image, Cohn suggests:

> Patting is an assertion of intimacy, sexual possession, affectionate domination. The thrill and pleasure of "patting the missile" is the proximity of all that phallic power, the possibility of vicariously appropriating it as one's own.
>
> But if the predilection for patting phallic objects indicates something of the homoerotic excitement held by the language, it also has another side. For patting is not just an act of sexual intimacy. It is also what one does to babies, small children, the pet dog. The creatures one pats are small, cute, harmless—not terrifyingly destructive. Pat it, and its lethality disappears. (p. 696)

The same effect, she argues, is induced by a host of other "domestic" metaphors that are endemic in this language. Missiles, ready for launching, are lined up on "Christmas tree farms"; their landing patterns are called "footprints"; warheads are referred to as "RVs" and are "delivered" in a "bus." Acronyms for electronic missile systems include PAL and BAMBI. Cohn writes:

> In the ever-friendly, even romantic world of nuclear weaponry, enemies "exchange" warheads; one missile "takes out" another; weapons systems

can "marry up"; "coupling" refers to the wiring between mechanisms of warning and response. (p. 698)

Replacement of the flesh and blood referents by their macabre substitutes becomes total when the world thus created includes death itself—that is, when it is bombs and missiles rather than people that are "killed," where "fratricide" refers to the destruction of one warhead by another; where "vulnerability" and "survival" refer to weapons systems, not living beings; where strategic advantage is measured by the number of "surviving" warheads, independent of whether or not there are any human survivors.

In this surrogate world, a world that may have originated (in fantasy as well as in reality) as a world with only one sex, there is, finally, no sex. Once it has become totally split off from its human origins, taking on a "life" of its own, disassociated from its capability for destroying actual living bodies, one doesn't need to be a Frankenstein or a Dr. Strangelove to participate. One can be an ordinary, decent, caring man—or woman. Once the metaphor is dead, missiles can be patted with equal comfort by both men and women (though perhaps not so easily by mothers).

In this world, there are no longer "men's secrets" and "women's secrets." Modern biology has revealed the secret of life to everyone, and nuclear discourse permits the sharing of secrets of death with men and women alike. Only the deadly danger we all live in remains a secret—a secret we collectively learn to keep from ourselves—split off from our everyday consciousness as we learn to talk not of the threat of actual annihilation, but of surgical strikes and collateral damage. (Even the word bomb is gone; in its place we have nuclear devices.)

But secrets that we keep from ourselves work rather differently from those we keep from each other. The latter, everyone actually knows; the former, nobody knows. And as Freud taught us, secrets we keep from ourselves serve very different psychological functions from those we at least pretend to keep from each other. Most crucially, they serve to contain not the forces of death, but the forces of life. In this process, they work by foreclosing the normal processes of integration and reparation—split off, unopposed by guilt or love, or even by the impulse for self-preservation, it becomes possible for our destructive impulses to take on, as it were, a life of their own

(see, for example, Hanna Segel 1987). The language of technostrategic analysis may indeed represent a kind of ultimate success of rational discourse; but surely it also bespeaks a kind of ultimate psychosis.

The question I end with is this: Granting the urgency of our situation, and even its psychotic aspects, in what way might we hope such an analysis as this could be helpful? Surely, the fantasies I describe can neither be seen as causal (in any primary sense) nor as inconsequential. Where then, between causal and inconsequential, are we to place the role of such fantasies—fantasies that are in one sense private, but at the same time collectively reinforced, even exploited, by collateral interests? What is their role in the dynamics of the overtly (and primarily) public and political crisis we find ourselves in? And finally, is such an analysis as this itself an attempt to fend off an unacceptable reality?—a quasi-magical attempt to gain control over what may have already gotten away from us? My hope, of course, is that it can provide some help in a cause not yet entirely lost.

3

Secrets of God, Nature,
and Life

Introduction

One virtually infallible way to apprehend the thickness (or "viscosity") of language and culture is to take a key image employed by a culture in transition and attempt to track its shifting meanings, referents, and evocative force. This indeed was the task that Raymond Williams set himself in compiling his now famous *Keywords* (1983). Almost inevitably, one quickly finds (as Williams himself found) that an entire critical vocabulary is called forth, all of its terms shifting in concert. And as the individual meanings of these words shift and reorient themselves, their collective meaning, the worldview the vocabulary (or "lexicon") represents, is transformed. Tracking such a collection of keywords can thus yield a temporal and cognitive map of a cultural transformation in process.

Take, for instance, the image of "secrets" as it was evoked in sixteenth- and seventeenth-century English discourses of nature, attending in particular to how that image changed over the course of the scientific revolution—how it changed in its usage, in its denotative or connotative force; in its referentiality and its consequentiality. Of these changes, one aspect alone might be said to provide an almost perfect marker of the origins of modern science. I am thinking, of course, of the rhetorical shift in the locus of essential

Originally published in *History of the Human Sciences* 3(2):229–42 (1990).

secrets from God to Nature. Over time, the metaphorical import of this shift was momentous; above all, it came to signal a granting of permission to enquiring minds—permission that was a psychologically necessary precursor for the coming Enlightenment. Indeed, Kant's own answer to the question "What is Enlightenment?" was simply this: *"sapere aude"*—to dare to know.

Arcana Dei signaled forbidden knowledge, the hidden affairs or workings of God, "the secret[s] which god hath set Ayein a man mai noght be let" (OED:357)—"hyd to alle men," or at best revealed to only a chosen few. To be allowed to share in God's secrets meant to be enclosed by the same protective veil. The knowledge acquired by those privileged few who *had* gained such access remained similarly (and properly) shrouded in secrecy. Once known, secrets did not become open knowledge in our sense of the term; rather, knowledge itself remained secret. Indeed, knowledge and secrets were at times almost interchangeable terms (see, for example, Eamon 1984).

But between the sixteenth and early eighteenth centuries, the term "secrets" entered a new register of meanings, graphically corresponding to the crucial shift in reference from *Dei* to *naturae*—a shift that deprived them of their privileged and protected status. At one end of this new range of meanings, "secrets" came to be understood as an enticement to discreet courtship (as Francis Bacon wrote, "Enough if, on our approaching her with due respect, she condescends to show herself" [quoted in Lloyd 1984:15]); and the other end, as a provocation demanding penetration, violation, "putting nature on the rack" and "storming her stronghold and castles" (also Bacon [cf. Keller 1985:123]). To the new seekers of truth, the act of knowing became one of disclosure rather than enclosure. If the idea of *Arcana Dei* invited privileged entrance into a veiled inner sanctum, the expression "secrets of nature" came to be heard as an invitation to dissolving, or to ripping open, the veil of secrecy.

However, in order for the passage of secrets from God to Nature to have such import for the pursuit (and with it, for the definition) of knowledge, many other terms had to shift in concert. Perhaps especially, the terms God and Nature had themselves to undergo subtle transformation as they came to mark a different—simultaneously more distant and more authoritarian—relation between God and the natural world. Once alive and intelligent, participating in (even having) soul, by the beginning of the eighteenth century,

Nature had given way to nature: devoid of both intelligence and life. As Carlo Ginzburg has written, "the secrets of Nature are no longer secrets; the intellectual boldness of scientists will put Nature's gifts at our feet" (1976:41). He might have said as well that Nature, relieved of God's presence, had itself become transformed—newly available to inquiry precisely because it was newly defined as an object.

But still, between availability and compulsion is quite a long way, and in order to understand why the move from God to Nature lent to "secrets" the sense not merely of accessibility, but in addition, of demanding penetration, something else is needed. In particular, it is necessary to add the terms "woman" and "life" to the shifting lexicon,[1] paying special note, as we do, to the rhetorical import of the role of gender in that discursive transformation.

Women, Life and Nature

Recent literature in feminist theory has called for a critical examination by historians and sociologists of science of the significance of the gender markings that have pervaded virtually all of the discourse of modern science, and that were especially prominent in early writings. In particular, a series of arguments have been put forth for the central role played by the metaphoric equation, first, between woman and nature, and collaterally, between man and mind, in the social construction of modern science, especially in the articulation of new criteria for certain knowledge, and in the demarcation of scientific from other forms of knowledge (see, especially, Merchant 1981; Keller 1985; Harding 1986). From this perspective, it would be tempting indeed to think of the passage of secrets from God to Nature in the sixteenth and seventeenth centuries as a simple retagging from male to female—as it were, a sex-

[1] It is T. S. Kuhn who has introduced the term "lexicon" into the history and philosophy of science to denote a "structured vocabulary" of scientific terms (see, for example, Kuhn 1989). My own use of the term, although indebted to Kuhn, is conspicuously looser: Because my "structured vocabulary" includes terms denoting social as well as scientific categories, it will be considerably more difficult to delimit than Kuhn's.

change operation on the term "secrets." But such a view is itself a consequence of the reconfiguration that this passage signaled—a reconfiguration in which the meanings of male and female (as well as of God and Nature) were themselves both participants and products. In other words, along with the change of meaning for the terms God and Nature went a simultaneous change of meaning for the terms man and woman. The very construction, "secrets of nature," called forth a metaphoric convergence between women, life and nature that bound these terms together in a new way, and in so doing, contributed to changes in all their meanings. What was new was not the metonymic use of women to stand for life, or even, by extension, as representation of nature; rather, the newness lay in the naming of the conjunction between women, life, and nature as the locus (or refuge) of *secrets that did not belong to God.* It is in this move—in the wedge between Nature and God that was rhetorically inserted by such a shift in reference—that the language of secrets acquired its most radically new implication: not respect for the status of things as they are and must be, but first, permission, then, a challenge, and finally, a moral imperative for change.

Of course, it might be argued, since the affiliation between Woman, Nature, and Life had been established long before the period we are discussing, that it had always served to guarantee a latent antithesis between God and Nature, even before those terms had themselves become officially separate. Indeed, as Gillian Beer has observed, one effect of personifying nature as female is to promote just this separation, to distinguish nature from God (Beer, in Jordanova 1986:233). But in fact, before naming nature as female could work to properly effect such a distinction, any residual trace of a divine image had itself to be more fully erased from the term "woman." The latent antithesis between God and Nature, or for that matter, between God and female, does not become fully manifest until a wedge has been inserted between both parts of the dyadic construct, woman/nature, and the divine. God cannot stand in antithetical relation to either nature or to woman until He is first made to stand apart; antithesis can only work to drive deeper a wedge that is already in place. However, once in place, the tension between male and female then can (and inescapably does) come to work on behalf of a process that ends in radical schism—finally, not

only between God and Nature, God and woman, but also between male and female.

It is just this complex process of interlocking separations growing into demarcations that, I am suggesting, is marked, and facilitated, by the naming (or renaming) of "secrets" as belong to "Nature" rather than to "God." That renaming *could* come to signal the loss of His protection precisely because of the preexisting tension between the terms. Yet it is only *with* such a renaming that the language of secrets could now be heard as an invitation to exposure, as a call to arms. The net effect of the demarcations that emerged from the new configurations—demarcations between God and Nature, between God and woman, and between woman and man—was to transform the implication of Nature's obscure interiority for enquiring men from an intimation of exclusion to a certainty; banishing forever any possibility of participation; making of that interiority a secret that, once no longer forbidden, must be exposed precisely because it cannot be shared.

It might be said that the cultural function of secrets is always to articulate a boundary—an interior not visible to outsiders, the demarcation of a separate domain, a sphere of autonomous power. Belonging to God, that sphere was inviolable. And as long as the power associated with women, nature, and life was seen as belonging to, or at least blessed by, God, it too was inviolable. The critical move in the transformation of these relations came in the disassociation of these powers from God, and accordingly, in the dissolution of the sanctions an earlier association had guaranteed. Unless severely checked, the power that had been and continued to be associated with women, nature, and life, once disassociated from God, automatically took on an autonomy that seemed both psychologically and conceptually intolerable. No longer a part of, it took on the guise of a challenge to the powers of God and man. A key development in this transformation—indeed, in the very disassociation of nature from God—was, of course, the change in conception of God contributed by Reformation theology, a change that radically emphasized the absoluteness of His sovereignty.

God and Nature

The connections between Reformation theology in seventeenth-century England and the scientific revolution, and the particular notion

of "positive sanctions," first argued by Robert Merton in 1938, have, in the intervening fifty years, become familiar territory to historians of science. Gary Deason (1986) reminds us of one such link that is surely pertinent here. Though more than one hundred fifty years separated the architects of the scientific revolution from the beginnings of Protestantism, many of their arguments bear a striking resemblance to those of Luther and Calvin before them. For Calvin, as for Luther, to assure God's "radical sovereignty" it was necessary to retrieve the world of animate and inanimate objects from the Aristotelians and Thomists, relieving these objects of their intrinsic activity and recast as His "instruments." To godly men, "These are . . . nothing but instruments to which God continually imparts as much effectiveness as he wills, and according to his own purpose bends and turns them to either one action or another" (Calvin, quoted in Deason 1986:176–77). In almost identical language, Robert Boyle argued against the Aristotelian view of a personified nature on the grounds that it "seems to detract from the honour of the great author and governor of the world" (Boyle 1744, 4:361). To grant activity to nature is to detract from "the profound reverence we owe the divine majesty, since it seems to make the Creator differ too little by far from a created (not to mention an imaginary) Being" (Boyle 1744, 4:366; in Deason 1986:180). Moses, Boyle reminds us,

has not a word of nature: and whereas philosophers presume, that she, by her plastic power and skill, forms plants and animals out of the universal matter, the divine historian ascribes the formation of them to God's immediate *fiat* . . . (1744, 4:368).

In much the same spirit, Newton may have been even more deeply committed to the belief that homage to God required that matter be seen as brute, passive, in a word, pure inertia—capable only of resistance to force, and not of generating (or causing) it. That even gravity, the force that by his own account derives from "the quantity of solid matter which [particles] contain,"

should be innate, inherent and essential to Matter . . . is to me so great an Absurdity, that I believe no Man who has in philosophical Matters a competent Faculty of thinking, can ever fall into it (in Deason 1986:183).

For Newton, all motion and all life derived from without, from "active Principles" associated not with material nature, but with God.

And if it were not for these Principles, the Bodies of the Earth, Planets, Comets, Sun, and all things in them would grow cold and freeze, and become inactive Masses; and all Putrefaction Generation, Vegetation and Life would cease, and the Planets and Comets would not remain in their Orbs (in Deason 1986:184).

As Deason writes, "the radical sovereignty of God required the animation of nature to come from God alone and not from matter" (p. 183).

Deason's point is well taken. But still missing from his analysis is the work done on and by the marks of gender in the language of God and nature. There are not two terms in the transformation to which Boyle and Newton contribute so importantly, but in fact three, each of which is itself at least dual. Rather than a simple renegotiation between God and nature, seventeenth-century rhetoric aimed at a renegotiation of the relation between sets of cultural entities that could at the time still be treated as relatively coherent dyads: God and father; nature and mother; man and brother. (The last dyad, man and brother, is generally tacit in these texts, appearing only obliquely, if at all.) To see the actually workings of this rhetoric, it is necessary to reread the same texts for the marks of gender. I choose one essay in particular, Boyle's *A Free Inquiry into the Vulgarly Received Notion of Nature*, to illustrate how only a slightly more attentive reading permits us to see much of the complexity of the linguistic and cultural reorientation that Boyle, here as elsewhere, actively sought to effect. Boyle himself was of course only one actor among many in this transformation, and the rhetorical structures of his writing were effective precisely to the extent that they spoke to the readers of his time. My primary purpose in singling out this particular essay, however, is as much to exemplify a method of reading as it is to make an example of a particular method of writing.

Rereading Boyle

Boyle announces both his intention and his strategy in the title itself: one notion of nature, already devalued by the label "vulgar," is to be replaced by another, the result of "free inquiry." The term "free" is used by Boyle throughout his text interchangeably with "bold."

His title thus announces the author as one who (anticipating Kant) "dares to know." The object of Boyle's inquiry is clear enough—it is "right ideas" of "nature herself." But before Boyle even identifies the "wrong" or "vulgar" ideas of nature from which he dissents (we learn only along the way that it is the picture of nature as active, potent, and intelligent), he sets out to examine the constraints that bond some men to "vulgar" notions—that is, those commonly (but mistakenly) held scruples that require a special freedom and daring to overcome.

Two such scruples are named in the very first section of his discourse. First, is the compunction of filial obligation, raised only to be cast in immediate a priori doubt:

> [I]t may seem an ingrateful and unfilial thing to dispute against nature, that is taken by mankind for the common parent of us all. But though it be an undutiful thing, to express a want of respect for an acknowledged parent, yet I know not, why it may not be allowable to question one, that a man looks upon but as a pretended one, . . . *whether she be so or no;* and until it appear to me, that she is so, I think it my duty to pay my gratitude, not to I know not what, but to that deity, whose wisdom and goodness . . . designed to make me a man. . . . (my italics) (Boyle 1744, 4:361).

This first scruple, re-presented as a question, is immediately followed by two counterscruples of Boyle's own:

> I might add, that it not being half so evident to me, that what is called nature is my parent, as that all men are my brothers, by being the offspring of God . . . I may justly prefer the doing of them a service, by disabusing them, to the paying of her a ceremonial respect.

But even "setting allegories aside,"

> I have sometimes seriously doubted, whether the vulgar notion of nature has not been both injurious to the glory of God, and a great impediment to the solid and useful discovery of his works (Boyle 1744, 4:361).

Thus Boyle begins his opening argument for transferring veneration from nature to God with a tacit reversal, invoking not paternal but maternal uncertainty, inserting doubt where there had heretofore been none. As in Boyle's other writings, skepticism is employed here as a "rhetorical tool"—invoked to "challenge the authority of

a particular discursive tradition" (Golinski 1987:59).[2] Doubt is, after all, the very stuff of "free inquiry"—so long, that is, as it is not debarred by faith. Assurance that *this* question at least is not so debarred is given promptly: "I know not," he writes, "why it may not be allowable to question . . . whether she be so or no." In other words, Boyle's first task is to create the space for a question, and this he accomplishes by invoking the authority of "free inquiry." But from where does that authority derive? From the very first moment of his text. The authority of "free inquiry" is rooted in the tacit opposition between "free" and "vulgar" that Boyle has inserted in his opening title.

Having thus authorized himself—and his readers—to replace what had commonly been taken to be a certainty by a question, the field is now open for new (or newly invoked) kinds of certification. For this, Boyle looks with one eye to the evidence of his own senses, and with the other, to biblical authority. Though philosophers may presume of nature "that she, by her plastic power and skill, forms plants and animals out of the universal matter," Boyle reminds us that the Bible tells us differently:

> God said, let the earth bring forth the living creature after its kind. . . . And God (without any mention of nature) *made the beast of the earth after his kind.* (Boyle 1744, 4:368)

The particular difference Boyle wishes to note is underscored by both the subject of and the actual verb designating creation, and by the gender of the originary parent or model of living beings: From "she," with "her" plastic powers, the biblical quotation shifts, first, to "it," the earth, still retaining sufficient active power to enable it to "bring forth," and finally, to "Him," who "made" the beast of the earth (as it were) after "his" kind.

At the very least, the reader feels obliged to conclude that it is not "half so evident" that nature is not a true parent after all, and accordingly, that the scruple of filial respect does not apply. Instead, a counterscruple—wedding scientific doubt with religious certainty—

[2] Golinski's very interesting analysis of Boyle's use of skepticism as a rhetorical strategy focuses especially on its use in the *Skeptical Chymist* to "challenge the authority of the prevalent mode of chemical discourse, and to initiate a restructured discourse" (Golinski 1987:61).

ought prevail. Together, the logical doubt that will be revealed by a free inquiry, and the theological certainty that is by definition not open to question, combine to argue for a reorientation of affiliation. Fraternal duty (propelled by free inquiry) and paternal gratitude (guaranteed by faith) are made one: True veneration belongs only to Him who "makes me a man," who, "setting allegories aside," binds all men in a brotherhood dedicated to "the solid and useful discovery of his works."

The second scruple that Boyle attributes to common belief is closely related to the first: It follows from the view of nature as an agent, or "viceregent" of God, and hence as sacrosanct. The identification of this second scruple, a "scruple of conscience," is in fact preceded by just the sort of rhetorical polarization Deason describes:

> I think it more consonant to the respect we owe to divine providence, to conceive . . . God [as] a most free, as well as a most wise agent. . . . This, I say, I think to be a notion more respectful to divine providence, than to imagine, as we commonly do, that God has appointed an intelligent and powerful Being, called nature, to be as his viceregent, continually watchful for the good of the universe in general . . . I am the more tender of admitting such a lieutenant to divine providence, as nature is fancied to be, because I shall hereafter give you some instances, in which it seems, that, if there were such a thing, she must be said to act too blindly and impotently, to discharge well the part she is to be trusted with (Boyle 1744, 4:362–63).

Nature is demoted from her position as viceregent, first, in the name of "the respect we owe to divine providence," and second, in the name of a promised (empirical) demonstration. Having thus disparaged the role of nature, any lingering "scruple of conscience" concerning the "removal of [her] boundaries" is automatically undermined:

> To this I add, that the veneration, wherewith men are imbued for what they call nature, has been a discouraging impediment to the empire of man over the inferior creatures of God: for many have not only looked upon it, as an impossible thing to compass, but as something of impious to attempt, the removing of those boundaries, which nature seems to have put and settled among her productions; and whilst they look upon her as such a venerable thing, some make a kind of scruple of conscience to endeavor so to emulate any of her works, as to excel them (Boyle 1744, 4:363).

The offense committed in making "a Goddess" of nature, "as if it were a kind of Antichrist, that usurped a great share in the government of the world" (Boyle 1744, 4:364), is an offense simultaneously against God and against man. Precisely because the two are kin, like father and son, to delimit the "empire of man" is tacitly to delimit the empire of God; it is for the glory of God that men must seek to "emulate" and "excel" the works of nature. Man himself is of course exempted—neither to be counted among those works that had been commonly thought of as hers (but must now be recognized as God's), nor in fact as a part of nature. He stands beyond her boundaries. Not only is nature not a true parent after all—merely, as Boyle describes her later in the same text, "a great . . . pregnant automaton" (1744, 4:373); but perhaps more to the point, her domain, though it encompasses all animal kind, does not include the sons of God:

> I shall here consider the world [that is, the "corporeal works of God"] but as the great system of things corporeal, as it once really was towards the close of the sixth day of the creation, when God had finished all his material works, but had not yet created man (Boyle 1744, 4:364).

Arriving only on the seventh day, man stands apart, and above—his proximity to God measured by his distance from nature, and proven by his ability to examine "the nature of the spring, that gets all [the parts of "the great automaton"] amoving" (Boyle 1744, 4:358)—in short, by his capacity to "emulate" and "excel" the workings of her parts. The knowledge thus acquired provides not only proof of (at least some) men's proximity to God, but, as well, to each other. Its function is to cement the brotherhood of man under the fatherhood of God. So conceived, knowledge must be "freely and generously communicated" (Boyle 1655)—not secreted for either personal glory or personal gain.[3]

On the place of woman in this new cosmology, Boyle is virtually silent.[4] But though unspoken, she is doubly figured, and doubly

[3] See Golinski (1987:66) for some interesting remarks about the boundaries of class implicit in Boyle's arguments against "the retention of 'secrets and receipts' for commercial gain."

[4] Elizabeth Potter makes an interesting argument showing that the absence of women in Boyle's discourse and cosmology is neither neutral nor idle, but rather that it actively works to frame man as *the* scientific presence (see Potter 1989).

dispossessed: once, explicitly, as the mother who is not, and again, implicitly, as the unnamed wife of the man who is. Truly a spokesman of his time, Boyle leaves her to oscillate ambiguously between deconstructed nature and reconstructed man. And indeed, there she will remain for almost the entire history of modern science, dislocated without a clearly viable relocation in view.

The Problem of Life

At least part of the reason for the enduring uncertainty in the status of "woman," oscillating between nature and man, can be identified quite readily: It lies in the problem of life, a problem that can be described simultaneously in terms of the science of life and in terms of the language of life—but perhaps especially, as a problem evident in the life of the language of science.

There is indeed a sense in which the workings of language can be said to have a life of their own, yet more complex than the above (already rather convoluted) reading suggests. Especially, it might be said that the metaphor of "secrets of nature" has had a life of its own, with its own built-in mortality. Notice, for example, how, with the reorientation between God and Nature just described, the conjunction between Woman, Nature, and life that was itself so useful a rhetorical resource in the secularization of nature is set on a course that ultimately works toward its own dissolution: Once Nature's secrets are penetrated, nature no longer holds that which had marked it with the personalizing "N," that is, as alive; "Nature" can no longer serve as a trope (or prosopopeia) for the world of living creatures. If the metaphoric passage of "secrets" marked a wedge between Nature and God that in turn licensed an all-out crusade on Nature's secrets, the very success of that crusade guaranteed the emergence of a new kind of wedge, now between nature and life. It is this new wedge that leads Richard Westfall (1972) to write in hindsight of the revolution that "banished life from the universe," and that even before much had happened, had led Henry More to complain to Descartes of "the sharp and cruel blade [with] which in one blow, so to speak, [you] dared to despoil of life and sense practically the whole race of animals, metamorphosing them into marble statues and machines" (Easlea 1983:23). The life of Man

was of course not so despoiled; for Boyle, as for Descartes, man is set apart by his "rational soul" (1744, 4:364), arriving on the scene only on the seventh day of creation. Indeed, in certain respects, the deanimation of nature seemed merely to enhance man's own sense of animation, an animation now, however, marked more by difference from than by kinship with the rest of the natural world.

Were it the case that the same wedge that had "banished life from the universe" had placed Woman squarely on the side of Man, equally (or similarly) severed from nature, the history of science might have looked quite different. As it was, however, the metaphoric structure of the entire discourse precluded such a turn. That structure propelled the tropic course of scientific language in a rather different direction, a direction that, for the short run at least, left the identification of women with nature ambiguously intact. On the one hand, it was precisely the survival of the metaphoric link between woman and nature that facilitated the reflection of nature's deanimation, desanctification, and mechanization in the social domain; that is, that facilitated the parallel and contemporaneous taming (or "passification") of the image of Woman that has been noted by social historians.[5] On the other hand, it was precisely the survival of women's still mysterious relation to the production of life—especially, of the life that mattered most (that is, our own)—that sustained the identification of women with nature, and that simultaneously provided the irreducible ground of resistance to the final mechanization of nature. As long as the generation of life—human life/all life—remained beyond our grasp, both women and nature would retain some of their/its sense of residual potency.[6] Machines might be powerful, but they are not omnipotent; to imagine them capable of generation, as Descartes did, was to go beyond the bounds of credulity. Fontanelle (d. 1657) put it quite simply in his early retort to Descartes:

[5] The significance of this transformation for shifting social norms of gender (that is, for actual men and women) is not an explicit subject of this paper, but it is an obviously related question of fundamental importance. A brief discussion, as well as some references to the literature on this subject, can be found in Keller (1985) (cf. especially chapter 3).

[6] As well, it might be added, as sexual agency. Consider, for example, that it was only toward the end of the eighteenth century that "medical science and those who relied upon it cease[d] to regard the female orgasm as relevant to generation" (Laqueur 1986:1).

Do you say that Beasts are Machines just as Watches are? Put a Dog Machine and a Bitch machine side by side, and eventually a third little Machine will be the result, whereas two Watches will lie side by side all their lives without ever producing a third Watch (from Jacob 1973:63).

In other words, as long as mechanism failed to provide a plausible solution to the mysteries of genesis and generation, a trace of divine blessing survived; one pocket of secrecy remained sacrosanct.

For a brief while, a radically different solution to the problem of generation enjoyed some popularity. In this solution, generation was attributed not to mechanical forces, but to divine creation. If, harking back to St. Augustine, all living beings came into existence with the creation of the universe, the direct result of divine intervention, and nature (and woman) merely the vessel in which they grow, then the mysteries of genesis and generation are not properly nature's secrets, but God's.[7] In short time, however, this solution too came to be regarded by most scientific thinkers as lacking in credibility; it could accommodate neither the evidence of ordinary senses, nor that of scientific investigations. By the beginning of the eighteenth century, it would have to be admitted that here, in the twin problems of genesis and generation, where the domains of women, life, nature, and God could not be clearly demarcated, a limit to man's "dare to know" stood firm.

Conclusion

For all the rhetorical persuasiveness and scientific acumen of Bacon, Descartes, Boyle, and Newton; long after Henry Oldenburg's invitation to suitors with "boldness and importunity," who could "penetrate into Nature's antechamber to her inner closet" (from Easlea 1983:26); long after Halley had sung his praises of Newton's prowess

[7] Although, to my knowledge, Boyle himself was not an explicit advocate of such preformationist (or preexistence) theories, and even seems to have vacillated both on the question of preexistence and on the adequacy of purely mechanical accounts of generation (see, for example, Pyle 1987), I think it can be argued that his argument in "A Free Inquiry . . ." did help to set the stage for the preformationist arguments that followed. (For further discussion of seventeenth-century preformationism, see Bowler 1971; Roger 1971; Gasking 1967.)

in "penetrating . . . into the abstrusest secrets of Nature"; long even after Alexander Pope's dictum that, after Newton, "All was *Light*," the most vital of nature's laws lay, still, "hid in Night." A full two centuries would follow in which the most "penetrating genius" of human culture would reveal many of the "most mysterious recesses of nature," and yet, even so, it would still have to be granted that the secrets of greatest importance to men remained as they'd begun, as Davenant had written in 1630, "lock'd" in Nature's "cabinet" (OED:357). In the early nineteenth century, Sir Humphrey Davy complained that "The skirt only of the veil which conceals these mysterious and sublime processes has been lifted up" (quoted in Easlea 1983:28). Across the channel, using almost identical language, Francois Magendie wrote: "Nature has not up to the present permitted man to raise the veil which hides from him the understanding of vital phenomena" (quoted in Mendelsohn 1965:216). The same basic observation would be heard, again and again, in England, in France, and in Germany, until well into the second half of the nineteenth century.

As long as the problems of genesis and generation would remain recalcitrant, the ambiguity that continued to animate the metaphoric relation between women, nature, and life would also endure. Indeed, it could be said that it is these mysteries that constitute the very source of the ambiguity. In turn, however, that same ambiguity functioned as a force impinging on the status of "woman" in the larger cultural field, a force that was simultaneously generative and constraining. Above all, it permitted, and even required, an understanding of "woman" that could mediate, at one and the same time, between man and nature, and between animate and inanimate. One might say that it is just this ambiguity that is captured by the enduring trope "secrets of nature"—indeed, that maintains its entire metaphoric structure.

But there is also a dynamic at work within this language that is itself quintessentially dialectical. The survival of the ambiguous relation between women, life, and nature rests on the endurance of an inaccessible domain—on a domain of difference that maintains the life of the metaphor, "secrets of nature." At the same time, however, the tropic structure of this metaphor itself constitutes a relentless pressure aimed at its dissolution. Once resolved, once the secrets of genesis and generation are completely revealed, once na-

ture has become truly lifeless, so too, in that moment, the metaphor of "secrets of nature" will also have died. And because the life of language is always *in* culture, it should come as no surprise that many of the social norms that had served all along to nourish and animate it will also have died.[8]

Perhaps the only surprise is how very long this process would take to work itself out. We might marvel at the longevity of the language that has continued to animate the scientific project even as both that project, and that language, worked to deanimate the sources that provided them with their vital energies.

In retrospect, we might say that those who had "dared to know" had lacked the means to know; that Davy's (or Magendie's) remarks reflected the inadequacy of the instruments (both conceptual and technological) available to seventeenth- and eighteenth-century mechanists for fully penetrating N/nature's ultimate secret, that the force of nature's resistance was too great. But in actuality, these remarks also reflected a human (or cultural) resistance that worked alongside natural resistance to keep this boldest of all crusades beyond the reach of Newton's gaze.

In the late eighteenth and early nineteenth centuries, this human resistance manifested itself in the demarcation of a separate domain of nature for living beings, and with it, a separate domain of science. And for a while at least, the demarcation of "life," and the parallel demarcation of "biology," served to provide living beings with something of a refuge from the incursions of seventeenth- and eighteenth-century mechanism. Eventually, of course, mechanism did prevail. But before this final conquest, indeed, before the "secret of life" could even be named as a fitting quest for natural science, life itself would first have to be relieved of the residual sense of sublimity that had, despite all the efforts of the mechanical philosophers, continued to attach to the nature of animal and plant forms. Secrets would have to make a final passage, from nature to life—a passage that both marked and facilitated the transformation of twentieth-century science and culture, much as the earlier passage, from God

[8] The change in the language of science of the second half of the twentieth century, and the parallel changes in social norms that we witness around us, are of course a subject of their own. Some of the interactions between scientific language, technology, and social norms characteristic of our own time will be elaborated in a later essay; here I wish only to call attention to the existence of such interactions.

to nature, had marked and facilitated the transformations of that period; a passage that was necessary if the ordinary people that scientists are were to condone the rhetoric and the technology required for the dissolution of this last stronghold. When that happened, a new religion would be resurrected: a God neither of "man" nor "woman," but of atoms and molecules. For the one religious reference that Francis Crick is willing to embrace, he quotes Salvador Dalí:

> And now the announcement of Watson and Crick about DNA. This is for me the real proof of the existence of God (Crick 1966:1).
>
> Salvador Dalí

I am indebted to the National Endowment for the Humanities for supporting the work for this essay during my stay at the Institute for Advanced Study in 1987–88.

72

4

Critical Silences in Scientific Discourse: Problems of Form and Re-Form

Part I: Introduction
(The Question I Would Like to Ask)

I begin with a few philosophical platitudes about the nature of scientific knowledge upon which I *think* we can agree, but which, in any case, will serve to define my own point of departure. First,

- Scientific theories neither mirror nor correspond to reality.

- Like all theories, they are models, in Geertz's (1973) terms, both models of and models for, but especially, they are models *for;* scientific theories represent in order to intervene, if only in search of confirmation. And the world in which they aim to intervene is, first and foremost, the world of material (that is, physical) reality. For this reason, I prefer to call them tools. From the first experiment to the latest technology, they facilitate our actions in and on that world, enabling us not to mirror, but to bump against, to perturb, to transform that material reality. In this sense, scientific theories are tools for changing the world.

- Such theories, or stories, are invented, crafted, or constructed by human subjects, interacting both with other human subjects and with nonhuman subjects/objects.

- But even granted that they are constructed, and even abandoning the hope for a one-to-one correspondence with the real, the effectiveness

Presented at the Institute for Advanced Study, Princeton, N. J., on February 4, 1988. I am indebted to the National Endowment for the Humanities for supporting this work.

of these tools in changing the world has something to do with the relation between theory and reality. To the extent that scientific theories do in fact "work"—that is, lead to action on things and people that, in extreme cases (for example, nuclear weaponry), appear to be independent of any belief system—they must be said to possess a kind of "adequacy" in relation to a world that is not itself constituted symbolically—a world we might designate as "residual reality."

- I take this world of "residual reality" to be vastly larger than any possible representation we might construct. Accordingly, different perspectives, different languages will lead to theories that not only attach to the real in different ways (that is, carve the world at different joints), but they will attach to different parts of the real—and perhaps even differently to the same parts.

So far so good. All these differences seem to reveal a space indicating the operation of choice in the construction of scientific knowledge. Yet, the moment we attempt to juxtapose the representational plasticity of scientific theories with their instrumental efficacy, this space seems to disappear before our eyes, leaving in its place an aura of inevitability.

From critical theory, to hermeneutics, to pragmatism, the standard response to so-called relativist arguments has been that the scientific stories are different from other stories for the simple reason that they "work." If there is a single overriding point I want to make in this essay, it is to identify a chronic ellipsis in these responses: As routinely as the effectiveness of science is invoked, equally routine is the failure to go on to say what it is that science works *at*, to note that "working" is a necessary but not sufficient constraint. Science gives us models/representations that permit us to manipulate parts of the world in particular ways. In a way, Charles Taylor says it all: The inescapable difference between theoretical and atheoretical cultures, he says, lies in the technological success of modern scientific culture, and to bring his point home, he cites the nineteenth-century British ditty, "Whatever happens, We have got The Gatling gun, And they have not" (in Hollis and Lukes 1982:104). What I am saying is that it is not sufficient to grant that scientific ways of knowing have instrumental value, or that they proceed out of instrumental interests: Neither instruments themselves, nor the values, interests or efficacy associated with them are devoid of aim. To be sure, instrumental knowledge has force in the world, but force, as

we learned in freshman physics, is a vector. It has not only magnitude, but directionality as well. And if we grant directionality to the force of scientific knowledge, then the obvious question arises: In what other directions might science work? Toward what other aims? Furthermore, by what criteria are we to measure science's instrumental success? Surely, not simply by the magnitude of its impact on the world—not if we also ask what, if anything, guarantees that the particular ways in which our best science "works" are humanly adaptive? And finally, if they are not, how might we re-vision the scientific project—as it were, to make it "work" better?

Such questions may seem obvious enough, but we know that past attempts to deal with them have been notoriously unsuccessful. Most recently, and arguably with some more success than their predecessors, feminist critics of science have suggested that the particular directions that the forms of scientific knowledge have taken since the seventeenth century are grounded in (or at least supported by) a historically explicit identification of scientific values with the values our particular cultural tradition takes to be masculine, and a collateral and equally explicit exclusion of those values which have been labeled "feminine." In contrast to other attempts, such as, for example, Marcuse's (1964) earlier vision of an "erotic science," feminist analyses of science have given us some strategies for identifying both the dynamics and consequences of such a "genderization of science." In particular, we have grounded our critique by looking to the history of science for traces of alternative visions and practices present within our own Western traditions, even within the domain of modern science. These traditions prove rich in such variability, and their history does indeed provide evidence for at least a loose conjunction between criteria of selection and prevailing gender ideologies.

It is apparent that we ourselves have tended to fall into the old (and notably counterproductive) polarity between understanding and manipulation, concentrating our critical attention on alternative meanings of the former, and disdaining the latter. It is as if, entrapped by the bifurcation between representing and intervening, we have come to agree with the critical theorists that it is control and prediction in themselves that must be the culprit. (See, for ex-

ample, *The Race to the Double Helix*, BBC film 1987, in which Rosalind Franklin is quoted as saying, "I just want to look, not touch."[1])

Coincidentally, feminist critics of science have been almost totally silent on the subject of physics—historically (at least until current developments in molecular biology), the most powerful agent of change to come out of the entire corpus of scientific knowledge. True, sociologists of science have balked at the conventional privileging of physics, at accepting the hierarchical organization of knowledge that places physics at the apex of knowledge, and they have had good (and obvious) reasons for doing so.[2] Yet, however extensive its social and rhetorical inflation, the status that physics enjoys today cannot be separated from its newly proven prowess in not only moving the world, but making it shake at its very roots.

In short, feminist theory has helped us to re-vision science as a discourse, but not as an agent of change. And it is this latter question that I want to press on now. Since it is demonstrably possible to envision different kinds of representations, we need now to ask what different possibilities of change might be entailed by these different kinds of representation? For this, we need to understand the enmeshing of representing and intervening, how particular representations are already committed to particular kinds of interventions. Is there, for instance, a sense in which we might say that the program of modern genetics already has, written into its very structure, a blueprint for eugenics? Or that nuclear weapons are prebuilt into the program of nuclear physics? And if so, what kinds of theories of the natural world would enable us to act on the world differently?

[1] Indeed, feminist criticism itself provides us with ways of thinking about other meanings of control that may be extremely useful for undermining this simplistic dichotomy. A metaphor that I find particularly useful comes from parenting: No one would suggest that a loving parent ought be content to simply "look," disavowing all attempts to shape and control. At the same time, attempts at forms of control that are too rigid or too intrusive are also understood to be counterproductive, if not actually destructive. I suggest that the work of "mothering," performed either by mothers or fathers (see, for example, Ruddick 1989), provides a promising metaphor for thinking about alternative relations between scientific knowledge and effective action.

[2] For example, physics is not an obviously applicable model even for the biological sciences, much less for the human sciences. An adequate account of its historical preeminence—of why the explanations of the universe that physics offers have seemed so extraordinarily satisfying—would surely require attention to the social and rhetorical dynamics that have helped to sustain it.

In other words, I start by repudiating the view of an undirected search for knowledge, leading inexorably to the science of genetics, out of which suddenly and unexpectedly emerges the wherewithal for a fully fledged and perhaps even unstoppable eugenics program. I want to ask instead, how might the very framing of the questions of genetics already commit us to the possibility of eugenics? At the same time, however, I take it as self-evident that no simple account can be given of the conjunction between knowledge, power, and desire. The story of DNA does not map on to the eugenics script in any straightforward way, any more than the story of nuclear physics could be made to simply map on to the bomb—if only because the array of motivations and consequences attaching to both these stories is vastly more complex. Nonetheless, there is reason to suspect that somewhere in the project of genetics there is already contained not only the possibility but the expectation of eugenics, just as the anticipation of explosive power is somewhere contained in the project of nuclear physics. But none of us, it seems, is able to say much about where, and how.[3] The difficulty we encounter is not in documenting either potential or anticipation of these consequences—that part is easy. Rather, it is in showing the influence of such ambitions on the structure and form of the biological and physical theories that realize them. *That* question appears to be foreclosed every which way we turn. And since I'm convinced that the question not only makes sense, but also has a kind of urgency, I'm led to ask: What is the nature of the impasse that obstructs its pursuit? In other words, although I take it that there *are* (at least some) real objects in the world, the barriers that prevent us from asking manifestly sensible questions are not among them. These are constructed alongside, and perhaps even as part and parcel of, the process that yields our scientific representation of the real.

So this essay is not about re-visioning or re-forming science, but about the obstacles such an effort encounters, especially in relation to physics. I want to take you on a tour of the ways in which these questions appear to get foreclosed if you happen to have been working in physics, biology, or the history, philosophy, or sociology of

[3] The beginnings of such an account is attempted in Keller (1990), reprinted in this volume and in Kay (1992).

science over the last couple of decades. In other words, if you happen to be me.

At the end, I will offer some suggestions of what I think we need to get beyond these obstacles—namely, a better and fuller understanding of *how science works*. Perhaps such an understanding might itself prove to be a tool for change, especially, for re-visions and re-form.

Part II: Some Obstacles in the Way

Physics: The Ideology of "Pure" Science

I start as a scientist. I was drawn into physics by an image of the discipline as the most rarified, purely mental—and pristine—endeavor of which human beings were capable. In theoretical physics I saw the promise of touching the world at its innermost being, a touching made possible by the power of pure thought. Physics appeared to me as a vision of exquisite power, but it was not the power of a Francis Bacon, it was more like the power imaged by Einstein—the power of connections, of being "sympathetically in touch with" reality, the power to feel rather than to move the world.

I of course did not invent this picture; I learned it from the community into which I was being inducted. However idiosyncratic my own personal embellishment, my romance with physics was part of a collective romance: It was the romance of pure science, communicated to me in its basic form and content by my teachers. I learned that, at its best, science was pure in all the senses listed by my thesaurus: It was pure in the sense of autonomous, virtuous, absolute, and elitist, in the sense of abstract, conceptual, and theoretical; in the sense of immaculate, unblemished, and virginal—perhaps above all, in the sense of innocent and blameless. Its antithesis—decorum prevents the purists among us from calling it "impure"—is called (instead) "applied science," or often, more simply, technology or engineering. In other words, this complex and multi-functional vision of a pure, autonomous science carries with it, or perhaps I should say, is premised on, the certitude of a clear demarcation between pure and applied, between science and technology. Pure scientists might claim responsibility for the ultimate

power to make the world move (although the purest of the pure would likely disclaim interest even in such potential movement), but with this demarcation, all responsibility for *what* changes are effected, for the choice of direction in which the world is moved, is disowned—that responsibility is located squarely in the lap of applied science, technology, or even better, in politics.

The notion that science might, or ought to, be "pure" was of course hardly new to scientists of my own generation.[4] It was preceded by a tradition begun long before World War II, and it continues—at least in its essential form—as an article of fundamental faith for most scientists today, perhaps especially for theoretical physicists. One might say that it is an ideal that finds its ultimately graphic representation here in the location, design, and organization of the Institute for Advanced Study. Yet, its invocation at that particular time in history (late 1950s and early 1960s) must be seen as at least ironic. World War II had triggered a transformation in American science, especially in physics, that left the demarcation between pure and applied science, between science and technology, increasingly difficult to locate in any space outside the hearts and minds of pure scientists. The exigencies of war precipitated a convergence between pure and applied, between basic and mission-oriented research— and more generally between academic science, industry, and the military—that culminated in, but did not end with, Hiroshima and Nagasaki. Some would even argue that it began there. Between 1938 and 1945, the military investment in R&D increased by an absolute factor of 50, and a relative factor of 3 (that is, from 30 percent to more than 90 percent of the total research budget). After the end of World War II, military expenditure in R&D remained roughly constant (with only a slight slump in the immediate postwar years), and by the late 1950s, actually came to exceed its wartime high, even when calculated in constant dollars.[5] The funds for what alternatively gets called basic, pure, or fundamental research increased hand-in-hand with the funds for applied (or mission-oriented) research. The rationale for this increase in support for basic research

[4] See, for example, Robert Proctor (1991) for a fuller discussion of the history of the idea of "pure science."

[5] The figures cited here are taken from Forman (1987).

was straightforward. As Alan Waterman explained his own program in the Office of Naval Research (this was 1950):

> [Since] it is assumed that something like the present degree of emergency will persist for an unforeseeable period of years . . . it is believed equally important to secure "defense in depth" . . . on the research and development front by providing stable, continuous support to basic research (from Forman 1987, p. 159).

In other words, even while insisting that the value of basiç research was not to be tied to its utility, scientists supported the general conviction that had been driven home by the atom bomb; namely, that "our national security rests on superior science." Their double message was clear and open: On the one hand, basic research was, in both the form of its questions and the content of its answers, entirely autonomous of any uses to which it might be put; at the same time, however, it was necessary to the maintenance of an adequate military defense.[6]

Early on, the irony of this not so much new as newly fraught cleavage between purity and danger in the character of scientific knowledge had found eloquent graphic representation in a popular image—an image first presented on the cover of *Time* magazine in 1946, but persisting as a kind of cultural symbol ever since. This is the juxtaposition of the face of Albert Einstein, the equation, $E = mc^2$, and the ominous mushroom cloud—an association, as it happened, that served both scientists and the public remarkably well. The sad, gentle face that was known throughout the world as an exemplar of pacifism stands here for the pure scientist; $E = mc^2$ for Einstein's notoriously abstract and obscure theory of relativity, the theory that was popularly said to be comprehensible to only twelve people in the world; and the mushroom cloud, well, we know what

[6] For an example of how this duality was argued in practice, consider Columbia University's proposal to the Office of Naval Research for support of an "Ultra-high energy machine." It read: "The whole field of nuclear physics and nuclear energy is based on a rather scanty theoretical foundation. . . . One must be prepared for the most extraordinary surprises such as came about through the discovery of nuclear fission. No real security can exist until this whole field of nuclear and high energy phenomena are understood as well as electromagnetic phenomena" (quoted in Forman 1987, n. 132, p. 222).

that stands for.[7] In conjoining these three images, the deeply ambiguous and profoundly troubling relation between science and the military acquires a message of tragic inexorability. If Einstein's pure and abstruse researches into the mysteries of space, time, and matter could result in a weapon as literally earth shattering as the atomic bomb, belief in choice and responsibility is radically confounded. Surely no one could hold Einstein himself, the pure scientist, to blame. No one would want to claim that Einstein, or anyone else, for that matter, could have foreseen the monstrous cloud in the elegant symmetries of Lorentz invariance. And furthermore (with that sleight of hand that has become so familiar), even if one could, surely no one is suggesting that the acquisition of such pure knowledge could, or should, be curtailed?

There is indeed tragedy in this vision of science, but there is no tragic flaw—nor, finally, is there any responsibility.[8] Scientists work to increase our fund of knowledge of the natural world as they must, for sooner or later, knowledge will out. Knowledge, as a distinguished physicist recently explained to me, can be thought of as an expanding sphere of light in a background of darkness. Its only directionality is outward; it just grows, without direction, and without aim.

It is noteworthy, however, that this use of Einstein to imply a relation between science and weapons beyond (at least our) control bespeaks more mystery than history: As anyone who was connected with the actual developments knows, neither Einstein nor the theory of relativity had very much to do with the development of the atom bomb. There *was* a chain of events linking basic (or pure) physics to the bomb, but it proceeded less through the theory of relativity

[7] See also A. T. Friedman and C. C. Donley, (1985) for discussion of this juxtaposition.

[8] With this logic, responsibility is shifted ever outward, from the pure scientist responsible only for "knowledge," to the engineers who make the weapons, and finally, to the politicians who choose to use them. As Richard Rhodes (author of the widely acclaimed new history of the atomic bomb) has written:

> Science is sometimes blamed for the nuclear dilemma. Such blame confuses the messenger with the message. Otto Hahn and Fritz Strassmann did not invent nuclear fission; they discovered it. It was there all along waiting for us, the turn of the screw. If the bomb seems brutal and scientists criminal for assisting at its birth, consider: would anything less absolute have convinced institutions capable of perpetrating the First and Second World Wars . . . to cease and desist? (1986:784)

than through research in nuclear physics. This other history (more familiar to scientists than to the general public) can be traced back to Rutherford and Soddy's 1903 calculations of the energy released by radioactive decay. Forty years before the Manhattan Project, and two years before Einstein published his special theory of relativity, Rutherford remarked "that, could a proper detonator be found, it was just conceivable that a wave of atomic disintegration might be started through matter, which would indeed make this old world vanish in smoke"—his biographer called it a "playful suggestion," and Soddy, though he took it more seriously, consoled himself with the faith that "We may trust Nature to guard her secret" (Rhodes 1986:44). From that point on, the possibility of an atomic bomb was never far from the consciousness of nuclear physicists.[9] If one particular scientist were to be singled out in the chain reaction that led from Rutherford to Oppenheimer, it ought perhaps be Leo Szilard (the man who thought the possibility of building an atomic bomb so likely that he patented his recipe for it in 1934), not Einstein. Einstein, after all, was only the signator of the letter that first alerted FDR of the possibility (and necessity) of making such a weapon; Szilard was its primary author.[10] Beginning with that letter, and persisting throughout the postwar years, it could be said that Einstein's principal role was that of icon, and there is reason to believe that he knew it. An apocryphal story floating around the Institute tells us that one day, asked by a stranger on the train what he did, Einstein replied, "I'm an artist's model."

[9] Soddy inspired the term "atomic bomb." He wrote: "If it could be tapped and controlled what an agent it would be in shaping the world's destiny! The man who put his hand on the lever by which a parsimonious nature regulates so jealously the output of this store of energy would possess a weapon by which he could destroy the earth if he chose" (from Rhodes, 1986 p. 44). Although neither Rutherford nor Soddy thought such an eventuality likely (Rutherford later called it "moonshine," and Soddy consoled himself with trust in nature ["We may trust Nature to guard her secret"]), H. G. Wells apparently thought Nature rather less trustworthy. In 1914 he published his vision of global atomic war (The World Set Free), set in the year 1956. Nineteen years later, stimulated by his reading of Wells, Szilard contrived his scheme for a chain reaction.

[10] The influence of this letter has itself been popularly overestimated. At least equally important was the train of events set into motion by the calculations of Peierls and Frisch, and the memo they and Oliphant sent to the Tizard Committee in early 1940 (see Rhodes 1986).

Like all successful myths, the myths surrounding Einstein's office persist (in both popular and scientific imagination, sometimes even alongside an awareness of their mythical character) because they work. In particular, they work *to* sustain belief in the a priori aimlessness and essential purity of scientific knowledge, even in the face of the unprecedented dangers that knowledge has enabled. Einstein's image effectively effaces all those others who cannot be said to be entirely innocent, precisely because they did anticipate the ominous cloud, and nonetheless worked actively toward it—either believing such an eventuality unlikely, or believing it all too likely. And the displacement is effective, at least in part, *because* of the congruence between the plasticity of Einstein's image and the (now necessary) ambiguity in the meaning of the term "pure": at once genuine, plain, blameless, innocent, virtuous, unblemished, abstract, conceptual, and theoretical. Thus bolstered, our confidence in the purity of scientific knowledge—even, or especially, at that historic moment which finds science at its most impure—works, in turn, to foreclose the questions we would otherwise ask about the aims of science, about the ways in which both the form and content of scientific knowledge have been shaped by the motivations driving it (either from below, in the consciousness or unconscious of individual scientists, or from above, in the programs of the sponsoring agencies). Most crucially, such confidence prevents us from thinking about the possibility of redirecting science, of doing it differently. For how can one redirect a venture that has no direction?

History, Philosophy, and Sociology of Science: The Focus on Truth OR Consequences, But Never Both

On these absolutely vital questions, working scientists are predictably silent. More oddly though, the analytic disciplines that grew around the natural sciences after World War II have been equally silent. Throughout this critical transformation in both the scale and character of scientific research, well into the 1960s, prevailing conventions in the history, philosophy, and sociology of science worked collectively and separately in ways that tacitly supported the inviolability of the scientific preserve. Historians of science, by concentrating their attention on the internal or strictly cognitive de-

velopment of science; philosophers of science, first, by their embrace of logical positivism, and even after attention shifted to the debate between rationality and realism, through an unspoken agreement to privilege questions of truth over questions of consequences; and sociologists of science, by their focus on the professionalization of scientists, and on scientific knowledge "as simply another commodity" (Dennis 1987:510). In these various ways, all of the disciplines devoted to analysis of the growth of scientific knowledge tacitly cooperated in demarcating the internal dynamics of science from its social and political influences. What inquiry was conducted into the changing character of American science was largely confined to the subject of external (that is, political or social) changes in the relation of society (or government) *to* science. And by definitions then current, this version of the problem both ensured its exclusion from the history and philosophy of science and helped delimit sociological inquiry to the "so-called external relations of science." The net result was to effectively foreclose inquiry into the formative influence of social and political factors on the development of scientific knowledge itself, and, in that evasion, to permit the dual rationale of science—as an intrinsic good *and* as an activity to be supported because of its utilitarian outcomes—to remain intact. In 1962, when A. Hunter Dupree's own research into the growing interdependence of science and government led him to write, "In the near future lies the possibility that social relations may be the key to the internal development of science as well" (1962, 135:1119–21), his suggestion fell on uncomprehending ears.

It may be worth distinguishing at this point between the kinds of questions that *couldn't* be asked from those that might have been asked but for the most part simply weren't, or if asked, weren't pursued. Even granting a view of scientific knowledge based on the model of discovery—of taming, or illuminating, the great unknown—there remains the question of what kinds of things we choose to know, in what directions we aim our great searchlight of scientific inquiry. In this view, it may not be seen as mattering in the long run, but it will surely be acknowledged that, in the short run, the profile of scientific research (even of basic research) depends on funding priorities. The more resources invested in one line of research, say laser physics, the more rapidly we accumulate knowledge about how to build a laser. These are obvious points; they

grant that the particular content, even if not the form, of our knowledge may well depend on where we invest our energies. Such a picture does indeed disturb the isotropic, expanding sphere of light conception of the growth of scientific knowledge, but only slightly. It posits time as the great leveler. Ian Hacking calls this the "menu view" of knowledge:

> We cannot afford (or eat) all three of the entrees; meat, fish, and vegetarian. So we settle on one, but our choice does not affect the menu. Choosing meat today has no consequences for fish tomorrow, unless the restauranteur did not purchase enough fish, guessing we would go for meat again. But that defect can be cured in one more day, and the menu is restored (1987:238).

Hacking suggests that this view "deflects us from the menu itself"; by focusing on the *content*, it deflects us from thinking about the *forms* of scientific knowledge, about "what is held to be thinkable, or possible, at some moment in time" (p. 243)[11]. But a prior point also needs to be noted: Obvious as such questions are, the disciplinary structures that were in place until the early or mid-1960s labeled them as concerns of ethics and policy, not as properly belonging to the history, philosophy, or even (for the most part) the sociology of science. They stood as self-evident observations that could perhaps serve as starting points for policy or protest, but not for investigation into *how* the profile, even the short-run profile, of scientific knowledge is affected.[12] And without such an investigation, we have no way of knowing whether content and form can in fact be so easily separated—whether what is known is so readily separable from what is knowable, or for that matter, from what we *want* to know, and, of course, want to do. The truth is, we never really

[11] As well, I would add, as what counts as knowledge. For both Hacking's notion of "forms" of scientific knowledge and my own, the important point is their inherent directionality.

[12] We cannot look to scientists themselves for an answer to this question because for the most part they do not, perhaps even cannot, know. I recall, for example, my own work as a newly vintaged theoretical physicist on a problem I saw as being of purely theoretical interest (Keller 1965). Only many years later—and only by reading historical accounts such as Forman's (1987)—did I learn, to my utter astonishment, that the problem had not only arisen from the needs of laser physics, but also that its solution might possibly even have contributed to the subsequent development of laser weapons.

asked. Our confidence in scientific realism was so strong that it preempted even those questions that were ostensibly within its own sway, but that, if pursued, might have led us beyond naive faith.

In the past twenty-five years, however, all that seems to have changed. A revolution has taken place in the history and sociology of science, and, on a smaller scale, even in the philosophy of science. With the exception of natural scientists themselves, few people in the academy still believe in the inexorability, inevitability, or even purity of scientific truth—in the expanding sphere of light picture of scientific knowledge. Historians of science have demonstrated that the very ideal of pure science is itself a historical construction, maintained by normative conventions of scientific discourse (see for example, Markus 1987). In the new history and sociology of science, Robert Young's rallying cry of the mid-1970s ("Science *is* social relations") has become a methodological principle. When field studies of actual laboratory practices began to appear, it quickly became fashionable (in some quarters at least) to conclude "that nothing extraordinary and nothing 'scientific' was happening inside the sacred walls of these temples" (Latour 1983:141), that "the very distinction between 'social' and 'technical' is produced through scientists' own interpretive practices" (Knorr-Cetina 1983:13). From our present vantage point, Dupree looks to have been remarkably prescient.

Yet, in spite of the enormous increase in our sophistication about how science works, there remains one crucial respect in which we are as helpless today as we were in the early sixties: As soon as we try to think about how science might be different, we are met by the same impasse as before, though perhaps from the opposite side.

Social studies of science describe a science that is if not exactly out of control, for all practical purposes, beyond the possibility of control. It is as if, in disdaining the instrumentalist agenda of the natural sciences, the aspiration of prediction and control, sociologists of science have opted for a different (pretechnological) model of science for themselves: naturalist rather than empirical, descriptive rather than predictive; once again, representing, not intervening. But with a crucial difference. The confidence the early naturalists shared in full—that the basic order of things is good—is gone. Now, however, we may be finding sustenance in another illusion: the move that turns Bacon on his head and asserts, not knowledge is power,

but power is knowledge—that the real locus of politics is in the force of representations; that doing is in the knowing.

Though the new sociology of science may in fact have grown out of an explicitly political agenda that can be traced back to Hessen and Bernal, by the late seventies and early eighties, earlier ambitions to reclaim science "for the people" seemed to have largely vanished. Much as in contemporary philosophical discourse, critical focus has come to revolve around claims to truth in science, leaving its consequences, once again, out of bounds. With the shift from naive realism to relativism, as even Latour acknowledges, "The terms have changed, the belief in the 'scientificity' of science has disappeared, but the same respect for the boundaries of scientific activity is manifested by both schools of thought" (Latour 1983:142). Accordingly, all questions about how that activity might be redirected have remained unaskable. With the shift of disciplinary structures that permitted the embrace of science as social relations, somehow, even the simple questions about the influence of funding on the shape of scientific knowledge that, as realists, we might have asked but didn't, became (or remained) virtually invisible. Until the last couple of years, even such relatively straightforward questions as these have managed almost entirely to elude the attention of historians and sociologists of science.[13] It would appear that, when we were naive realists, faithful to the ideals of pure science, we were either too timid or didn't know how to ask; and as relativists, disabused of both "purity" and "scientificity", we somehow lost interest.[14]

Signs of Change

Still, even if neither realism nor relativism provided us with the interest, courage, or conceptual handle with which to approach such

[13] Paul Forman may be speaking for his entire generation when he describes his own response to Hunter Dupree's call of twenty-five years ago as "fascinated but fearful," a fascination itself "rigidly clamped between attraction and repugnance." MacKenzie, however, goes considerably further, suggesting "a form of intellectual treachery" (1986:363).

[14] Suggesting, perhaps, that neither the history, philosophy, nor sociology of science are any more immune to socio-political interests than are the natural sciences themselves.

questions, I want to suggest that the tension made conspicuous by their opposition may now enable (perhaps even demand) a beginning. In part, I draw confidence from the upsurge (I'll resist the temptation to say explosion) of research activity we have begun to see just in the last two or three years, centering on the impact of World War II on American science. To name just a few: Bromberg, Forman, Heilbron, Schweber, Kevles, Pickering, Roe Smith, Reingold, Seidel . . . are all now hard at work documenting the impact that military funding has had on the growth of post–World War II American science (especially physics)—a necessary precursor to (indeed, that makes it possible to ask) the kinds of questions that Hacking, or I, want to ask. In fact, it is from Forman's comprehensive review of the development of the physics "behind quantum electronics"—stimulated most immediately by the striking parallels between funding patterns of the 1950s and those of the 1980s—that I have drawn many of the quotes and figures cited here. Forman's introductory and concluding remarks are at once compelling and poignant:

> The picture drawn here may be surprising to those of us who have viewed science with much the same ideological commitments as those most devoted to its pursuit. We, like them, saw the enormous expansion of basic physical research after World War II as a good in itself, a praiseworthy diversion of temporal resources to transcendental goals. We, like them, have been pleased to suppose that science was here using society to its own ends (1987:150).

In the end, Forman recognizes in this supposition what he calls "scientists' own false consciousness,"

> which succeeded so well in what it was intended to do, to mislead others even as it blinded themselves. On the one hand they focused so narrowly on immediate cognitive goals of their work as to miss its instrumental significance . . . to their military patrons. On the other hand they pretended a fundamental character to their work that it scarcely had, and/ or compartmentalized, as scientifically irrelevant, the very large technical component that bought them their quota of scientific freedom. . . . Though they have maintained the illusion of autonomy with pertinacity, the physicists had lost control of their discipline (1987:228).

It is Forman's actual investigation that leads him to this conclusion, but the mere fact that he, along with so many of his colleagues, has

now taken up this work is striking in itself. Surely (as I've already indicated) that fact has something to do with the current escalation in political pressures on scientific communities. But it also has a great deal to do with the extent to which the earlier, and crucially inhibiting, confidence in the purity and autonomy of science (that even Forman shared) has now been eroded by the intellectual pressures growing out of developments in the social studies of science. It is in just this sense that I take the confrontation between realism and relativism as having generated a place to start.

But to continue the analysis, to now try to understand the impact of our military aspirations on the *forms* (as well as the content) of scientific knowledge, is of course harder. If nothing else, the last twenty-five years in the history, philosophy, and sociology of science have taught us the inadequacy of any simple view of a direct, or witting, relation between military aims and the forms of knowledge. As Hacking writes,

> There is no monolithic military conspiracy . . . to determine the kinds of possibilities in terms of which we shall describe and interact with the cosmos. But our ways of worldmaking . . . are increasingly funded by one overall motivation. If content is what we can see, and form is what we cannot, but which determines the possibilities of what we can see, we have a new cause to worry about weapons research. It is not just the weapons . . . that are being funded, but the world of mind and technique in which those weapons are devised. The forms of that world can come back to haunt us even when the weapons themselves are gone. For we are creating forms of knowledge which—spinoffs or not—have a homing device. More weapons, for example (1987:259–60).

Part III: Conclusion

To sum up and recapitulate, I suggested at the beginning that what we need for the task of re-visioning science is a better understanding of *how science works*. Scientific theories impinge on the real, but they do so selectively, not neutrally, effecting some kinds of changes rather than others. And to make sense of how science works, we need to account for the process by which such selectivity operates. In other words, we need to enlarge our understanding of the meaning of the verb "to work" to include action on human as well as

nonhuman subjects. In my remaining few minutes, let me try, very schematically, to sketch out a way of doing this.

If scientific theories are produced by particular groups of people, interacting among themselves, with nonscientists, and with nonhuman subjects (Latour would call all these participants "actors"), then the effectiveness of the resulting theories must be judged in terms of all these interactions that generate them. These interactions, internal and external together, produce an interlocking system of needs and desires demanding at least partial satisfaction by any theory or research program that is said to "work." Intentionality might be said to be located in the production of this system of needs, consequentiality in its satisfaction.

A certain amount (perhaps even much) of the work that a successful theory or research program must do can be described in strictly human (psychosocial, political, and economic) terms. It must be able to generate jobs and doable problems; it must offer explanations that provide aesthetic and emotional satisfaction; it must work rhetorically to recruit students, "win allies," get grants from the National Science Foundation. In short, it must have the power to persuade a number of different constituencies—the funding agencies, the scientists themselves, the public at large, the potential recruits—where even within each of these constituencies, interests are multiple, overlapping, and shifting. For example, a student might be drawn into physics by promises of beauty, elegance, simplicity, certainty, the sheer erotics of knowing, a good job, and/or epistemological, social, or technological prowess. The relative weight of these different appeals will of course vary with time, circumstance, and individual idiosyncrasy. In the 1960s, for example, an educational film was made for high-school students that began with Jerrold Zacharias banging his fist, proclaiming, "Physics is about power!" For emphasis, a mushroom cloud fills the screen. To seventeen-year-olds, the promise of such prowess necessarily appeals more to personal than political desires: It promises to make one big, strong, and "manly"—as an individual rather than as a nation. Fortuitously, perhaps, the same rhetoric could also be used for legislators; then, as now, there was enough of a convergence of interests in this promissory note to appeal both to a pool of potential recruits and to funding agencies. But the promises held out—to future physicists as well as to legislators—must be made good. For a research

program to work, it must satisfy the desires that motivate it, at least well enough to keep it going. In the short run, a stable network of interests might be well enough satisfied without the need to invoke any particular interactions between science and the nonhuman world: Jobs, satisfying explanations, doable problems might all be generated by the human work of a research program. But over the long run, even these promises demand satisfaction in terms of direct interactions with (or intervention in) the world of nonhuman subjects. By scientists' own internal ethic, explanations must provide at least some predictive success to remain satisfying; and by the social and political ethic justifying their support, this predictive success must enable the production of at least some of the technological "goods" the public thinks it is paying for.

The truly remarkable thing about physics, and now, molecular biology as well, is that it has been able to realize so many of these needs and desires, that it has produced a body of theory that matches the world well enough to satisfy this network of overlapping interests, that has given us stories good enough (or true enough) to enable us to change the world in ways that we seem to want. That success I think is testimony, above all, to the resourcefulness of physicists. Out of their interactions with each other, with the public at large, with their own heritage, and with a judiciously culled set of facets of the inanimate world, they have succeeded in producing tools that appear to dissolve nature's resistance to our own needs.

But in marveling over their extraordinary success, we need also to consider the almost equally remarkable particularity (perhaps even singularity) of our needs, of the facets of the natural world we designate for experimental and theoretical inquiry (that is, what it is we seek to know about), and of the social arrangements that facilitate the convergence of these needs and facets. All of these, separately and convergently, are products of a particular historical moment. Consider, for example, the availability of jobs down the road at Jet Propulsion Laboratories for the Cal Tech students who, for kicks, spend their Saturday nights building spectacular explosive devices; or the consonance between the explanatory preferences of particular groups of scientists and the psychosocial and political norms of these same groups; or the dependence of technical or mathematical feasibility on available resources. With so much contingency in view, we might now be able to ask how this same re-

sourcefulness might be employed toward the fulfillment of other desires, satisfying a convergence of human interests that would be yielded by different social arrangements.

To be sure, the possibilities of alternative nodes of convergence between the technical and the social are severely limited. As Gyorgy Markus writes, "If history teaches us anything, it is . . . that among the great many imaginable and perhaps desirable things at any historical moment, only a very few have any chance of a practical-social realizability" (1987:46). But embedding the directionality of scientific work in its variable psychosocial and political context on the one side, and in the invariant capaciousness of its epistemic potential on the other, brings the possibility of alternative directions within at least imaginative reach. Given our remarkable ingenuity, skill, and imagination, I have no doubt that, with sufficient interest, we could develop representations of natural phenomena adequate to the task of changing the world in different ways—perhaps, as some have hoped, giving us solar energy, rather than nuclear power; ecological rather than pathogenic medicine; better rearing rather than better breeding of our offspring. We have proven that we are smart enough to learn what we need to know to get much of what we want; perhaps it's time we thought more about what we want. It is of course true, and I have not forgotten, that our interests are neither unitary nor consensual, nor are they themselves free of the network of interactions that make science "work": Wanting, knowing, and doing are *all* mutually implicated. Nevertheless, there may still be *something* that grounds this entire process, a point on which the convergence of our interests might be said to be obligatory— and that is on the matter of survival. After all, for whom or for what can a science that provides tools powerful enough to destroy even their own makers be said to work?

5

Fractured Images of Science, Language, and Power: A Post-Modern Optic, or Just Bad Eyesight?

◆

Introduction

Almost four centuries ago, Francis Bacon put forth a vision of a kind of knowledge, a veridical reading of the Book of Nature that would enable the translation of knowledge to power, and thus restore man's proper dominion over nature. In the intervening centuries, Bacon's rhetoric of dominion served simultaneously to describe and to foster the growth of a social institution that succeeded in transforming that vision into material reality. In the late twentieth century, modern science has come into its maturity, producing technologies next to which Bacon's own vision seems modest. None of the early architects of modern science ever anticipated a day when men would acquire the kind of control over nature that would enable them, should they so chose, to destroy the human species, or, if not destroy it, shape its future according to their fantasies of a personal best. With a few exceptions, it was not until the twentieth century that men dared to dream of the power over life and death that is today enabled by modern physics and promised by modern biology.

Yet, just as such dreams appear on the verge of realization, their founding mythology has, for many, lost all credibility. In the late twentieth century, we can no longer appeal to a veridical reading—

Originally published in *Poetics Today* 12(2): 227–243 (1991). A longer version of this argument has appeared under the title, "Physics and the Emergence of Molecular Biology," *J. History of Biology* 23(3): 390–409, 1990.

not of Nature, nor even of more ordinary texts—to explain what has made such realization possible. Instead, we have learned to read that very mythology for its particular forms of intentionality and subjectivity—expressing a will to knowledge that is itself socially constituted, born of relations of power, and siring a discourse with the power to transform those relations. In this new reading of the relations between science and nature, we have begun to unravel the insidious power of discourse to generate its own forms of truth, to shape the future of human bodies not through genetics, but through politics. Transducing the project of "dominating nature" into a metaphor, genetics itself comes to be seen more as a construct that is simultaneously excrescence and vehicle of particular forms of power relations between speaking subjects than as the founding essence of human nature, that is, having more to do with social than with chemical mechanisms. In a word, we have become postmodernists.

Yet there is a striking irony in the fact that, at the very moment when the Baconian equation between knowledge and power has come to assume such ominous proportions, the basic facts of its conspicuous force have receded from view; that it is at this point in history that so much of our collective attention has shifted instead to a different equation between knowledge and power, away from its material force and toward the discursive mechanics of knowledge. This inattention to material consequences is not so much the subject of my paper, as it is the object of my concerns. The basic problem, put as succinctly as I know how, is this: If classical scientific realism must be rejected (as I agree it must), and if contemporary analytics take the domain of power, and hence of knowledge, to be the purely social body, then we are left with no way of understanding how it happened that what began as socially constituted dream has been able to insinuate itself into material reality, inducing the objects of a nondiscursive regime to behave as reflections of our own purely discursive regime. To put it yet more bluntly, we are left entirely unable to account for the material and technological efficacy of those domains of modern science that have what Foucault calls a "high epistemological profile" unless we take that efficacy as unproblematic—a move that is, in my view, tantamount to granting the veridicality of classical scientific realism.

To avoid this retreat, I suggest that it is necessary to reexamine the question of the *forms* of scientific theory (cf. Hacking 1987), only

this time, in simultaneous and dual relation to the subjects they speak for and the objects they speak to. Scientific theories, I want to argue, may be thought of as tools; like ordinary tools, they reflect in their very form the agency and intentionality of their makers. In the forms of theory, one can see not only the discourses they embody, but also the structures facilitating their adequacy in meeting the goals for which they have been designed. Good theories are theories that work, that facilitate the kinds of action for which they are intended: They enable an "us" to act in and on the world in ways that a "we" deems desirable. As such, they reflect both the subjectivity of human objectives and the objects of human action. And because the forms of human objectives and the objects of their actions are so variable, so too should be the forms of theory available to us, even of theories that "work." In other words, although scientific theories cannot be understood as faithful reflections of either culture or nature, perhaps they can be understood as good enough reflections of the forms of interaction that speaking and desiring social actors seek to implement with that mute but nonetheless responsive world of actors we call nature—representing, in short, neither nature "as it is," nor even some unquestioned and unquestionable notion of instrumentality, but rather a network of intentionality, consequentiality, and the relations between them that determine even the meaning of instrumentality. To speak of intentionality is immediately to invoke a world of social actors embedded in relations of social and material power, but to speak of consequentiality, where the objects of our actions are prelinguistic, is to invoke a different kind of world—a world of material things that, once called forth (that is, named), become subject to more mundane forms of physical power.

In an effort to illustrate the conjoint workings of intentionality and consequentiality, of social and material forms of power, I want here to locate a small but critical episode of recent scientific history within this general framework. In particular, I want to recapitulate an aspect of the early history of a scientific movement that, over the last few decades, has grown to transform the very meaning of biological science. I am referring, of course, to molecular biology[1];

[1] According to popular usage, molecular biology begins with the identification of

my particular focus is on its early conceptual and social relations to physics.

I begin by identifying the critical shifts in twentieth-century biology that can be attributed to molecular biology:

1. Relocation of the essence (or basis) of life. The locus of vital activity was now to be sought neither in the physical-chemical interactions and structures of the organism-niche complex, of the organism itself, nor even of the cell, but rather, in the physical-chemical structure of one particular component of the cell; namely, in the genetic material, or more exactly, in the gene.[2]

2. Redefinition of life. From the complex of characteristics of living organisms that have historically been employed to define life (for example, growth and development, reproduction, irritability), life came to be redefined by molecular biologists as the "instructions [or information] encoded in the genes" or more simply, as a code, or "code-script." As J. D. Bernal put it twenty-two years ago, "Life is beginning to cease to be a mystery and becoming . . . a cryptogram, a puzzle, a code."[3]

3. Recasting of the goals of biological science. One popular description of the distinctiveness of biological science since the end of the nineteenth century is cast in terms of the shift from an observational science to an experimental one. This shift might alternatively be expressed as a shift in aim from representation to intervention (or from description to control). But the shift that I think can fairly be attributed to molecular biology is a more subtle one: It is not so much from representation to intervention, but from intervention in the

DNA as the material basis of genetics, although numerous authors have argued for an expanded (and earlier) usage to include the biological and chemical study of DNA, RNA, and protein (see, for example, Kendrew 1967; Abir-Am 1985). I would suggest, however, that it is from classical genetics that the clearest and most important lines of continuity can be traced. Accordingly, I use the term here to refer to the study of molecular structure and the activation of genetic information residing in DNA.

[2] It should be noted that this move distinguishes molecular biology (as well as its antecedent traditions in classical genetics) from other reductionist research agendas in twentieth-century biological science; that is, from programs that have sought the physical-chemical basis of biological phenomena in different kinds of structures and processes, located, for example, in the cell, in the organism, or in organism-environment interactions. In other words, the shift that I am identifying with the molecular revolution represents the selection of one particular theoretical orientation among a number of others that would also qualify as reductionist in the usual sense of the term.

[3] Renato Dulbecco, 1987:17; Bernal, 1967:13. For a historical overview of earlier definitions of life, see Hall, (1969); Smith, 1976; and for a discussion of the particular redefinition of life attributable to molecular biology, see Yoxen 1982.

larger and indirect sense of the term appropriate to the aspirations of most late nineteenth-century and early twentieth-century biological science to the particular conception of intervention or control that promises effective mastery over the processes of making and remaking life.

I suggest that these three shifts can be taken as definitional of the conceptual transformation represented by molecular biology. They occurred in parallel, and in mutual interdependency. H. J. Muller, an early advocate of all three of these shifts, articulated their interconnections unambiguously. His argument for the gene as the basis of life, and mutation as the central problem of biology, was from the start framed in terms of the promise that "a control of [mutation] might obviously place the process of evolution in our hands."[4] J. D. Bernal's quote (above) goes on in a similar vein: "Life is . . . becoming . . . a cryptogram, a puzzle, a code *that can be broken, a working model that sooner or later can be made*" (italics mine).[5] This essay examines the particular role that physics and physicists played in facilitating these shifts.

A great deal, almost certainly too much, has been made of the importance of physics and physicists in the emergence of molecular biology, especially of their contribution of technical and cognitive skills. But here, I want to argue that physics and physicists provided a resource of far greater import for the success of molecular biology than any particular skills; namely, they provided social authority. That authority was, of course, acquired in the first place through the formidable displays of technological and instrumental power issuing from physics itself, but this initially technical authority soon became available for deployment far beyond the domain of their technical triumphs; it became, in short, an authority that could be

[4] Quoted in Pauly (1987:179).

[5] It is important here to distinguish the particular ambitions associated with molecular biology from more general aspirations toward control and intervention in biological science. Just as most biological scientists were committed to some form of materialism by the end of the nineteenth century, so too, had their efforts already both aimed at and resulted in visible technological consequences. These consequences, however, had been of a different order than those both envisioned, and now virtually promised, by molecular biology—directed more to maintenance and regulation than to the creation, or imitation, of life.

called upon for the essentially social process of reframing the character and goals of biological science. This borrowing proceeded in a variety of ways—first, through the borrowing of an agenda that was seen as looking like the agenda of physics; second, by borrowing the language and attitude of physicists; and finally, by borrowing the very names of physicists.

Indeed, even the borrowing of purely technical expertise, ostensibly in the name of making biology "better," was instrumental in reframing biology, in making it different. And in all this borrowing—of agenda, of language, attitude, names, technique—the material underpinning of the social power of twentieth-century physics, and physicists, lay in close view, evoking in some at least the hope that that too, the technological prowess of physics, could also be borrowed. In short, I am arguing that the intersection of physics and early molecular biology provides an illustration of the conjoint workings of the Baconian *and* the Foucauldian equations between knowledge and power; that is, of the social and material dimensions of the knowledge/power nexus.

To make this argument, I want to review two moments in the prehistory and early history of molecular biology. First, I want to explore the vision of H. J. Muller, a classical geneticist who has been rightly claimed as a major forerunner of molecular biology; and then more briefly, to consider the influence of the physicist Erwin Schroedinger.

Born in 1890, Muller is known to biologists, first, for his work with T. H. Morgan in establishing the chromosomal basis of inheritance and perhaps foremost for his development of the techniques of x-ray-induced mutagenesis in 1927, for which he was later awarded the Nobel Prize. But his primary importance to the history of biology may well lie in his early and forceful advocacy of a program for biological science premised on all three of the shifts I earlier attributed to molecular biology. For my purposes however, his real interest lies in the clarity of his vision and in its explicit dependence on a parallelism with current developments in physics.[6]

[6] To frame Muller's thinking, a few historical markers might be helpful: 1896, radioactivity discovered; 1900, rediscovery of Mendelian "factors" (particulate genetic elements); 1901, spontaneous transmutation of elements observed by Ernest Rutherford and Frederick Soddy (so named by Soddy in 1901); 1902, identification of

In the year 1916—just five years after Rutherford's discovery of the atomic nucleus, fifteen years after the observation of spontaneous transmutation of elements, and three years before the first artificial transmutation was induced—Muller, a new Ph.D., drew attention in a public address to the

> curious similarity which exists between two of the main problems of physics and of biology. The central problem of biological evolution is the nature of *mutation*, but hitherto the occurrence of this has been wholly refractory and impossible to influence by artificial means, tho' a control of it might obviously place the process of evolution in our hands. Likewise, in physics, one of the most important problems is that of the *transmutation* of the elements, as illustrated especially by radium, but as yet this transmutation goes on quite unalterably and of its own accord, tho' if a means were found of influencing it, we might have inanimate matter practically at our disposal, and would hold the key to unthinkable stores of concentrated energy that would render possible any achievement with inanimate things. Mutation and Transmutation—the two keystones of our rainbow bridges to power (quoted in Carlson 1971:160–61).

And five years later, he wrote: "It is not physics alone which has its quantum theory. Biological evolution too has its quanta—these are the individual mutations" (Ibid, p. 161). By 1926, Muller was ready to formulate the strong form of his argument for "The Gene as the Basis of Life": In a closely reasoned polemic, Muller here argued that the gene can be viewed as, in effect, a biological atom; it is that entity which is solely responsible for maintaining physiological and morphological properties, for the evolution of higher life forms, for growth and variation. On these grounds, he inferred that the gene must be temporally as well as logically prior to all living forms. For the key to "penetrating" these fundamental units of life, he concludes, we must look to the study of mutations. His somewhat rhapsodic language is worth noting:

> The secret of this immutable (but mutation-permitting) autocatalytic arrangement of gene parts may perhaps be reached first by an upward thrust of pure physical chemistry, or perhaps by biologists reaching down

nuclear chromosomes as the site of genetic factors; 1909, coinage of the term "gene"; 1911, Rutherford's discovery of the atomic nucleus; 1919, Rutherford induces the first artificial transformation.

with physico-chemical tools through the chromosome, the virus, of the bacteriophage. . . . The beginning of the pathway to the micro-cosmic realm of gene-mutation study thus lies before us. It is a difficult path, but with the aid of the necromancy of science, it must be penetrated.

We cannot leave forever inviolate in their recondite recesses those invisibly small yet fundamental particles, the genes, for from these genes, . . . there radiate continually those forces, far-reaching, orderly, but elusive, that make and unmake our living worlds (Muller 1926:200–202).

Only one year later, Muller succeeded in his quest: Employing not alpha rays, but X rays, he found a way to induce mutagenesis. Just eight years after Rutherford's success in inducing artificial transmutation, and eleven years after articulating his own ambitions for establishing the keystone to that other "rainbow bridge to power," he published a paper, entitled, appropriately enough, "The Artificial Transmutation of the Gene." Using essentially the identical tool that Rutherford had used, he had found a handle on those forces, "radiating" from the gene, "that make and unmake our living worlds." "In conclusion," he wrote,

the attention of those working along classical genetic lines may be drawn to the opportunity, afforded them by the use of X rays, of creating in their chosen organisms a series of artificial racies for use in the study of genetic . . . phenomena . . . Similarly, for the practical breeder, it is hoped that the method will ultimately prove useful. The time is not ripe to discuss here such possibilities with reference to the human species (Muller 1927:87).

Muller was now in a position to meet physics, and physicists, eye-to-eye. He had a theoretical conception of the relation of the gene to living organisms directly paralleling the relation of the atom to inanimate matter, with a technology to match. Now, it might be possible to close the gap. However, his assessment of American capitalism persuaded him that the United States was not ready for his ambitious program to improve upon the blind, "trial and error," mechanism of natural selection (Muller 1935:45) and "refashion [the living world] to man's own advantage" (Muller 1935:70), and he emigrated to the Soviet Union. In 1936, at the physics section of the meeting of the USSR Academy of Sciences, he made his pitch to physicists to join forces with him and his colleagues in the "conquest over matter, space, life, mind, and the other hitherto inscru-

table riddles of existence" (Muller 1935:48–9). "The evidence . . . indicates," he begins, "that it is in the tiny particles of heredity—the genes—that the chief secrets of living matter . . . are contained." These genes—he calls them the "ultimate particles of life"—"have properties which are most unique from the standpoint of physics"—indeed, "so peculiar are [they] . . . that it may well be that an elucidation of them may throw light not only on the most fundamental questions of biology, but even on fundamental questions of physics as well" (Muller 1936:214).

Two properties in particular stood out as demanding explanation, and also as promising new insights into both physics and biology: the problem of "specific auto-attraction of like with like" (that is, the alignment of chromosomes), and the problem of "auto-synthesis" (that is, replication). It is through these two mechanisms that the gene becomes "a modeller . . . an active arranger of material . . . after its own pattern." Noting the analogy to crystallization, he notes also a crucial difference in the magnitude of specificity that needs, here, to be preserved in replication: "Each of these [thousands of different] genes has to reproduce its own specific pattern out of the surrounding material common to them all." Only a "fundamental feature of gene structure" can explain this feat. "It is this," he concludes, "which lies at the bottom of both growth, reproduction, and heredity."[7] He even suggests that a fruitful line of approach "might

[7] A more complete excerpt reads:

Each gene, reacting with the . . . surrounding material . . . exerts such a selectively organizing effect upon this material as to cause the synthesis, next to itself, of another molecular or super-molecular structure, quite identical in composition with the given gene itself. The gene is, as it were, a modeller, and it forms an image, a copy of itself . . .; it is an active arranger of material . . . after its own pattern. The analogy to crystallization hardly carries us far enough in explanation of the above phenomenon when we remember that there are thousands of genes . . . having different patterns, in every cell nucleus, and that each of these genes has to reproduce its own specific pattern out of surrounding material common to them all. When . . . a sudden change in the composition ("pattern") of the gene takes place, . . . a "mutation," then the gene of the new type . . . now reproduces precisely the new pattern. This shows that the copying property depends upon some more fundamental feature of gene structure that does the specific pattern which the gene has. . . . It is this fact which gives the possibility of biological evolution and which has allowed living matter ultimately to become so very much more highly organized than non-living. It is this which lies at the bottom of both growth, reproduction and heredity (Muller, 1936: 211–12).

be through the study of x-ray diffraction patterns [such as carried out by Astbury]—more specifically, he suggests that physicists attempt x-ray diffraction studies of the viral substance identified by Stanley, which, he infers, "represents a certain kind of gene."[8] He concludes, "The geneticist himself is helpless to analyze these properties further. Here the physicist as well as the chemist must step in. Who will volunteer to do so?"

Muller's plea went unheeded, and for the most part, unheard. True, it was delivered in the Soviet Union. But the fact that it was also (and promptly) published in the *Scientific Monthly* suggests other factors as well. One such factor is that physicists were, in the late thirties, otherwise occupied. But also, I would argue that Muller, being a mere biologist, lacked the authority either to command the attention of physicists themselves, or to persuade other biologists to a program that most biologists of the time found totally alien. Eight years later, a remarkably similar plea was reissued—this time, not by a biologist, but by a physicist known worldwide for his role in the development of quantum mechanics. In 1944, Erwin Schroedinger, apparently entirely unaware of Muller's arguments, published his own speculations about the basis of life in a thin volume entitled *What Is Life?* that echoed many of the same thoughts. This work did not fall on deaf ears; indeed, it has been described as the "Uncle Tom's Cabin of the revolution in biology that . . . left molecular biology as its legacy" (Stent 1968:392).

Like Muller, Schroedinger quickly identifies the chromosome fiber as "the most vital part of the organism" (1944:4), as "the material carrier of life" (1944:5). Indeed, his basic argument about the role of the gene as the basis of life—that the distinctive characteristics of living organisms reside in the fidelity of transmission of genetic information—repeats virtually all of Muller's arguments, sometimes even in almost identical language. He, like Muller, suggests that one should look to the study of mutation for the key to understanding both the structure and mechanism of genes, remarking that

> The significant fact [of mutations] is the discontinuity. It reminds a physicist of quantum theory . . . He would be inclined to call . . . mutation

[8] The proximity to Watson and Crick's actual endeavor should be noted.

theory, figuratively, the quantum theory of biology (Schroedinger 1944:36).

For the most part, however, Schroedinger's language is different from Muller's, as are his theoretical tools: Where one speaks of code, or code-script, the other speaks of "pattern"; where one points to the mechanism of auto-synthesis and auto-attraction as the heart of the dilemma of life, the other points to the uncanny reliability of the "production of order from order" and the evasion of the laws of statistical thermodynamics. But perhaps the most significant difference between the two is to be found in Schroedinger's total silence on the question of practical consequences. He does not envision molding the evolutionary future of the human race; rather, he speaks only of his "keen longing for unified, all-embracing knowledge."

Schroedinger does not, in fact, solve the problem he identifies as the central problem of life, and it is well known that the details he does have to offer on gene structure were based on an already discredited work of Max Delbruck's (in fact, discredited by Muller himself).[9] In retrospect, one would have to say that Schroedinger not

[9] Indeed, Schroedinger's argument seems to build not toward a solution, but rather to a refutation of Nils Bohr's earlier contention of an inherent barrier to understanding the secrets of life—a barrier he claimed to be predicted by an extension of the principle of complementarity. In other words, I am suggesting that a proper understanding of Schroedinger's contribution requires reference to Bohr's earlier (and opposing) bid for a conceptual unification of biology with physics. Bohr had argued that "We should doubtless kill an animal if we tried to carry the investigation of its organs so far that we could tell the part played by the single atoms in vital functions." He therefore concluded:

In every experiment on living organisms there must remain some uncertainty as regards the physical conditions to which they are subjected, and the idea suggests itself that the minimal freedom we must allow the organism will be just large enough to permit it, so to say, to hide its ultimate secrets from us. On this view, the very existence of life must in biology be considered as an elementary fact, just as in atomic physics the existence of the quantum of action has to be taken as a basic fact that cannot be derived from ordinary mechanical physics (Bohr 1958:9).

In contrast, the central point for Schroedinger seems to be that living matter is distinctive from inanimate matter only in being *too* lawful, in its apparent excess of order; far from constituting a barrier to our understanding, quantum mechanics is

only did not solve the problem of life, but that the particular "paradox" he identified as lying at the heart of this problem effectively dissolved in the face of subsequent developments. Nor can his book be said to have provided any actual suggestions for further research that proved to be useful. As Max Perutz has written, "A close study ... has shown me that what was true in his book was not original, and most of what was original was known not to be true even when it was written" (1989:231). Nonetheless, the influence the book had on the subsequent course of molecular biology is undeniable. It has been credited by most of the physicists who turned to molecular biology after the war as a critical if not decisive factor in their move to biology (Stent, Wilkins, Crick, Benzer, etc.). In addition, many of the biologists who came to star in the molecular revolution—Watson, Luria, Hershey, Jacob—have also cited the influence of this book. The question that needs answering is, What kind of influence?

Such physicists as Stent, Benzer, and, before them, Delbruck were excited by the promise of new laws; others, like Crick, were lured by the promise of a "foundation of certainty" grounded in already established laws. Almost as if countering Nils Bohr's contention of natural limits to our capacity to understand the fact of life directly, Crick writes that his own motivation was "to try to show that areas apparently too mysterious to be explained by physics and chemistry, could in fact be so explained" (Olby 1970: 943). For this, Schroedinger's book was nothing if not supportive. As Crick himself

> remarked, "Its main point was one that only a physicist would feel it necessary to make, but the book ... conveyed in an exciting way the idea that, in biology, molecular explanations were just around the corner. This had been said before, but Schroedinger's book was very timely."
> ... (from Perutz 1989:216).

It was indeed. In fact, timing may provide us with the key to

precisely the branch of physics that can resolve this paradox. In closing, he writes:

> We seem to arrive at the ridiculous conclusion that the clue to the understanding of life is that it is based on a pure mechanism, a 'clock work'. . . . But please do not accuse me of calling the chromosome fibres just the cogs of the organic machine—at least not without a reference to the profound physical theories on which the simile is based . . . the single cog is not of coarse human make, but is the finest masterpiece ever achieved along the lines of the Lord's quantum mechanics (Schroedinger 1944:91).

understanding how it was that Schroedinger's legacy depended so little on the utility of any of his particular biological arguments and so much on disciplinary politics. To physicists, he promoted the idea that at least one area of biology was worthy of their talents (that is, genetics), at a time when many were seeking just such an alternative. As Jacob has written,

After the Second World War, many young physicists were shocked by the military use made of atomic energy. Some . . . moreover, were dissatisfied by the direction taken in . . . nuclear physics . . . Just to hear one of the leaders in quantum mechanics asking "What is Life?" . . . was enough to fire the enthusiasm of certain young physicists and to bestow some sort of legitimacy on biology. Their ambition and interest were limited to a single problem: the physical basis of genetic information (Jacob 1973:259–60).

World War II provided a powerful impetus for some not-so-young physicists as well—most notably perhaps, Leo Szilard—arguably an even more important influence on the actual development of molecular biology than either Schroedinger or Bohr. All these physicists shared the disciplinary and intellectual habits of the world they had left behind—habits that led them to frame biological problems in the particular terms they could understand, in the terms that could lead to what they could recognize as a "solution." Szilard was explicit about what he believed he brought to biology: "not any skills acquired in physics, but rather an attitude: the conviction which few biologists had at the time, that mysteries can be solved." Life (development, reproduction, etc.) was not a problem that could be "solved"; the physical basis of genetic information was.

To biologists whose own ambitions (either personal or intellectual) resonated with such a stance, the authority of these physicists provided an invaluable resource in promoting just that transformation of attitude and mind-set in their own profession that Muller had earlier sought but had been unauthorized to effect. Indeed, it was precisely this transformation—this relocation and redefinition of life—that Watson and Crick depended upon for success in their quest for "the secret of life," and which their success, in turn, did so much to cement. Let me explain.

The story of Watson and Crick invites the interest it does—be it in film, autobiography, or history of science—not simply because of

the "greatness of their discovery," but also, because of their particular unlikely casting as scientific heroes. In one of the most perceptive early accounts of this story, Donald Fleming poses for

> himself the double question of why Crick and Watson blithely conceived of their research in these provocatively unfashionable terms [that is, as the quest for the secret of life] and what fed their expectations of victory. . . . How had they come to form these superbly arrogant ambitions, unbuttressed by any truly compelling evidence and offering total defiance to contemporary standards of good taste in biological discourse (Fleming 1968:152-55).

Fleming's answer is that it was above all Schroedinger's imprimatur, along with that of Szilard and Delbruck, that permitted and legitimated such a conception. As Watson himself recalls, "from the moment I read Schroedinger's *What Is Life?* . . . I became polarized toward finding out the secret of the gene" (Watson 1966:239).

In my version of the story, Watson and Crick were not unlikely, but in fact rather ordinary scientific heroes. Like all good scientists, they made use of the resources that were available to them, in the process, adapting their aims to fit. They drew on certain disciplines—especially, on crystallography, physical chemistry, and biochemistry—as well as on certain individual crystallographers, physical chemists, and biochemists for crucial technical information and concrete assistance in employing these borrowed tools to decode the structure of DNA. But they drew on modern physics, and physicists, for the authority to license their formulation of their quest and, even more importantly, their representation of their accomplishments. The important question is not so much about their ambitions but about the scope of their success. It is not even about their claim for a mechanism of genetic replication, or even for a physical basis of genetic information, but rather the claim that mechanism *is* "the secret of life." For the plausibility that *this* claim acquired, the authority of modern physics was critical, not only for Watson and Crick, but also for the larger cultural transformation of biology that had already to have begun for such a claim to find general acceptance.

Given this representation of the secret of life as the mechanism of genetic replication led, the elucidation of that mechanism inevitably led to the conclusion that life itself was not complex, as had

been thought, but simple—indeed simple beyond our wildest dreams. The only secret of nature was that there were no secrets, and now that secret was out.[10]

This larger transformation—of language, of focus, of methodology, of the very definitions of what constitute legitimate questions and adequate answers—is what I take to be the hallmark of molecular biology. Born in the conceptual shifts I named at the start of this essay, nourished by multiple kinds of success (or power)—at first only in physics, but eventually in biology as well—it soon gathered enough momentum to reset the future course of biology. In its wake, it left the ratification of an entire set of new beliefs: belief in the absolute adequacy not simply of materialism, but of a particular kind of (linear, causal) mechanism; belief in the incontrovertible value of simplicity; belief in the unitary character of truth; and, finally, belief in the simultaneous equations between power and knowledge and between virtue and power. From the vantage point of this new constellation of beliefs, the older biology (and many of the older biologists) became objects of disdain; they had lacked, above all, an understanding of scientific progress. Francis Crick's complaint about fencing ["stab, stab, stab, but no penetration"][11] was *intended* to apply to biology.

In its early stages, this transformation drew at one and the same time on the politics of the disciplines, and on more global politics of knowledge. No one in the late 1940s and early 1950s could ignore just how much power at least some kinds of knowledge could deliver. To quote Crick again, "We [knew] how to blow ourselves up, but we still [didn't] know how we reproduce ourselves" (BBC film).[12]

[10] There is no doubt that the triumph of the double helix would have had major significance no matter how it had been described, but its particular representation allowed molecular biologists an assumption of scientific hegemony heretofore unfamiliar in biology. Having solved the problem of life—as Monod put it, "in principle if not in all details"—there was no longer room for doubt, for uncertainty, for questions unanswerable within that framework, even for data that would not fit, or for another conception of biology. A science that had historically been characterized by diversity—perhaps like the life it presumed to study—became if not totally monolithic, very close to it. Molecular biology became synonymous with scientific biology.

[11] From the recent film version of this story, *The Race to the Double Helix*, to which Francis Crick served as advisor.

[12] An earlier remark of Crick's linked the problem of reproduction with subatomic physics in terms strikingly reminiscent of Muller's own associations. In a 1968 in-

But it may well be that the very shock of the atomic bomb made both physicists and biologists peculiarly reticent about the general issue of technological/instrumental goals in science. Without question, the horror of Nazi experiments in eugenics made that particular word unspeakable and the idea behind it virtually unthinkable. The fact is that the particular agenda that had been so clear to Muller was, after World War II, nowhere in oral or written evidence. Indeed, there was virtually no mention of any practical consequences of a new approach to biology, at least not until the war on cancer. One might say that there didn't need to be. The technological prowess that underwrote the authority of physicists after World War II was perhaps too much in evidence, and too worrisome, to need or want to mention. The attraction of a science of life over a science of death was palpable; in like terms, so was the attraction of pure over applied science.

But the technological potency of scientific knowledge has never depended directly on styles of scientific rhetoric, and despite the silence of early molecular biologists on these issues, it is precisely this—the enormous technological and social power promised by modern molecular biology—that engages our concern today. In a word, I am saying that that power should come as no surprise.

The reason that the technological prowess of molecular biology is not a surprise is simple: In the first place, it *was* anticipated; in the second place, I am suggesting that its pursuit was written into the genetic program as it has evolved over the past fifty years—not into the sequence of nucleotides, but into the forms of knowledge that biology, following physics, has taken as norm. As Muller dimly intuited so many years ago, theories that structure our understanding in terms of linear causal chains—that posit ontological cores as master molecules, blueprints, or "central offices"—serve to focus our attention on equally linear chains of consequences. With life relocated in genes, and redefined in terms of their informational content, the project of "refashioning" "life," of redirecting the future course of evolution, is recast as a manageable and doable project. Or, to

terview with Robert Olby, he turned to the question of how "the egg form[s] the organism" and said:

"If you look at the problem in its full horror, it's like Rutherford surveying the atom at the beginning of subatomic physics" (quoted in Judson, 1979:209).

put it differently, the kind of theory that would provide a workable guide for such a project is precisely a theory that focuses on the causal relations between identifiable and controllable elements. Other processes, less identifiable, and less controllable, are bracketed in the double name of intellectual economy and technological efficacy. In this way, the very meaning of knowledge—what counts as knowledge—is shaped by a tacit instrumental mandate, perhaps even when that mandate has been forgotten.

Over the past thirty-five years, the world according to molecular biology has become progressively more complex, revealing intricacies and convolutions undreamt of in the central dogma of 1953. And as molecular biology has moved into the domain of developmental biology, the inadequacies of the core concept of the genome as a master program or blueprint have become especially visible. Nevertheless, the momentum behind this basic view remains powerful—powerful enough to maintain an effectively single-minded focus on the (as it were, autonomous) force of genes, even in the face of an increasing awareness of the complexities of genetic organization. Today's dramatic growth in the technology of nucleotide sequencing and genetic mapping works to further catalyze this earlier momentum, in fact, carrying us right into the human genome project. Growing out of the past, such a project points our way into the future. Drawing simultaneously and conjointly on the material *and* social dimensions of the knowledge-power nexus, it works to realize the ambitions that fueled its development in the first place. Finally, we are in a position to fulfill Warren Weaver's early dream of "a new science of man" and even (though most biologists still prefer not to talk about it) to realize Muller's dream of reshaping the future course of human evolution. We are in this position not simply because we have developed sufficient technological wherewithal, but also because those with the technical expertise have acquired the concomitant political and social power to implement, or sell, the goals appropriate to that technology. When Watson was invited to direct the new National Institute of Health Office of Human Genome Research, a program that is currently being hailed as the "Manhattan Project" of the life sciences, he confessed that the appeal of "starting with the double helix and going up to the double helical structure of man" was undeniable. I am suggesting not only that the double helix provided the first rung of Watson's ladder to

man, but also that DNA is itself a ladder that has "always already" pointed to man, with a directionality, intentionality, and a particular kind of interventional capability built into its originary conception.

A seemingly perverse juxtaposition—between the history of the unfolding of molecular biology and a story from another time, and another place, that engaged Foucault's attention—might serve to close this essay, if only to underscore what makes these stories different. In 1836 a Norman peasant, Pierre Riviere, was convicted of murdering his pregnant mother, his sister, and his brother. What captured Foucault's interest here was the memoire Riviere left, a memoire written before his fatal act. Foucault writes:

> Pierre Riviere was the subject of the memoir in a dual sense; it was he who remembered. . . . He contrived the engineering of the narrative/ murder as both projectile and target, he was propelled by the working of the mechanism into the real murder. And, after all, he was the author of it all in a dual sense; author of the crime and author of the text (Foucault 1975:209).

The case file that Foucault assembled, he says, gives us

> a key to the relations of power, domination and conflict within which discourses emerge and function, and hence provide[s] material for a potential analysis of discourse (even of scientific discourses) which may be both tactical and political, and therefore strategic (1975: xi–xxii).

By contrast, an adequate analysis of scientific discourses with the high epistemological profile of molecular biology requires recognition of a crucial difference between these two stories—namely, the fact that between the projectile and target of molecular biology lies another world, not of human actors nor even of human construction, but of material things, available to be called forth by the names we give them, but constrained in their responses by their own laws of behavior. The trick that has given modern science so much of its power is the recognition of the need to actively engage this material—above all, to engage it in ways that permit an effective arrangement of its constituents into an instrument that enables the projectile to meet its predesignated target. Perhaps it is the choice of target that we need to examine most of all.

PART III

6

Language and Ideology in Evolutionary Theory

♦

Part I: Reading Cultural Norms into Natural Law

In the mid-twentieth century, biology became a "mature science"—
that is to say, it succeeded, finally, in breaking through the formi-
dable barrier of "life" that had heretofore precluded it from fully
joining the mechanico-reductive tradition of the physical sciences.
For the first time in history, the "secret of life" could credibly be
claimed to have been solved: Living beings—presumably including
humans along with the rest of the animal kingdom—came to be
understood as (mere) chemical machines.

But the chemical machine that constitutes a living organism is
unlike machines of the eighteenth and nineteenth centuries—not a
machine capable only of executing the purposes of its maker, but a
machine endowed with its own purpose. In short, it is a machine
of the twentieth century, a cybernetic machine par excellence: ab-
solutely autonomous, capable of constructing itself, maintaining it-
self, and reproducing itself. As Jacques Monod has explained,

the entire system is totally, intensely conservative, locked into itself,
utterly impervious to any "hints" from the outside world. Through its

A version of this essay appears in *The Boundaries of Humanity: Humans, Animals,
Machines*, ed. J.J. Sheehan and M. Sosna (Berkeley: U.C. Press, 1991). Partial support
for this research was provided by the National Science Foundation, Visiting Profes-
sorship for Women, #8410007-RII.

properties, by the microscopic clockwork function that establishes between DNA and protein, as between organism and medium, an entirely one-way relationship, this system obviously defies any "dialectical" description. It is not Hegelian at all, but thoroughly Cartesian: the cell is indeed a *machine* (1972:110–111).

The purpose, the sole purpose, of this machine is its own survival and reproduction, or perhaps more accurately put, the survival and reproduction of the DNA that is said both to program and to "dictate" its operation. In Dawkins's terms, an organism is a "survival machine"—a "lumbering robot" constructed to house its genes, those "engines of self-preservation" that have as their primary property inherent "selfishness." They are

> sealed off from the outside world, communicating with it by tortuous indirect routes, manipulating it by remote control. They are in you and in me; they created us, body and mind; and their preservation is the ultimate rationale for our existence (Dawkins 1976:21).

With this description, man himself has become a machine, but perhaps it might alternatively be said that the machine itself has become man.

The general question I want to put before you is this: To what extent can our contemporary scientific description of animate forms, culminating in the description of man as a chemical machine, be said to be strictly technical, and to what extent does it actually encode particular conceptions of man—conceptions that derive not so much from a technical domain as from a social, political, and even psychological domain? Have animate, even human, forms finally been successfully deanimated and mechanised, or have their mechanical representations themselves been inadvertently animated, subtly recast in particular images of man?

I suggest that traces of such images might be found in virtually all scientific representations of nature, but are perhaps especially conspicuous in our descriptions of the evolution of animate forms—even in those representations that make the greatest claims to conceptual neutrality. It is no secret that evolutionary biology has provided a particularly fertile field for those who seek to demonstrate the impact of social expectations on scientific theory. Indeed, it might be said that it is precisely for this reason that modern evolutionary

theorists have sought so strenuously to place their discipline on a firm scientific footing. Population genetics and mathematical ecology are the two subdisciplines that have been constructed to meet this need—to provide a rigorous substructure for all of evolutionary biology. The general methodological assumption that underlies both of these subdisciplines can be described as atomic individualism; that is, the assumption that a composite property of a system both can and should be represented by the aggregation of properties inhering in the individual atoms constituting that system, appropriately modified by their pair-wise or higher order interactions.[1] As is conventional in biological discourse, I take the individual atom to be, alternatively, the organism or the gene. I want to focus, in this essay, on the particular attributes that are customarily assumed to characterize the basic unit of analysis, that is, the individual organism or gene.

In other words, my focus here will be on the practice rather than the principle of atomic individualism in evolutionary theory. Others have argued for an ideological load in the very assumptions of this methodological orientation (see, for example, Wimsatt, 1980), but here I wish to bracket such questions and focus instead on the lack of neutrality in its actual applications. In particular, I claim that properties of the "individual" that are generally assumed to be necessary are in fact contingent, drawn not from nature, but from our own social and psychosocial heritage. More specifically yet, I will argue that much of contemporary evolutionary theory relies on a

[1] The basic claim of atomic individualism can be schematically expressed as follows:

$$X = \sum_i x_i + \sum_{ij} x_{ij} + \sum_{ijk} x_{ijk} + \ldots$$

where successive orders of interaction are represented by the terms x_{ij}, x_{ijk}, x_{ijkl}, etc.

The actual implementation of this methodology depends, however, on three implicit assumptions:

- The first term in the series is primary.
- All relevant interactions are included in the subsequent summations, and finally, that
- The series converges (that is, there are no unexpected effects from neglected higher order terms).

Ultimately, it seems to me that the application of all three of these assumptions to evolutionary theory is subject to serious question. My particular focus here, however, is on the adequacy of the first two assumptions.

representation of the "individual"—be it the organism or the gene—that is cast in the particular image of man we might call the "Hobbesian man": simultaneously autonomous and oppositional, connected to the world in which it finds itself not by the promise of life and growth, but primarily by the threat of death and loss—its first and foremost need being the defense of its boundaries. In psychological terms, we might say that such an individual betrays an idealized conception of autonomy, one that presupposes a radical conception of self, and that simultaneously attributes to the relation between self and other an automatic negative valence—a relation, finally, not so much of independence as of dynamic opposition.

I claim that this psychosocial load is carried into evolutionary theory not by explicit intention but by language—by tacit linguistic conventions that privilege the autonomy of the individual at the expense of biologically constitutive interactions, and at the same time, obscure the logical distinction between autonomy and opposition. In this, they support the characterization of the biological individual as somehow "intrinsically" competitive—as if autonomy and competition were semantically equivalent, collapsed into one by that fundamentally ambiguous concept, self-interest. Accordingly, it is the language of autonomy and opposition in contemporary evolutionary theory that is the specific object of my concern.

Discourse of Self and Other

To introduce this discussion, I begin with a relatively accessible example of actual confusion between autonomy and opposition that is found not in the theoretical literature per se, but in a more general genre of scientific discourse, at once popularizing and prescriptive. Here the focus is not so much on the independence of one individual from another, of self from other, as on the independence of the most abstract other from self—of Nature from man. Accordingly, the negative value that tacitly accrues to this relation attaches not so much to the self as to the other, that is, to Nature.

With Darwin, evolutionary biology joined a tradition already well established in the physical sciences—a tradition that teaches that the laws of nature are, in Steven Weinberg's words, "as impersonal and free of human values as the rules of arithmetic" (Weinberg 1974).

But this rhetoric goes beyond impersonality: Nature tends to become uncaring and "hostile"—traits that are impersonal in a quite personal sense. To illustrate this tendency, consider, for example, Steven Weinberg's own elaboration of his message:

> It is almost irresistible for humans to believe that we have some special relation to the universe, that human life is not just a more-or-less farcical outcome of a chain of accidents reaching back to the first three minutes . . . It is very hard to realize that this all is just a tiny part of an overwhelmingly hostile universe (in Midgley 1985:88).

In much the same vein, Jacques Monod writes:

> If he accepts this message in its full significance, man must at last wake out of his millenary dream and discover his total solitude, his fundamental isolation, he must realize that, like a gypsy, he lives on the boundary of an alien world, a world that is deaf to his music, and as indifferent to his hopes as it is to his suffering or his crimes (1972:2).[2]

The world we must steel ourselves to accept is a world of "uncaring emptiness" (p. 173), a "frozen universe of solitude" (p. 173). The natural world from which animism has been so carefully expunged has become not quite neutral, but "empty," "frozen," "overwhelmingly hostile," and "terrifying."

For the record, though, it was a poet, not a scientist, who gave us our most familiar metaphor conflating an absence of benevolence in nature with "overwhelming hostility." A Nature that does not care for us becomes indeed a Nature "red in tooth and claw"— callous, brutal, even murderous. It is a Nature who cries: "I care for nothing; all shall go."

Mary Midgley suggests that such residual animism properly belongs to what she calls "the drama of parental callousness":

> First, there is the tone of personal aggrievement and disillusion, which seems to depend . . . on failure to get rid of the animism or personification which [these scientists] officially denounce. An inanimate universe cannot be hostile. . . . Only in a real, conscious human parent could uncaringness equal hostility. . . . Certainly if we expect the non-human world

[2] Although the actual words here are neutral enough, Monod's giveaway is in his use of the "gypsy" simile, for the world on the margins of which the gypsy lives is first and foremost a human world, a society, whose indifference is in fact rejection.

around us to respond to us as a friendly human would, we shall be disappointed. But this does not put it in the position of a callously indifferent human (1985:87).[3]

Midgley's explanation is persuasive—perhaps precisely because the slippage between an indifferent and a hostile nature so clearly does denote a logical error, once pointed out. But a similar problem surfaces in another set of contexts as well, where the move from a neutral to a negative valence in the conceptualization of self-other relations is less evidently a simple "mistake." Here it is not Nature but the individual organism, the first rather than the second term of the self-other dichotomy, whom the insistently unsentimental biologist taxes with hostility.

I am referring in particular to the tradition among evolutionary biologists that not only privileges the individual descriptively, but that also, in the attempt to locate all relevant causal dynamics in properties intrinsic to the individual, tends to attribute to that individual not simply autonomy, but an additional "intrinsic" competitive bent, as if independence and competition were inseparable traits. The very same move that defines self-interest and altruism as logically opposed makes independence virtually indistinguishable from competition. Michael Ghiselin is one of the most extreme representatives of this position and provides some particularly blatant examples of the rhetorical (and conceptual) conflation I am speaking of. To dramatize his position, he concludes:

> The economy of nature is competitive from beginning to end . . . No hint of genuine charity ameliorates our vision of society, once sentimentalism has been laid aside . . . Given a full chance to act for his own interest, nothing but expediency will restrain [an organism] from brutalizing, from maiming, from murdering—his brother, his mate, his parent, or his child. Scratch an "altruist" and watch a "hypocrite" bleed (1974:247).

Of course, Ghiselin's language is *intended* to shock us—but in order to underscore his thesis. In this effort, he is counting on our ac-

[3] Midgley's manifestly psychological explanation is at least congruent with my own more explicitly psychological account of another, perhaps related, rhetorical and conceptual conflation—namely, that between objectivity and domination seen in a number of traditional attempts to describe (and prescribe) relations of mind to nature (see Keller 1985, chapter 6).

ceptance, as readers, first, of the rule of self-interest as logically equivalent to the absence of altruism or charity, and second, of competitive exploitation as a necessary concomitant of self-interest. Our usual willingness to accept these assumptions, or rather, to allow them to pass unnoticed, is itself a measure of the inaccessibility of a domain where self-interest and charity (or altruism) conjoin, and correlatively, of a distinction between self-interest and competition. Unlike the previous example, where no one, if pressed, would say that nature "really is" hostile, Ghiselin's assumptions do seem to accord with the way things "really are." Because the difference between self-interest and competition is less obvious to most of us than the difference between impersonality in nature and hostility, the problem here is much more difficult. In other words, before we can invoke a psychosocial explanation of the conceptual conflation between radical individualism and competition, we need first to *see* them as different.

We can do this best by turning our attention from a prescriptive discourse that aims to set ground rules for evolutionary theory, to an examination of uses of the same language in the actual working out of particular theoretical strategies. The focus of the remainder of this essay is therefore on the technical uses of the language of individualism in mathematical ecology and population genetics—in the first case, on the language of competition, and, in the second, on the language of reproductive autonomy. I hope to show how particular conventional interchanges, or trade-offs, between technical and colloquial language cast a blanket of invisibility, or rather, of unspeakability, over certain distinctions, categories, and questions. And I suggest that it is precisely through the maintenance of such an aura of unspeakability that social, psychological, and political expectations generally exert their influence, through language, on the actual structure and content of scientific theory.

Competition and Cooperation in Mathematical Ecology

The first problem I want to examine arises in the systematic neglect of cooperative (or mutualist) interactions, and the corresponding privileging of competitive interactions, evident throughout almost the entire history of mathematical ecology. But when we ask prac-

titioners in the field for an explanation of this historical disinterest in mutualist interactions, their response is usually one of puzzlement, not so much over the phenomenon as over the question: How else could it, realistically, be? Yes, of course, mutualist interactions do occur in nature, but they are not only rare, they are necessarily secondary—often indeed it is assumed that they are in the service of competition; such phenomena have at times actually been called "cooperative competition." Indeed, the expectation of most workers in the field that competition is both phenomenologically primary *and* logically prior is so deeply embedded that the very question has difficulty getting air-space: There is no place, as it were, to put it. My question thus becomes: What are the factors responsible for the closing-off of that space?

Part of the difficulty we have in answering this question undoubtedly stems from the massive linguistic confusion in conventional use of the term "competition." One central factor, however, can be readily identified, and that is the recognition that, in the real world, resources *are* finite, and hence ultimately scarce. Scarcity, in the minds of most of us, automatically implies competition—both in the sense of "causing" competitive behavior, and in the sense of constituting, in itself, a kind of de facto competition, independent of any actual interactions between organisms. Indeed, so automatic is the association between scarcity and competition that, in modern ecological usage, competition has come to be defined as the simultaneous reliance of two individuals, or two species, on an essential resource that is in limited supply (see, for example, Mayr 1963: p. 43). Since the scarcity of resources can itself hardly be questioned, such a definition lends to competition the same a priori status.

This technical definition of competition was probably first employed by Volterra, Lotka, and Gause in their early attempts to provide a mathematical representation of the effects of scarcity on the population growth of "interacting" species, but it soon came to be embraced by a wider community of evolutionary biologists and ecologists—partly, at least, in an attempt to neutralize the discourse, and so bypass the charge of ideological laden expectations about (usually animal) behavior, in fact freeing the discourse of any dependence on how organisms actually do behave in the face of scarcity. The term "competition" now covered apparently pacific behavior just as well as aggressive behavior, an absurdity in ordinary usage

but protected by the stipulation of a technical meaning. As Ernst Mayr explains,

> To certain authors ever since [Darwin], competition has meant physical combat, and, conversely, the absence of physical combat has been taken as an indication of the absence of competition. Such a view is erroneous. . . . [T]he relative rarity of overt manifestations of competition is proof not of the insignificance of competition, as asserted by some authors, but, on the contrary, of the high premium natural selection pays for the development of habits or preferences that reduce the severity of competition (1963: 42–43).

Paul Colinvaux goes one step further, suggesting that "peaceful coexistence" provides a better description than any "talk of struggles for survival": "Natural selection designs different kinds of animals and plants so that they *avoid* competition. A fit animal is not one that fights well, but one that avoids fighting altogether" (1978: 144).

But how neutral in practice is the ostensibly technical use of competition that is employed both by Mayr and by Colinvaux? I want to suggest two ways in which, rather than bypassing ideological expectations, it actually preserves them, albeit in a less visible form— a form in which they enjoy effective immunity from criticism. In order not to be caught in the very trap I want to expose, let me henceforth denote competition in the technical sense as "Competition," and in the colloquial sense (of actual contest), as "competition."

The first way is relatively straightforward: The use of a term with established colloquial meaning in a technical context permits the simultaneous transfer and denial of its colloquial connotations. Let me offer just one example: Colinvaux's own description of Gause's original experiments that were designed to study the effect of scarcity on interspecific dynamics—historically, the experimental underpinning of the "competitive exclusion coexistence." He writes:

> No matter how many times Gause tested [the paramecia] against each other, the outcome was always the same, complete extermination of one species . . . Gause could see this deadly struggle going on before his eyes day after day and always with the same outcome. . . . What we [might have] expected to be a permanent struggling balance in fact became a pogrom (Colinvaux 1978: 142).

Just to set the record straight, these are not "killer" paramecia, but

perfectly ordinary paramecia—minding their own business, eating and dividing, or not—perhaps even starving. The terms "extermination," "deadly struggle," and "pogrom" refer merely to the simultaneous dependence of two species on a common resource. If, by chance, you should have misinterpreted and taken them literally, to refer to overt combat, you would be told that you had missed the point: The Lotka-Volterra equations make no such claims; strictly speaking, they are incompatible with an assumption of overt combat; the competitive exclusion principle merely implies an avoidance of conflict. And yet the description of such a situation, only competitive in the technical sense, slips smoothly from "Competition" to genocide—much as we saw our neo-Tennysonians slip from impersonality to heartless rejection.

The point of this example is not to single out Colinvaux (which would surely be unfair), but to provide an illustration of what is in fact a rather widespread investment of an ostensibly neutral technical term with a quite different set of connotations associated with its colloquial meaning. The colloquial connotations lead plausibly to one set of inferences and close off others—while the technical meaning stands ready to disclaim responsibility if challenged.[4]

The second and more serious route by which the apparently a priori status of competition is secured can be explored through an inquiry into the implicit assumptions about resource consumption that are here presupposed, and the aspects of resource consumptions that are excluded. The first presupposition is that a resource can be defined and quantitatively assessed independently of the organism itself; and the second, that each organism's utilization of this resource is independent of other organisms. In short, resource consumption is here represented as a zero-sum game. Such a representation might be said to correspond to the absolutely minimal constraint possible on the autonomy of each individual, but it is a constraint that has precisely the effect we are focusing on—namely, of establishing a necessary link between self-interest and competition. With these assumptions, apparently autonomous individuals are in fact bound by a zero-sum dynamic that guarantees not quite

[4] See "Demarcating Public from Private Values . . ." (this volume) for a discussion of Hardin's use of the same slippage in arguing for the universality of the "competitive exclusion principle."

an absence of interaction, but the inevitability of purely competitive interaction. In a world in which one organism's dinner necessarily means another's starvation, the mere consumption of resources has a kind of de facto equivalence to murder: Individual organisms are locked into a life and death struggle not by virtue of their direct interactions, but merely by virtue of their existence in the same place and time.

It is worth noting that the very same (Lotka-Volterra) equations readily accommodate the replacement of competitive interactions by cooperative ones, and even yield a stable solution. This fact was actually noted by Gause himself as early as 1935 (Gause and Witt 1935) and has been occasionally rediscovered since then, only to be, each time, reforgotten by the community of mathematical ecologists. The full reasons for such amnesia are unclear, but it does suggest a strong prior commitment to the representation of resource consumption as a zero-sum dynamic—a representation that would be fatally undermined by the substitution (or even addition) of cooperative interactions.

What get left out of this representation are not only cooperative interactions, but *any* interactions between organisms that affect the individual's need and utilization of resources. Also omitted are all those interactions between organism and environment that interfere with the identification and measurement of a resource independently of the properties of the organism. Lewontin (1982), for example, has argued that organisms "determine what is relevant" in their environment—what, for example, *is* a resource—and actually "construct" their environment. But such interactions, either between organisms or between organism and environment, lead to payoff matrices that are necessarily more complex than those prescribed by a zero-sum dynamic—payoff matrices that, in turn, considerably complicate the presumed relation between self-interest and competition, if they do not altogether undermine the very meaning of self-interest.

Perhaps the simplest example is provided by the "prisoner's dilemma." But even here, where the original meaning of self-interest is most closely preserved, Robert Axelrod (1984) has shown that under conditions of indefinite reiterations, a kind of cooperative strategy ("tit-for-tat") is generally better suited to self-interest over the long run than are more primitive competitive strategies.

Interactions that effectively generate new resources, or either in-

crease the efficiency of resource utilization or reduce absolute requirements, are more directly damaging to the principle of self-interest itself. These of course are just the kinds of interactions that are generally categorized as special cases: as "mutualist," "cooperative," or "symbiotic" interactions. Finally, interactions that affect the birth rate in ways that are not mediated by scarcity of resources, for example sexual reproduction, are also excluded by this representation. Perhaps the most important of these omissions for interspecific dynamics is that of mutualist interactions, whereas for intraspecific dynamics, I would point to sexual reproduction, a fact of life that, I will argue, potentially undermines the core assumptions of radical individualism. In the last few years, there has been a new wave of interest in mutualism among not only dissident but even a few mainstream biologists, and numerous authors are hard at work redressing the neglect of previous years.[5] But in the sixty years in which the Lotka-Volterra equations have reigned as the principal if not the only model of interspecific population dynamics, even in the more genial climate of recent years, the omission of sexual reproduction from this model has scarcely been noted.

This omission, once recognized, takes us beyond the question of selective biases in admissible or relevant interactions between organisms. It calls into question the first and most basic assumption for the methodology of individualism in evolutionary theory, namely, that intrinsic properties of individual organisms are primary to any description of evolutionary phenomena.[6] To follow out this argument, I need to shift the focus of my discussion from mathematical ecology to population genetics, that branch of evolutionary theory that promises to avoid the practical difficulties of selective focus on certain kinds of interactions by excluding the entire question of competitive or cooperative interactions from its domain. In other words, traditional population genetics addresses neither interactions between organisms, nor limitations in resources; it effectively assumes populations at low density with infinite resources.

Before I make this shift, however, one last problem with the lan-

[5] Douglas Boucher (1985) has even suggested a new metaphor: In place of "nature red in tooth and claw" he offers "nature green in root and bloom."

[6] That is, it raises a question about the adequacy of the third assumption of my schematic account of the methodology of individualism—that in which the essential (or existential) autonomy of the individual organism is assumed.

guage of competition must be noted lest it carry over into our discussion of individual autonomy in population genetics, and that is the widespread tendency to extend the sense of "competition" to include not only the two situations we distinguished earlier (that is, [1] conflict and [2] reliance on a common resource), but also a third situation[7] where there is no interaction at all, where "competition" denotes an operation of *comparison* between organisms (or species) that requires no juxtaposition in nature, only in the biologist's own mind. This extension, where "competition" can cover all possible circumstances of relative viability and reproductivity, brings with it, then, the tendency to equate competition with natural selection itself.

Darwin's own rhetorical equation between natural selection and the Malthusian struggle for existence surely bears some responsibility for this tendency. But contemporary readers of Darwin like to point out that he did try to correct the misreading his rhetoric invited by explaining that he meant the term "struggle" in "a large and metaphoric sense," including, for example, that of the plant on the edge of the desert; competition was only one of the many meanings of struggle for Darwin. Other authors have been even more explicit on this issue, repeatedly noting the importance of distinguishing natural selection from "a Malthusian dynamic." Lewontin, for example, has written,

> Thus, although Darwin came to the idea of natural selection from consideration of Malthus' essay on overpopulation, the element of competition between organisms for a resource in short supply is not integral to the argument. Natural selection occurs even when two bacterial strains are growing logarithmically in an excess of nutrient broth if they have different division times (1970:1).

However, such attempts—by Lewontin, and earlier and more comprehensively, by L. C. Birch (1957)—to clarify the distinction between natural selection and competition[8] have done little to stem the underlying conviction that the two are somehow the same. Thus,

[7] Which is, in fact, the situation of population genetics.

[8] Closely related to what Engels called "Darwin's mistake" in his own attempt to distinguish between "the pressure of overpopulation" and the variable "capacity of adaptation" (Engels 1940:286).

for example, in a recent attempt to define the logical essence of "the Darwinian dynamic," Bernstein et al (1983) freely translate Darwin's "struggle for survival" to "competition through resource limitation" (p. 192), thereby claiming for competition the status of a "basic component" of natural selection. Even more recently, George Williams (1986) describes a classic example of natural selection in the laboratory as a "competition experiment," a "contest" between a mutant and normal allele, in which he cites differential fecundity as an example of "the competitive interactions among individual organisms" that cause the relative increase in one population (pp. 114–15).

The question at hand is not whether overtly competitive behavior or more basic ecological scarcity is the rule in the natural world; rather, it is whether or not such a question can even be asked. To the extent that distinctions between competition and scarcity on the one hand, and between scarcity and natural selection on the other, are obliterated from our language and thought, the question itself is foreclosed. As long as the theory of natural selection is understood as a theory of competition, confirmation of one is taken to be confirmation of the other, despite their logical (and biological) difference.

Although this clearly raises problems about the meaning of confirmation, my issue here is with the dynamics by which such an oversight or confusion is sustained in the theory and practice of working biologists—with the internal conventions that render it effectively resistant to correction.

There is, of course, a stock answer to charges of oversight familiar to any working scientist, and that is the invocation of the catch-all term, "simplicity." "Simplicity" denotes a value routinely employed to justify all sorts of exclusions, including those which are necessary to any modeling process. But, however it is used, such a justification always carries the tacit provision that the simplifying assumptions in question are not, at least not in the first order of magnitude, counterfactual. In the critique I have presented here, my aim has been to at least raise the question of a possible violation of this tacit provision. Furthermore, I am suggesting that the assumptions actually made are not in fact always simplifying. Finally, there is the question of consistency, a value generally understood to have absolute priority over the value of simplicity in scientific work. In the

next paper, where I turn to an analysis of similar dynamics operating in the language of reproductive autonomy, the issue of consistency will become considerably more explicit. But my principal point in both essays is not that scientists are making "mistakes," but rather that the very language on which they must rely, even when apparently strictly technical, can subvert their best intentions for "objective," value-free description. Both stories I tell are intended to illustrate a general mechanism by which particular conventions of language permit, even facilitate, the unwitting incorporation of social values into the substance of scientific theory.

7

Language and Ideology in Evolutionary Theory

At the resurrection, sex will be abolished, and Nature made one. There will then only be man, as if he had never sinned.
 Johannes Scotus Erigena, 9th c.

Part II: The Language of Reproductive Autonomy

In the preceding essay, I drew attention to some of the ways in which language operates as a carrier of social expectations into scientific theory by focusing on the language of competition in evolutionary theory. Here, I will examine some peculiarities in the language of biological reproduction in a slightly more technical field, namely, population genetics, focusing in particular on how that language bears on the central project of evolutionary theory.

In much of the discourse of evolutionary theory, it is commonplace to speak of the "reproduction of an organism"—as if reproduction is something an individual organism does, as if an organism makes copies of itself, by itself. Strictly speaking, of course, such language is appropriate only to asexually reproducing populations because, as every biologist knows, sexually reproducing organisms neither produce copies of themselves, nor produce other organisms by themselves. It is a striking fact, however, that the language of individual reproduction, including such correlative terms as "an individual's offspring" and "lineage," is used throughout population biology[1] to apply indiscriminately to both sexually and asexually reproducing populations. Although it would be absurd to suggest

* A version of this paper appears in *Biology and Philosophy* 2:383–96 (1987).
[1] Including both population genetics and mathematical ecology.

that users of such language are actually confused about the nature of reproduction in the organisms they study (for example, calculations of numbers of offspring per organism are always appropriately adjusted to take the mode of reproduction into account), we might nonetheless ask: What functions, both positive and negative, does such manifestly peculiar language serve? And what consequences does it have for the shape of the theory in which it is embedded?

I want to suggest first, that this language, far from being idle or inconsequential, provides crucial conceptual support for what might be called the central project of evolutionary theory, as bequeathed to us by Darwin. Despite the many important developments since Darwin, that project remains the location of the causal efficacy of evolutionary change in heritable properties of individual organisms. Necessary to this ambition is the basic assumption of methodological individualism, namely, the assumption that such properties, intrinsic to the individual, are primary to any description of collective (population) phenomena. My claim is that this assumption rests on the language of individual reproduction for its basic credibility. I will further argue that this language, along with the confidence it inspires, is maintained by certain methodological conventions that not only obscure problems in both the language and the project itself but also serve to actively impede attempts to redress those difficulties that can be identified. Finally, I will argue that removal of these supports may radically undermine the individualist focus of the endeavor they presently sustain. To make these arguments, I will offer a brief, necessarily schematic, account of some of the key features of the history of sexual reproduction in evolutionary theory, particularly as represented in population biology.

Sexual Reproduction and Individualism: Problem · and Solution

One of the few undebated propositions of evolutionary theory is that the subject of evolution—what changes—is the population. Most evolutionary biologists would also agree that *a*, if not *the*, principal mechanism of evolutionary change is that of natural selection. But the question of what natural selection acts on—what or where are the properties that, in Elliott Sober's words, "drive the causal en-

gine" of natural selection (1984:100)—remains extremely problematic. For Darwin, as for most of his followers, what selection acts *on* are the individual organisms that make up the population in a given generation, and the properties that are selected *for* over the course of generations are heritable properties that inhere in individuals, causing, on average, their differential survival and reproduction. Thus, for both asexually and sexually reproducing organisms, differential survival and reproduction constitute the phenomenological bridge between individual properties that don't change and attributes of the population that do.

For those in the past who were still inclined to view the reproductive contribution of females as providing the raw materials or nutriments for growth, sexual reproduction could be thought of, along with survival, as fundamentally pertaining to the individual— posing no special difficulty to the view that individuals with properties that "fit" them to survive and reproduce more successfully than others simply made more of their own kind. From such a perspective, the relation between individual properties and population change would appear relatively unproblematic. Equally easy, from such a perspective, was the view of sexual reproduction as a variant of and not essentially different from asexual reproduction.[2] But as soon as the complications of biparental inheritance are considered, the apparent seamlessness of the relation between individual and population is necessarily undermined.

For modern biologists who must reckon with Mendelian genetics and contemporary accounts of sexual reproduction, the relation between individual properties and population change became especially problematic. Once individuals could no longer be thought of as simply making more of their own kind, new rules of correspon-

[2] A view sometimes embraced by Darwin himself (according to Farley [1982] and Churchill [1979] at least). In *The Variation of Animals and Plants under Domestication,* Darwin wrote: "Sexual and asexual reproduction are thus seen not to differ essentially; . . . the power of re-growth and development are all parts of one and the same fundamental law" (quoted in Churchill 1979:176), and, "All forms of reproduction graduate into each other and agree in their product . . . Sexual and asexual generation are fundamentally the same" (quoted in Farley, p. 109). These quotes seem however to be quite uncharacteristic of Darwin given his preoccupation, especially in his later writings, with the particular issue of sexual reproduction. Frank Sulloway suggests that the intent of these particular remarks must properly be seen in the context of Darwin's specific arguments for pangenesis (personal communication).

dence between individual and population were required if the central project of evolutionary theory was to be retained—rules that would somehow continue to provide a characterization of reproduction in terms of individual properties. That is to say, a method had to be devised, to carry us across this qualitatively different kind of bridge between individual and population, that could somehow preserve the vision of rooting population change in individual properties.

It was the theory of population genetics (based on the Hardy-Weinberg calculus) that appeared to provide just such a method. In this theory, population change was to be measured in terms of changes in the frequency of genes carried by individual organisms, and reproduction represented as the random union of gametes (each housing its individual parent's genes) in a pool out of which pairs of gametes (unlabeled by sex) are independently selected to form zygotes.[3] Once formed, zygotes, in turn, become organisms in a process of maturation that requires no further interaction. In the absence of natural selection, a temporally stable distribution of genotypes is reached in a single round of mating, with the proportion of different genotypes given by the familiar Hardy-Weinberg ratios; that is, a distribution dependent only on the frequency of alleles in the population, and not on its actual genotypic composition. It was generally assumed that the effects of natural selection could readily be added to this model under the rubric of differential survival of (basically autonomous) individual zygotes.

Although such a representation of the relation between genes, organisms, and reproduction is obviously highly idealized, it nonetheless accomplished a great deal. Most important, it provided a remarkably simple calculus for mediating between individuals and populations that apparently succeeded in preserving the individualist focus of Darwin's vision. One might even say that it did so, perhaps somewhat paradoxically, by tacitly dispensing with individual organisms and their troublesome mode of reproduction. With the shift of attention from populations of organisms to well-mixed,

[3] Strictly speaking, in order to ensure the independence of gametic unions, it is also necessary to assume that the pool of gametes is both well mixed and effectively infinite, although the importance of the latter assumption is often lost from view by authors who attempt to apply this calculus to finite populations.

effectively infinite, pools of genes, the gap between individual and population closed. In this picture (colloquially called beanbag genetics), individual organisms could indeed be thought of as mere bags of genes (anticipating Richard Dawkins's "survival machines" [1976:21])—as the end product of a reproductive process now reduced to genetic replication plus the random mating of gametes. Effectively bypassed in this representation were all the problems entailed by sexual difference, by the contingencies of mating and fertilization that result from the finitude of actual populations,[4] and also, simultaneously, all the ambiguities of the term reproduction as applied to organisms that neither make copies of themselves nor reproduce by themselves. In short, the Hardy-Weinberg calculus provided a recipe for dealing with reproduction that enabled people to continue to think (and to speak) about reproduction as an individual process—to the extent, that is, that they thought or spoke about it at all.

It is a noteworthy historical fact that in almost all subsequent efforts to incorporate the effects of natural selection into the Hardy-Weinberg model, the contribution of reproduction to natural selection fell largely if not wholly by the wayside.[5] One might argue that the tradition of inattention to reproduction should more accurately be dated back to Darwin's own tendency to equate natural selection

[4] The most obvious exception to this tradition is undoubtedly to be found in the works of Sewall Wright, for whom assortative mating and the finitude of interbreeding populations were central concerns (see, for example, Wright 1980). However, even for Wright, these effects were generally regarded as relevant only to the formation of populations on which natural selection could subsequently act, that is, as separate from the effects of selection itself.

[5] The tendency among classical population geneticists to ignore the contribution of differential reproduction to changes in gene frequency has in fact been noted by a number of more recent authors. In 1965, Bodmer wrote: "Almost all investigations of the changes in gene frequency caused by natural selection are based upon the assumption that selection operates through differential survival of the zygote from birth to maturity" (p. 411). The same observation has been frequently reiterated since that time (see, for example, Hadeler and Liberman [1975]: "Almost all the analysis of the frequency changes in natural populations has been carried out under the assumption that selection operates during the stage between birth and maturity" [p. 19], and Abugov [1983]: "the modern theory of population genetics, by and large, addresses fitness only as related to survival" [p. 880]). The fairness of this complaint can be readily confirmed by a brief review of the major textbooks of population genetics, noting how commonplace it is to equate selection coefficients with intragenerational survival rates.

with a "struggle for existence," his frequent allusion to the primacy of mortality in natural selection, and his definitive distinction between natural and sexual selection.[6] But Darwin was at other times quite explicit in including differential procreation along with survival in his definition of natural selection. Furthermore, the basic equations of the Hardy-Weinberg calculus provided the means, unavailable to Darwin, to incorporate at least part of the reproductive process (namely the production of gametes) into the dynamic of natural selection. In spite of this fact, however, the theoretical (and verbal) convention that subsequently came to prevail in much of the teaching and practice of population genetics was to equate natural selection with differential survival and ignore fertility altogether. In other words, the Hardy-Weinberg calculus seems to have actually facilitated not one but two kinds of elision—first, of all those complications incurred by sex and the contingency of mating that are lost in the representation of reproduction as gametic production, and second, more obliquely, of reproduction *en toto*.

I want to suggest that these two different kinds of elision in fact provided important tacit support for each other. In the first case, the representation of reproduction as gametic production invited confidence in the assumption that differential reproduction, or fertility, was *like* differential survival, and hence did not require separate treatment. And in the second case, the technical equation of natural selection with differential survival in turn served to deflect attention away from substantive difficulties in the representation of reproduction as an individual process. The net effect has been to establish a circle of confidence first, in the adequacy of the assumption that, despite the mechanics of Mendelianism, the individual remains both the subject and object of reproduction, and accordingly, in the adequacy of the metonymic collapse of reproduction and survival in discussions of natural selection.

The more obvious cost of this circle undoubtedly comes from its

[6] The tradition of demarcating sexual selection from natural selection (established by Darwin and provisionally continued in the present analysis) obviously bears quite directly on the ambiguous role of reproduction in natural selection, and hence on the maintenance of an individualist focus in classical population genetics. For this reason, the very distinction between natural and sexual selection needs itself to be examined from the same analytic perspective. But the history of this distinction is so complex and interesting that it seems (to this author, at least) to warrant separate treatment.

second part: As a number of authors have recently begun to remind us, the equation between natural selection and differential survival fosters both the theoretical omission and the experimental neglect of a crucial component of natural selection. The cost resulting from unresolved difficulties with the individualist representation of reproduction that this equation has helped obscure is necessarily less apparent.

Two Definitions of Fitness

The most serious such difficulty derives from the basic fact that, for sexually reproducing organisms, the rate at which individuals of a particular genotype are born is a fundamentally different quantity from the rate at which individuals of that genotype give birth—a distinction easily lost in a language that assigns the same term, "birth rate," to both processes. One relatively accessible consequence of the absence of a distinction between these two meanings of "birth rate" can be identified in the persistence of a chronic confusion between two definitions of individual fitness: one, the (average) net contribution of an individual of a particular genotype to the next generation, and the other, the geometric rate of increase of that particular genotype (originally introduced by R. A. Fisher as "the Malthusian parameter"). The first refers to the contribution an individual makes to reproduction, while the second refers to the rate of production of individuals. In other words, the first definition refers to the role of the individual as subject of reproduction, and the second to its role as object. (The same ambiguity appears also in the use of Fisher's term, "the Malthusian parameter," a term used by some authors interchangeably with fitness.)

Confusion between these two definitions has in fact plagued the theoretical literature of population genetics since its very beginning. It can be seen in Fisher's very definition of the Malthusian parameter when he wrote in 1930:

The vital statistics of an organism in relation to its environment provide a means of determining a measure of the relative growth-rate of the population, which may be termed the Malthusian parameter of population increase, and provides also a measure of the reproductive values

134

of individuals at all ages or stages of their life-histories. *The Malthusian parameter will in general be different for each different genotype, and will measure the fitness to survive of each* (italics mine) (p. 50).

The same confusion continues to persist wherever populations of genotypes are discussed as if they were separable populations. The problem with Fisher's definition is not simply that the Malthusian parameter of a genotype doesn't refer merely to survival, but that it necessarily varies with the composition of the population; that is, it depends on the frequencies of the other genotypes from which it may be produced.

Beginning in 1962, a number of authors have attempted to call attention to this confusion (Moran 1962; Charlesworth 1970; Pollak and Kempthorne, 1971; Denniston 1978), agreeing that one definition—the contribution a particular genotype makes to the next generation's population—is both conventional and correct, whereas the other (the rate at which individuals of a particular genotype are born) is not. Despite their efforts, however, the confusion continues to persist. Roughgarden (1979), for example, introduces his now classic text with the conventional definition (p. 28), only to later collapse this definition with the "per capita increase in population" (for example, p. 328). Exactly the same sequence appears in Hedrick (1984:46, 289–91). In a slightly earlier and somewhat more casual fashion, Ricklefs (1973) too begins by defining fitness as "an individual's relative contribution of progeny to the population" (p. 30), but later shifts to the "exponential growth rate" (p. 411), or the "absolute rate of growth" of "a population or some genetically distinguishable part of a population" (p. 385). Writing from a more traditionally ecological perspective, Emlen (1973) begins by defining the fitness of a genotype as "the ratio of its numbers in one generation to its numbers in the preceding generation" (pp. 12–13), but then proceeds on the assumption that this ratio is a constant (for example, p. 326). And more recently, Bernstein et al (1983), Michod (1985) and Byerly (1986) have advocated the general use of Fisher's "Malthusian parameter", meaning the "per capita rate of increase" of "any type, for example, a phenotype, genotype, or trait" ($1/X_i$ dX_i/dt), as a *more* appropriate definition of fitness, arguing that only this definition properly expresses the "Darwinian dynamic."[7]

[7] This last example is particularly noteworthy in view of the fact that one of the principal intentions of these authors has been to redress the omission of the specific consequences of sexual reproduction in their own analysis of that dynamic.

The point of these examples is not simply to demonstrate the persistence of confusion between these two definitions of fitness, but also to suggest that, although Charlesworth and Denniston agree that one definition (contribution to population growth) is correct and the other (geometric rate of increase) is not, a real question remains as to what "correct" means in this context, or more precisely, as to which definition is better suited to the needs the concept of fitness is intended to serve—in particular, the need to explain changes in the genotypic composition of populations. Given that need, we want to know not only which genotypes produce more but also the relative rate of increase of a particular genotype over the course of generations. This is particularly true to the extent that, as Michod and his colleagues observe, it is the latter quantity that is more readily measured. Population geneticists can, of course, avoid the entire problem reflected in this ambiguity by restricting their attention to intragenerational dynamics, as they generally do—in effect leaving the description of population change over the course of generations to students of population growth, that is, mathematical ecologists.

It is therefore not surprising that conflation of the two definitions of fitness is particularly likely to occur in attempts to establish a formal connection between the models of population genetics and those of mathematical ecology. Because the standard models for population growth (for example, logistic or Lotka-Volterra equations) all assume asexual reproduction[8] (a fact routinely forgotten in applications), the two formalisms actually refer to two different kinds of populations: one of gametic pools and the other of asexually reproducing organisms. I suggest that in attempting to reconcile these two theories, some conflation of just such a kind is required to finesse the logical gap incurred by that difference. The minimal

[8] It might be argued that these equations in fact ignore all population structure—not only sexual structure, but spatial, temporal and age structure as well—and that it is in the interests of "simplicity" that they do so. The exception that seems to prove the rule can be seen in the very great mathematical difficulty of models describing age- and sex-structured populations, virtually the only models available that accommodate the fact of sexual difference. But this very exception provides an interesting rebuttal to the customary rationale of simplicity: The fact is that models of sexual reproduction (without age structure) would be far simpler than models of age-structured populations, but such models have nonetheless not been pursued.

requirement for a more adequate reconciliation of the two formalisms would seem to be one of two possible theoretical moves: either the introduction of a compatible representation of the dynamics of sexual reproduction into mathematical ecology, or, a more thoroughgoing elision or at least compartmentalization of those dynamics in population genetics.

The second route can be said to describe two very different, even opposite, kinds of strategy that have been employed by those authors who have worried about the difficulties incurred by sexual reproduction in population genetics. One of these is the well-known move toward genic selection. In posing the question of "what are the things that natural selection is supposed to select?" Hamilton (1975) addresses the problem succinctly:

> The fittest what? Is it a trait, an individual, a set of individuals bearing a trait, or bearing its determinants expressed or latent? Can it be a population, a whole species, perhaps even an ecosystem? In such a confusion of possibilities . . . the individual organism stands out as one clear and obvious choice, with the number of its offspring as the measure of its fitness. But, beyond the problem of when to count and how to weight offspring for their ages, there is the problem that in sexual species the individual is really a physical composite of contributions from two parents, and it may be composite in slightly different ways for different parts . . . Does this matter? For safe conclusions, do we have to descend to the level of the individual gene, perhaps ultimately to that of changed or added parts of the replicating molecule? Or can we, on the contrary, confidently follow the consensus of biologists to a higher level, in believing that the generally significant selection is at the level of competing groups and species? (in Brandon and Burian 1984:194).

As we know, Hamilton's position is that "lower levels are inherently more powerful than higher levels," and that "safe conclusions" require replacing the individual by the gene as the proper object of evolutionary theory. Hamilton's concern is clearly a legitimate one, and genic selectionist formulations may be the most successful we have available in avoiding the problems of sexual reproduction, but, as numerous authors have pointed out, they incur other perhaps equally serious problems. Since these have been written about at length, I will simply identify them. First, selection does not act directly on genes, but on their phenotypic expression; second, genes

do not reproduce themselves, by themselves, but instead require the participation of the entire genome. Third, and last, their contribution to survival and reproduction is in general highly context dependent; genic selection coefficients (even differential genic selection coefficients) are themselves usually dependent not only on their genotypic context, but, as a result, on the structure of the entire population.[9] Partly because of these criticisms, many authors continue to favor the individual over the gene as a more adequate locus for the action of natural selection.

A quite different strategy sometimes invoked to deal with the difficulties of sexual reproduction is that of acknowledging sexual difference, and attempting (at least in some contexts) to restrict reproduction to only one sex—for obvious reasons, usually the females of the species. Here, all offspring are assigned to their female parents (a strategy actually employed by Lotka himself), males are assumed to be sufficiently abundant to fertilize all females, and fecundity to depend only on the properties of the female (see, for example, Charlesworth 1980)—as if, in short, for reproductive purposes, there is only one sex. This strategy (known in demographic theory as the reproductive dominance of females) would be perfectly adequate were there, in fact, only one sex, or alternatively, if neither the attributes nor the availability of males were relevant to the reproductive process, and we furthermore agreed not to inquire too closely about the reproductive fitness of males. The problem that arises there is that, even with random mating, the probability that a male will mate cannot in general be assumed to be one, but is contingent on the availability of females, and therefore depends on the proportion of males to females in the population; that is, on the relative viability of males and females. With nonrandom mating (often subsumed under the rubric of sexual selection), this difficulty is necessarily compounded.

If sexual reproduction cannot successfully be either elided or bracketed from population genetics, the obvious question to ask is, What would be required for the dynamics of sexual reproduction to be more fully incorporated into the theory of population biology?

[9] This is because genic selection coefficients depend both on genotypic selection coefficients and on gene frequencies (see, for example, Sober and Lewontin 1982).

Since the task of rewriting the equations of mathematical ecology for two sexes appears to be relatively straightforward, the discussion that follows will focus on the need for a fuller incorporation of the dynamics of sexual reproduction in population genetics. In fact, a considerable literature on fertility selection in population genetics has recently begun to emerge that at least partially addresses this need. This literature is distinguished from earlier accounts by its treatment of fertility as a property of the mating type rather than simply of the individual genotype; that is, both sexes are acknowledged as participating in the reproductive process.

Fitness and Fertility Selection

In 1949, Penrose offered a first attempt at the analysis of differential fertility for a two-sex population characterized by a single genetic locus, and over the past twenty years, a number of other authors have offered progressively more sophisticated analyses of this problem (see, for example, Bodmer 1965; Hadeler and Liberman 1975; Pollak 1978; Christiansen 1983; Feldman, Christiansen, and Liberman 1983; Abugov 1983)—many of these efforts motivated by the attention that has been drawn to the omission of fertility selection from traditional theoretical accounts (for example, Prout 1965). These efforts betoken a welcome advance in the technical literature,[10] demonstrating the existence of qualitatively new phenomena arising from the inclusion of fertility selection, particularly from the inclusion of genotypic interactions in fertility.

The results of these investigations have led at least some of their authors to conclusions in apparent agreement with the principal thesis of this paper. Precisely because of its requirement that neither individuals nor genes interact, "The classical concept of individual fitness is insufficient to account for the action of natural selection," (Christiansen 1983:75). More specifically, Christiansen writes, "The first assumption [that the process of natural selection may be described through the concept of individual fitness] . . . breaks down

[10] It needs to be noted, however, that fertility selection has not yet made its way into more than an occasional textbook.

SECRETS OF LIFE, SECRETS OF DEATH

for sexually reproducing organisms in which reproduction usually requires the interaction of two or more individuals (1983:66). This conclusion is reiterated by Christiansen and Feldman in 1986:

> The second and main problem in the definition of fitness value is that certain aspects of natural selection cannot be ascribed to the individual; fecundity, for example, describes a fitness attribute of the mated male and female pairs, while sexual selection[11] will usually depend on the genotypic composition of the population (p. 123).

But if the concept of *individual* fitness is insufficient to account for natural selection, we must return to our original question: To what does the concept of fitness properly refer? What does natural selection act *on?* The arguments against the adequacy of the gene as the proper unit of selection have already been cited. As Sober and Lewontin have themselves observed (1982), at least some of the same arguments can be readily extended to the genotype: When fertility selection is included in natural selection, the fitness of a genotype, like the fitness of a gene, is seen to depend on the context in which it finds itself—now, however, the context is one determined by the genotype of the mating partner rather than by the comple-mentary allele. In both cases, this context dependence shows up in the form of frequency dependence in the fitness coefficients. When contingency of mating (or sexual selection) is included, the problem of frequency dependence is of course considerably exacerbated.

A casual reading of the literature on fertility selection might sug-gest that the mating pair (represented in these analyses as a pair of genotypes) would constitute a more appropriate unit of selection than the individual, but the fact is that mating pairs do not reproduce themselves any more than do individual genotypes. As Pollak has pointed out, "even if a superior mating produces offspring with a potential for entering a superior mating, the realization of this potential is dependent upon the structure of the population" (1978:389). In other words, in computing the contribution of either a genotype or a mating pair to the next generation's population (of genotypes or mating pairs), it is necessary to take account of the

[11] Christiansen and Feldman apparently attribute differential mating probabilities to "sexual" rather than "fecundity" selection, understanding both, however, as com-ponents of natural selection.

contingency of mating: Such a factor, measuring the probability that any particular organism will actually mate, adds yet another source of frequency dependence, reflecting the dependence of mating on the genotypic composition of the entire population.[12]

In recent years, various philosophers of evolutionary biology (for example, Brandon, Burian, Lloyd, Sober, Wimsatt) have concluded that natural selection can operate on a variety of different levels— in some cases, on the level of the gene, in others, of the genotype, even occasionally, of the group. A particular case in which all three levels of selection are seen to operate simultaneously—one that is especially popular among philosophers of biology (see, for example, Sober 1984:262–63; Brandon 1982:320; Williams 1966:117–18)—is that of the t-allele in the house mouse *Mus musculus* (investigated by Lewontin and Dunn 1960). First, males that are heterozygous for the t-allele produce sperm cells in which this gene is dispropor- tionately represented (up to 95%) relative to its homologous allele (genic selection); second, individual males that are homozygous in the t-allele are either sterile or fail to survive altogether (organismic selection, acting in a direction opposite to that of genic selection); finally, isolated groups whose males are all homozygous with re- spect to the t-allele will go extinct, independent of the genotypic properties of the females in that group (group selection). That is, the fitness of a female in such a group is quite clearly seen to be context dependent; in particular, in this context, the fitness of the female is zero, not by virtue of its own contribution to fertility, but because all of its available mates are sterile.

I want to suggest, however, that this example is merely an extreme case of a general phenomenon: The fitness of a particular female (or male) reproducing sexually *always* depends, first, on the avail- ability, and second, on the fertility of males (or females) in the breeding group in which that organism finds itself, even if this factor is often less conspicuous than it is in the case of the house mouse. I therefore want to argue a somewhat more radical conclusion than

[12] Furthermore, as Abugov (1983) has reminded us, mating and fertility are not the only factors introducing interactive effects in the reproductive contribution to fitness; for many species, the very survival of a particular zygote from birth to maturity can and often does depend on the joint effectiveness of the mating pair as parents— a factor that would inevitably invoke the addition of both organism-environment and polygenic interactions.

these authors have argued: When a full account of reproduction is included in our deliberations, natural selection is seen as operating on all three levels as a rule, not merely under exceptional circumstances. For sexually reproducing organisms, fitness is *in general*, not an individual property but a composite of the entire interbreeding population, including, but certainly not determined by, genic, genotypic, and mating pair contributions. To the extent that the advent of sex undermines the reproductive autonomy of the individual organism, it simultaneously undermines the possibility of locating the causal efficacy of evolutionary change in individual properties. At least part of the "causal engine" of natural selection must be seen as distributed throughout the entire population of interbreeding organisms.

Conclusion

The point of this essay is not simply to argue for the inadequacy of the individualist program in the description of sexually reproducing populations, but rather to provide an instantiation of a more general issue about language and ideology in scientific theory. I want to suggest that the story of sexual reproduction in evolutionary theory that I have attempted to narrate here illustrates a quite general mechanism by which the particular conventions of language employed by a scientific community not only can permit a tacit incorporation of ideology into scientific theory but also can protect participants from recognition of such ideological influences and thus effectively secure the theoretical structure from substantive critical revision. In this particular story, the linguistic conventions of individual reproduction—conventions embodying belief in the essential autonomy of the biological individual—can be seen as serving both to perpetuate that belief and to promote its incorporation into the theory of evolutionary dynamics. In close and supporting parallel, the methodological convention of equating natural selection with differential survival has served to protect that theory from the disturbances of sexual reproduction, thereby lending at least tacit support to the assumption of individual autonomy that gave rise to the language

of individual reproduction in the first place. The net effect is to exclude from the domain of theory those biological phenomena that do not fit (or worse, threaten to undermine) the ideological commitments that are unspoken yet *in* language—built into science by the language we use in both constructing and applying our theories.

8

Demarcating Public from Private
Values in Evolutionary Discourse

Preamble

In "Language and Ideology of Evolutionary Theory" (Parts I and II), I argued that the language of competition and reproductive autonomy provides a vehicle for the importation of particular social and political value into evolutionary biology. In particular, it facilitates the modeling of the individual organism on the "Hobbesian man," autonomous and a priori competitive. Here I continue the same general argument, sometimes re-using same texts (cf. Dawkins and Ghiselin), but extend it to a critique of how the ostensibly "neutral" program of methodological individualism is actually implemented in evolutionary biology. I claim that the same sociopolitical assumptions projected onto the individual organism also adhere to the more general category of "individual," however the unit of "individual" is defined (that is, whether as species, group, organism, or gene).

The consequence is, first, a systematic "perceptual bias" in the kinds of interactions that are taken to occur between individuals and in the internal dynamics assumed to operate in their interior domains, and second, a conspicuous means by which current debates in the social and political realm can affect apparently "internal" debates in evolutionary biology. Of particular interest here are the

Originally published in *Journal of the History of Biology* 21(2):195–211 (1988).

recent debates over the unit of selection in population genetics and the status of competition theory in mathematical ecology. (Though the invocation of the notion of "bias" in discussions of the production of scientific knowledge has recently come to be seen as problematic, just because it suggests the possibility of a value-neutral science, the term nonetheless seems useful within the limited confines of the analysis offered here.) In brief, a systematic perceptual bias is manifested in a familiar series of interlocking arguments about the relation between what is "scientific," what is "tractable," and accordingly, what is taken to be "real."

Introduction

For Darwin, the object of evolutionary discourse, the biological individual, was unambiguously the organism. But since Darwin the locus of biological individuality has become more ambiguous. Not necessarily indivisible, the individual remains bounded and delineated, assumed a priori to be differentiable *because* it stands apart from, independent of, others. By contrast, the component parts that comprise the individual unit are bound in necessary union. Although the individual pictured as organism continues to underlie most discussions, David Hull (1984) offers us a more general definition: "Individuals are spatiotemporally localized, internally cohesive entities that develop continuously through time." They may be species, groups, organisms, or genes.

In this paper, I want to suggest that however the "individual" is specified in evolutionary biology (that is, whatever the choice of unit of selection), that individual serves the discourse in this field as a demarcator between two sets of values. In the first set, we have autonomy, competition, simplicity; a theoretical privileging of chance and random interactions, and the interchangeability (that is, equality) of units. In the second set, we have interdependence, cooperation, complexity; the theoretical privileging of purposive and functional dynamics, and often a hierarchical organization. Because of the obvious resemblance to values associated with a more explicitly political discourse, I will designate these two sets of values "public" and "private." My claim is that the dynamics that are generally assumed to prevail *between* individuals come almost entirely

from the first set of terms—that is, they are taken to be simple, random, competitive, etc.—while the dynamics corresponding to the second set—cooperative, interdependent, and complex (highly structured, and frequently hierarchical as well)—are generally confined to the interior of the individual. Both structurally and functionally, the role of the individual in evolutionary discourse resembles that of the family in political discourse. The family, itself once imaged on the organism, has in turn come to serve as an implicit metaphor for the now-generalized biological individual. In keeping with this analogy, debate over the proper locus of individuality can indeed be seen, at least in part, to reflect a more general debate over the proper domain of "public" versus "private" values. In particular, the bigger, the more complex the individual, the more scope there is for internal cooperation and interdependence, for functional and/ or purposive dynamics; the smaller the individual, the larger the scope for external competition and/or random interactions between individuals.

The following examples are offered to illustrate my claim:

1. Species, like groups, qua individuals, may compete with each other. Indeed, Michael Ghiselin (1974) hypothesizes competition between species to justify his claim that they are individuals: "Species are to evolutionary theory," he writes, "as firms are to economic theory . . . [they] are individuals, and they are real. They are as real as American Motors, Chrysler, Ford, and GM. If it be true that only individuals compete, then species as well as organisms can compete just as corporations and craftsmen can" (p. 538). For most authors, however (even if not for Ghiselin), species, like groups are seen as providing an internal medium conducive to cooperation, collaboration, mutual aid. That is to say, groups (species) conceived of as individuals are internally caring, externally selfish.

2. Even Peter Kropotkin, in his critique of Social Darwinism and in his effort to restore a more benign view of nature to our reading of Darwin, restricted his claim for the prevalence of mutual aid to intraspecific dynamics. While insisting on cooperation as the norm within species, he nonetheless granted the prevalence of competition between species. "However terrible," he wrote, "the wars between different species, . . . mutual aid within the community . . . [is]'the rule" (1902:14). Indeed, the internal cooperation of groups, like families, is often seen as enhancing the competitive ability of the group, thereby contributing to its survival in a harsh external world. Alfred Emerson, for example, a somewhat later advocate of group harmony,

wrote: "By means of cooperation, the group may become more powerful in its competition with other groups and species" (1954:82).

3. In mathematical ecology, however, where species, or groups, are reformulated as being constituted of individual organisms, the spectrum of interactions supportable by the species or group shifts. As aggregates of individuals, species (like groups) are assumed to be organized by randomly occurring, primarily competitive interactions, operating now both intraspecifically and interspecifically.

4. Indeed, interactions between organisms are quite generally assumed to be a priori competitive whenever the locus of individuality in evolutionary discourse is taken to be the organism. In the very same discourse, however, it is often taken for granted that the organism as a whole (as an unpartitioned unit) is sustained by a complex of other (domestic) interactions among its internal parts. As Stephen Jay Gould (1977) suggests, "Organisms are built by genes acting in concert"—their mutual interactions and interdependency so strong as to preclude partitioning. "Bodies," he concludes, "cannot be atomized into parts." In the same vein, Ernst Mayr's critique of the atomistic approach of population genetics—an approach that "ignores or at least minimizes gene interaction"—derives from his insistence on the "internal cohesion of the genotype" (1984:69). He acknowledges that "just what controls this cohesion is puzzling," and he cites Darwin's reference to "the mysterious laws of correlation" underlying the "balanced adaptive complex" that constitutes the organism (1984:82).

5. Finally, when we move down to the gene as the unit of selection (the biologist's atom), the domain of domestic values appears to vanish entirely. With this new characterization of the individual, there is no field in which the dynamics of interdependence and mutualism that are necessary to maintain the internal cohesion of the genotype—Darwin's "mysterious laws of correlation"—can operate. By default, as it were, genes are necessarily "selfish."

The principal point here, and one of direct relevance to the entire debate of methodological individualism versus holism, is that in evolutionary discourse, as elsewhere, *the individual is not a neutral unit.* Rather, it serves to demarcate a boundary between unlike and unequal spheres—unequal not only in their scientific credibility, but in their political values as well. Even Michael Ghiselin, a self-declared radical individualist, writes: "[T]he individualist outlook affects the structure of theory, the canons of evidence, and the manner of presentation" (1974:2)—and, I might add, the spectrum of defensible values as well. More specifically, my claim is that, in the dis-

placement of qualities and interactions from the interior to the exterior of the individual as boundary, it is possible to identify a more or less systematic transformation of the character of the qualities and interactions that are assumed to prevail. Potentially cooperative, highly coordinated interactions among complexly (and also often hierarchically) organized components are routinely displaced by simple, competitive, and statistical interactions between undifferentiated units. In short, private (or domestic) values exist only in the protected interior of individuals, which, qua individuals, exist in a purely public domain.

Interestingly, and perhaps parenthetically, it is not only domestic interactions that disappear in this transformation, but also, in a way that seems particularly curious for biology, sexual difference itself. Much as the atomic individual in political and economic discourse is simultaneously divested of sex and invested with the attributes of the "universal man" (as if equality can prevail only in the absence of sexual differentiation), so too, the biological individual is undifferentiated, anonymous, and autonomous—assumed even to be capable (perhaps like the head of the family in the political sphere) of reproducing itself.

This is most notably true in mathematical ecology, where the organism, rather than the gene, is the atomic unit. The model underlying all mathematical ecology is that provided by the Lotka-Volterra equations, which were introduced into biology over fifty years ago by two physicists, at least one of whom (Vito Volterra) was explicit about the virtue of treating organisms as "nonextendable and solid bodies . . . indeformable," like the components of perfect liquids and gases (1901; cited in Ingrao and Israel, 1985). Indeed, a notable feature of these equations is that they treat all organisms within a species as interchangeable, without distinguishing features. One consequence of this assumption is that the model precludes sexual difference, and hence sexual reproduction. For fifty years this inadequacy has gone virtually unquestioned—for the most part, even unnoticed. Equally interesting is the parallel that can be seen in population genetics, where the ultimate atom is the gene, rather than the organism, where in fact the organism never makes its appearance mathematically. Nevertheless, in much of the verbal discourse of population genetics, the individual organism is stripped of its sexually distinguishing characteristics much as it is in math-

ematical ecology—treated verbally (and even conceptually) as a self-reproducing entity.[1]

To speak of the reproduction of an organism in sexually reproducing species is of course an elision, but, like the equally endemic concept of the "fitness of an organism," it is an elision lacking in neither significance nor consequence. A clue to its significance might perhaps be found in the very difficulty that many have in seeing the problem. One colleague, for example, responded to my query with the counter, "But what is wrong with speaking of an individual's offspring? Surely, I can say, 'I have a son!'"

What is wrong, of course, is not simply that it is not an "I" who produces offspring, but, more seriously, that however offspring are produced, they are not reproductions of anyone or anything. Sexually reproducing organisms do not produce copies of themselves—they produce offspring that are necessarily *unlike* each of their parents.

Indeed, this very difficulty has been used by those wishing to redefine the individual on a lower level, to disqualify the organism's claim to individuality and to justify the gene's (see, for example, Dawkins 1982). Because genes do not reproduce sexually, their "offspring" *are* reproductions; that is, they are direct copies. There is, however, a problem with how these reproductions are produced. The fact is that genes do not reproduce themselves any more than do men. Although they do not require sexual mates, they do require the enzymatic products of many other genes in the organism. Whole genomes may perhaps be said to reproduce themselves (as, for example, in cellular reproduction), but genes cannot.

Recent Shifts in Evolutionary and Ecological Discourse

The usual language in which these debates is couched is, of course, not the overtly political language I am using here, but a methodological language. What I have described in terms of a contest over the domains of public versus private values in evolutionary theory is more customarily described in terms of a contest between scientific

[1] For more details, see the preceding essay in this book.

and pre- (or proto-) scientific values: a contest, on the one hand, for a space for phenomenology more complex than is (yet) amenable to scientific analysis, and, on the other hand, for an expanded domain of properly scientific discourse—where everything is clear, simple, and analyzable. What is of particular interest to me here is the convergence and interpenetration of political and methodological languages in the recent history of evolutionary and ecological theory. In the particular arenas on which I will focus in this essay—one being the interface between population genetics and evolutionary ecology, and the other centering on mathematical ecology—two notable shifts have occurred over the past twenty years, each of which can be described simultaneously in political and in scientific language. The first shift is the abrupt demise of group selection that occurred in the 1960s, and the contemporaneous rise of genic selection—a decisive downward slide in community preference of the appropriate unit of evolutionary interest, a shift "from the group above to the gene below." This movement is briefly described by Stephen Jay Gould in an article entitled, "Caring Groups and Selfish Genes" (1977). As Gould tells it, the story begins in 1962 with the publication of V. C. Wynne-Edwards's book, *Animal Dispersion in Relation to Social Behavior*—a kind of high water mark for group selection—and culminates in 1976 with the publication of Richard Dawkins's *The Selfish Gene*. Where Wynne-Edwards concluded his comprehensive review of animal behavior with the claim: "It is necessary to postulate that social organizations are capable of progressive evolution and perfection as entities in their own right" (cited in Gould 1977:22), Dawkins argued that "the fundamental unit of 'selection' and therefore of self-interest, is not the species, nor the group, nor even, strictly, the individual. It is the gene, the unit of heredity." In his opening manifesto, he writes:

> [This book] is not science fiction; it is science. Cliche or not, "stranger than fiction" expresses exactly how I feel about the truth. We are survival machines—robot vehicles blindly programmed to preserve the selfish molecules known as genes. . . . They swarm in huge colonies, safe inside gigantic lumbering robots . . . they are in you and me; they created us, body and mind; and their preservation is the ultimate rationale of our existence (Dawkins 1976:ix).

Although Wynne-Edwards was in fact part of a robust tradition

that flourished particularly in the early postwar period and included such eminent proponents of group selection as Emerson and W. C. Allee, by the late 1970s it is clear that community sentiment lay with Dawkins, despite—and even in protest over—his excessively hyperbolic language. For most (although certainly not for all) biologists, the gene had become the preferred unit of selection; group selection, on the other hand—just a decade earlier, a widely accepted concept among evolutionary biologists—had come, in David Sloan Wilson's words, "to rival Lamarckianism as the most thoroughly repudiated idea in evolutionary theory" (1983:159). Along with the repudiation of group selection, it needs to be added, came the simultaneous dismissal of an entire school (or generation) of evolutionary ecologists.

At approximately the same time, a related development was taking place in mathematical ecology. As early as the late 1920s, competitively interacting species had been modeled by differential equations (in particular, the Lotka-Volterra equations). These equations and the companion experiments of G. F. Gause had given rise to what after the mid-thirties came to be known as Gause's Principle: Two species with similar ecologies cannot live together in the same place. But until the 1960s, both the theoretical and the experimental aspects of this effort were widely criticized as "dangerously oversimplified," and the effort was generally disregarded, particularly by field ecologists. From time to time during this period, it was also observed that the same equations could be used to model cooperatively interacting species, but this point received even less attention.

The late 1960s, however, saw a dramatic improvement in the status of mathematical ecology in general and of the Lotka-Volterra equations in particular, a shift that is reflected in a sharp increase in mathematical analyses and volume of publication. A new ecology was born, in which competition emerged as the principal theoretical construct. By the late 1970s, it was generally agreed that competition theory had come to dominate theoretical ecology (See, for example, Salt 1984).

In a simple measure of the centrality of competition within the theoretical literature itself, Erika Stephens and I have documented a steep rise in the proportion of papers signaling competition in the title or key words, beginning in the late sixties and accumulating to a tenfold increase by the late seventies, with the proportion of papers

keying mutualism, cooperation, etc., remaining at a level too low to reflect a decline.[2]

Demise of Group Selection

As the story is usually told, the decisive transition came with the publication in 1966 of George Williams's enormously influential *Adaptation and Natural Selection*. According to D. S. Wilson (1983), it was not any new experiments, or even a new theoretical development, but simply the elegance and clarity of Williams's prose that lent his book such force. Let us briefly look, therefore, at some of that prose.

Surely one of its most striking features is its mix of scientific/analytic and programmatic—indeed, prescriptive—claims. Williams's goal is to make biology more scientific. To this end, he argues that certain concepts that have been common to biological discourse are inherently less suitable—by implication, more conducive to unscientific thinking—than others. The meaning of unscientific, here, like the meaning of scientific, is elaborated by example. In particular, he suggests that the concepts or terms "function" and "organization" are so troublesome that they should be avoided whenever possible. To put evolutionary biology on the right track, Williams advocates two general principles, summed up by the terms "parsimony" and "mechanism." On page 4, he gives us his first "ground rule (or doctrine)": "In explaining adaptation, one should assume the adequacy of the simplest form of natural selection [that is, genic selection] unless the evidence clearly shows that the theory does not suffice" (1966:4). He then proceeds to reinterpret Wynne-Edwards's phenomena in terms of individual selection. In the absence of evidence to the contrary, parsimony demands that we accept his reinterpretation.

Parsimony also demands, Williams later writes, "that an effect be called a function only when chance can be ruled out as a possible explanation. . . . In groups of organisms, an effect should be ascribed

[2] The journals we searched included *The American Naturalist, Ecology*, and *Theoretical Population Biology*.

completely, if possible, as the *fortuitous* summation of individual activities unless there is evidence of coordinated team work . . . or mechanisms for producing group benefit by individual self sacrifice" (pp. 261–62; italics mine).

In this framework, parsimony explicitly implies a methodological preference, first, for individual selection, and second, for a principled distinction between chance and a known mechanism. What cannot be ascribed to a clear, identifiable mechanism is to be attributed to accident. As a consequence, complex, interspecific, environmental feedback loops without a known mechanism are automatically devalued—relegated to the realm of "merely fortuitous effects," and hence "of no biological interest" (p. 9). In the same spirit, competition—defined so broadly by Williams that it requires no interaction between organisms—is assumed to be necessarily prior to cooperation. The implications of the shift that Williams advocates are subtle, perhaps not unlike the difference between the principles "innocent until proven guilty," and "guilty until proven innocent."

To support this shift, Williams argues against earlier views as manifestly unscientific. He writes:

> There is a rather steady production of books and essays that attempt to show that Nature is, in the long run and on the average, benevolent and acceptable to some unquestionable ethical and moral point of view. . . . Perhaps biology would have been able to mature more rapidly in a culture not dominated by Judeo-Christian Theology and the Romantic Tradition. It might have been well served by the First Holy Truth from the Sermon at Benares: "'Birth is painful, old age is painful, sickness is painful, death is painful'" (p. 255).

Other authors, frequently in far less circumspect language, quickly followed suit. Richard Lewontin, for example—a younger and perhaps less reflective Lewontin than most of us know today—wrote in 1967, in an introduction to a collection of papers on Population Biology and Evolution:

> It is unhappily true that there are population biologists who reject the analytic method and insist that the problems of ecology and evolution are so complex that they cannot be treated except by holistic statements. The influence of these people has held up progress in population biology for many years and, in addition, has tended to degrade population biology as a science. They are the stamp collectors of biology who, because

they themselves are unable to analyze the complex problems of ecology and evolution, try to convince the rest of us that nothing but "objective description" of nature is possible (1967:2).[3]

In short time, two tacit and complementary equations were collectively established: on the one hand, between conflict, competition, individualism, and scientific realism—that is, what life is really like—and, on the other hand, between cooperation, harmony, group selection, "benefit of the species," and a childish, romantic, and definitively unscientific desire for comfort and peace, benevolence, and security—indeed, motherliness itself. W. D. Hamilton, lamenting that "almost the whole field of biology [had] stampeded in the direction where Darwin had gone circumspectly or not at all," suggested that " 'Benefit of the species' can thus serve as a euphemism and as an escape from inner conflict, permitting us to pay no more emotionally than our childhood acceptance that most forms of life exploit and prey on one another" (1975:133–55). And W. Ford Doolittle's review of James Lovelock's *Gaia: A New Look at Life on Earth*— a thesis Doolittle describes as "group selection writ large"—is entitled, "Is Nature Really Motherly?" It begins: "The good thing about this engaging little book by Jim Lovelock is that reading it gives one a warm, comforting feeling about Nature and man's place in it. The bad thing is that this feeling is based on a view of natural selection . . . which is unquestionably false" (Doolittle 1981:58).

By contrast, Michael Ghiselin offers a view that he claims to be free from such sentimentalism, presented in such strong terms as to constitute a challenge, perhaps designed to expose the latent sentimentalism residual in even the toughest among us. He writes:

> The economy of nature is competitive from beginning to end. . . . No hint of genuine charity ameliorates our vision of society, once sentimentalism has been laid aside. What passes for cooperation turns out to be a mixture of opportunism and exploitation. . . . Given a full chance to act for his own interest, nothing but expediency will restrain [an organism] from brutalizing, from maiming, from murdering—his brother, his mate, his parent, or his child. Scratch an "altruist" and watch a "hypocrite" bleed (1974:24).

[3] Note, however, that Lewontin's more recent work (see, especially, Levins and Lewontin 1986) reveals a quite different view of these issues.

It appears to be with some justification, then, that Dawkins can write in 1982: "Genteel ideas of vague benevolent mutual cooperation [have been] replaced by an expectation of stark, ruthless, opportunistic mutual exploitation. . . . This kind of unsentimental, dog eat dog, language would not have come easily to biologists a few years ago, but nowadays I am glad to say it dominates the textbooks" (1982:55–56).

As it happens, in the last few years group selection has found some new advocates, especially Michael Wade and D. S. Wilson, who have provided both experimental and theoretical demonstration of many of the kinds of phenomena that Williams had dismissed as unrealistic, if not impossible. Although these authors are careful to distinguish themselves from the older tradition (sometimes referred to as "silly," or "naive" group selection), their work nonetheless demonstrates the operation of biases in what might be called the equally naive view of atomic individualism. As William Wimsatt concludes, in his review of reductionist research strategies:

> There is a strong tendency to see and to talk about groups of organisms as collections of individuals, rather than as unitary entities. . . . But description of an assemblage of units as a collection is a *theory laden description*. . . . The focus on individual organisms prevents us from at the same time seeing groups as individuals. . . . The bias [that results], I suspect, is a perceptual one (1980:249).

Rise of Competition Theory

A notably similar kind of language can be seen in a paper that serves as a precursor to the parallel shift in ecology. Garret Hardin is credited with providing a significant boost to the importance of competition in ecology in 1960 by renaming Gause's Principle, coining the term "the competitive exclusion principle." Hardin did more than provide a name: He provided a powerful rhetoric, arguing that the competitive exclusion principle is not subject to experimental verification but is simply a matter of logic, or of theory—a theory that he himself legitimates by reference to its isomorphism to economics. Like Hamilton, Hardin complains of the "bondage of psychological denial":

We stand at the threshold of a renaissance of understanding, a renaissance made possible by the explicit acceptance of the competitive exclusion principle. This principle, like much of the essential theory of evolution, has (I think) long been psychologically denied. . . . The reason for the denial is the usual one: admission of the principle to consciousness is painful. . . . It is not sadism or masochism that makes us urge that the denial be brought to an end. Rather it is a love of the reality principle. . . . To assert the truth of the competitive exclusion principle is not to say that nature is and always must be, everywhere, "red in tooth and claw." Rather, it is to point out that *every* instance of apparent coexistence must be accounted for. . . . On such a foundation we may set about the task of establishing a science of ecological engineering (1960:1297).

The shift in starting point advocated by Hardin, remarkably like the shift advocated by Williams, soon found powerful support in the community around him. A few people demurred. For example, L. C. Cole (1960:348–49) pointed out in an immediate retort to Hardin that the principle of competitive exclusion in fact contains a simple device for sidestepping any need to account for coexistence; that is, any observation of apparent coexistence can be simply attributed to a difference between niches, even if that difference is not visible. In a comprehensive review of the literature on competition published seven years later, R. S. Miller observed: "In their anxiety to 'prove' the competitive exclusion principle, ecologists have repeatedly ignored the important fact that many, if not most, laboratory studies of competition have provided better evidence of coexistence than they have of competitive exclusion" (1967:4). Such observations, however, did little if anything to slow the momentum of competition theory and growth of mathematical ecology. Within the new mathematical ecology, the concepts of mutualism and cooperation that had been significantly visible in an earlier qualitative literature simply failed to make their appearance. Even though they had long been shown to be amenable to the same kind of mathematical description as competition, mutualism and cooperation went virtually unstudied through most of the history of mathematical ecology—until quite recently,[4] simply ignored, but on occasion sub-

[4] Over the last few years, perhaps in response to criticism, theories of symbiosis and mutualism have witnessed a revival of interest almost as remarkable as the earlier disinterest (see, for example, Boucher 1985).

ject to a form of dismissal that would appear to require a concept stronger than that of neglect. I offer just one example to illustrate. An argument against the utility of studying mutualism in these mathematical models that is frequently cited after 1973 originates in a technical analysis of the "qualitative stability" of interacting populations by physicist-turned-mathematical-ecologist Volterra Robert May (1973). As it appears in the general literature, the claim takes the form, "mutualism has a destabilizing effect on communities" (see, for example, Boucher, James, and Keeler 1982; Thompson 1982; Vandermeer and Boucher 1978). Given the extensive influence of this claim, it is worthwhile, and indeed instructive, to retrace it back to its original source. As May himself acknowledges in the main text of his original paper, his result (whatever its applicability to real ecological systems) pertains equally to—indeed, cannot discriminate between—competitive and mutualist interactions. However, in the discussion and the abstract, this result undergoes an interesting elision. Where the initial statement in the text reads: "competition or mutualism between two species is less conducive to overall web stability than is a predator-prey relation," the statement in the abstract reads: "The discussion . . . suggests that on stability grounds predator-prey bonds should be more common than mutualist ones" (1973:639, 638). Finally, May's summary of this analysis in his 1974 book is as follows: "From the discussion of qualitative stability theory, it emerges that while predator-prey bonds in the food web tend to have a stabilizing influence, symbiosis or mutualism tends to be destabilizing. This suggests that stability considerations may play a part in explaining why symbiotic links between species are relatively uncommon in many natural ecosystems" (p. 4). Henceforth, no further mention appears in May's (or any other) publications about the equally "destabilizing" effect of competition, although the claim for mutualism continues, at least in some of the literature, to this very day.

Conclusion

What I suggest we can see in this brief overview of the literature is an extensive interpretation on both sides of these debates between scientific, political, and social values. Important shifts in political

and social values were of course occurring over the same period, some of them in parallel with, and perhaps even contributing to, these transitions I have been speaking of in evolutionary discourse. The developments that I think of as at least suggestive of possible parallels include the progressive encroachment of public values into the private domain of post World War II American life, the cold war, the rise of consumerism, and the flowering of what Christopher Lasch (1979) calls a "narcissistic individualism." In popular language, the 1960s gave birth to the "me" generation. Perhaps the most tantalizing analogue is suggested by Barbara Ehrenreich's argument for the emergence of a new meaning (and measure) of masculinity (1983)—an ideal of masculinity measured not by commitment, responsibility, or success as family provider, but precisely by the strength of a man's autonomy in the private sphere, his resistance to the demands of a hampering female. It is tempting to speculate about possible connections between changes in scientific discourse and developments in the social and political spheres, but such connections, however suggestive, would clearly have to be demonstrated.

For now, however, I want to focus on another kind of change—a transformation not so much in the social or political sphere as in the scientific sphere. I make this turn, or return, in support of a more complex account of scientific change that incorporates reverberations within the scientific community along with social and political changes.

In the 1960s, all of biology was undergoing a major transformation in direct response to the dramatic successes of molecular biology. These successes seemed to completely vindicate the values on which the molecular revolution was premised—namely, simplicity and mechanism. Following the victory of Watson and Crick, and of others after them, the fever of that endeavor swept through biology leaving in its wake a new standard of science, and of scientific discourse—one predicated on clarity, simplicity, and analyzability; on the definition (and implicit restriction) of legitimate questions as (or to) those capable of clear and unambiguous answers. Every biological discipline felt it—even evolutionary biology, which in some respects was at the furthest pole. Perhaps precisely because it seemed conceptually so remote, evolutionary biology may have felt it most of all. Lewontin (although elsewhere an outspoken critic of

some of the more inflated claims of molecular biology) inadvertently provides us with some direct support for this view. Indeed, he begins his introduction to *Population Biology and Evolution* (cited previously) with the following remarks:

> The twenty years since World War II have seen a vindication in biology of our faith in the Cartesian method as a way of doing science. Some of the most fundamental and interesting problems of biology have been solved or are very nearly solved by an analytic technique that is now loosely called "molecular biology." But it is not specifically the "molecular" aspect of biology of the last twenty years that has led to its success. It is, rather, the analytic aspect, the belief that by breaking systems down into their component parts, by simplifying them or using simpler organisms, one can learn about more complex systems. As it happens, the problems that were attacked and are being attacked by this method lead to answers in terms of molecules and cell organelles. . . . There is a host of problems in biology, however, that has been much neglected in these twenty exciting years, because the answers to them cannot be meaningfully framed in molecular and cellular terms (1967:2).

Lewontin is referring, of course, to problems in evolution. The remainder of his remarks is devoted to an argument for the applicability of the method, if not the content, of molecular biology to these problems. He writes, "It is not the case that molecular biology is Cartesian and analytic while population biology is holistic. Population biology is properly analytic and operates, within the framework of its own problems, by the process of simplification, analysis, and resynthesis" (1967:1). With these remarks, he leads into the criticism (quoted above) of the "holists" who have "held up progress."

This new ethic of simplicity, clarity, and mechanism—embodying the very virtues lauded by Williams—was explicitly carried into evolutionary biology in the name of scientific progress. As it happened, the values implied also fit conveniently well with other (social, political) values, each set of values providing crucial support for the other.

However substantive the scientific gains may have been in some respects, the net effect of this (now scientific/social/political) ethic has also been a systematic "perceptual bias"—a bias with profound practical consequences for the entire program of methodological individualism in evolutionary biology, if not elsewhere as well. It may

well be that the whole is equivalent to the reconstituted aggregate of its parts, if, in the process of aggregation or summation, all possible interactions among the parts are included. But if certain kinds of interactions are systematically excluded, our confidence in that program necessarily founders. My claim here is that such systematic exclusion does occur, and that it occurs on a number of different levels. To briefly review the interlocking kinds of "bias" that I see occurring in practice, I suggest the following schematic listing:

1. On the most general level: The ethic of simplicity—the privileging of certain values, even certain methodologies, as having an a priori superior claim to scientific credibility.

2. Only slightly less general, and crucially related, is the equation of "scientific" with "tractable": Given the techniques of analysis available (particularly the techniques of mathematical analysis), the equation of science with what we can do inevitably leads to a systematic technical bias favoring simplicity. That is, because we don't know how to model complex dynamics, nonlinear interactions are systematically biased against because of the limitations of our technical know-how. (There is here a further question that needs to be at least noted, namely, the development of particular techniques in response to particular demands.)

3. The consequences of this equation of the scientific with the tractable are greatly compounded by the additional equation between what we can do and what is; that is, by our temptation to confuse tractability with reality.

4. Finally, and also closely related, a further kind of elision occurs even within the confines of tractability. This kind of elision—taking the form almost of inferring tractability from one's prior assumptions of what is real—is exemplified by the history (or lack thereof) of a mathematical ecology of mutualism. Even when mutualism can be introduced into the same technical machinery (as, for example, in the Lotka-Volterra equations), it is still not pursued. The basic assumption is that competition is what is real, not because it is easier to model, but because it is what we expect. When the actual difficulties of modeling competition are then in turn suppressed, as they are in the Robert May story, what we have, given the temptation to equate the tractable with the real, are the makings of a truly self-fulfilling prophecy.

9

Between Language and Science: The Question of Directed Mutation in Molecular Genetics

◆

Francis Crick first articulated the "central dogma" of molecular biology in 1957. This principle, Crick explained,

> states that once "information" has passed into the protein *it cannot get out again.* [Italics in original.] In more detail, the transfer of information from nucleic acid to nucleic acid, or from nucleic acid to protein may be possible, but transfer from protein to protein, or from protein to nucleic acid is impossible (1957:153).

A few years later, Jacques Monod elaborated further:

> [W]hat molecular biology has done . . . is to prove beyond any doubt but in a totally new way the complete independence of the genetic information from events occurring outside or even inside the cell—to prove by the very structure of the genetic code and the way it is transcribed that no information from outside, of any kind, can ever penetrate the inheritable genetic message (cited in Judson 1979:217).

But the credit Monod attributed to molecular biology must be seen in retrospect as clearly hyperbolic. The unidirectionality of the flow of genetic information was not in fact proven by the structure of the genetic code, and even the relatively simple process of transcription then envisioned did not entirely preclude penetration of

Originally published in *Perspectives in Biology and Medicine* 35(2):292–305, 1992. I would like to thank Maurice S. Fox, Helen Longino, John Cairns, Andy Wedel, and Sahotra Sarkar for their helpful comments and discussion.

all "information from outside." Today, as the complexities of the transcription process have become vastly elaborated, and theoretical possibilities for reverse translation correspondingly easier to imagine, it should be evident that confidence in the central dogma now requires, as it indeed required then, grounds well beyond the mere logic of genetic structure.

In retrospect, it would appear, rather, that the basis for this claim lay in a consensus that had earlier emerged in the biological community, and especially among geneticists, that biological variation among individual organisms always arose spontaneously and never adaptively. Much of this consensus had been forged by the neo-Darwinian synthesis of the 1920s and 1930s. To many biologists, however, bacteria continued to provide an outstanding example of biological adaptation directly induced by environmental stress. Thus, full consensus around the spontaneous origin of biological variation—at least, in the standard account appearing in virtually all genetics textbooks of the last several decades—was cemented neither by the neo-Darwinian synthesis nor by molecular biology, but by a pivotal analysis of bacterial mutation published ten years before Watson and Crick. In their 1943 paper, "Mutations of Bacteria from Virus Sensitivity to Virus Resistance," Salvador Luria and Max Delbruck examined the origin of mutations rendering E. coli resistant to infection by the bacterial virus that is now called T1 and concluded that the presence of the selective agent (in this case, the virus itself) had no influence on the emergence of these particular bacterial mutants. (Their exact wording is as follows: "We consider the above results as proof that in our case the resistance to virus is due to a heritable change of the bacterial cell which occurs independently of the action of the virus" [1943:509].) In most textbook accounts, their proviso ("in our case") is dropped, and the work is taken as conclusive demonstration that even bacteria (which Luria himself described as "the last stronghold of Lamarckism") were organized by genes subject to spontaneous mutation, and hence to the conventional process of natural selection. With this, biology appeared, finally, to be cleansed of the last traces of Lamarckian thought.

But the ghost of Lamarck has proven curiously difficult to lay to final rest. Its resurrection has been periodically attempted ever since, and perhaps most dramatically, in a recent article in *Nature* by the highly respected and widely known molecular biologist, John

Cairns, and his colleagues. In 1988, Cairns and his colleagues published a critical review of the principal source of our belief in the "spontaneous" generation of genetic variation (namely, the Luria-Delbruck experiment), followed by a description of their own experiments suggesting that bacteria may in fact be able to "choose which mutations they should produce . . . The early triumphs of molecular biology," they conclude, "strongly supported the reductionists. . . . Now, almost anything seems possible. In certain systems, information freely flows back from RNA into DNA; genomic instability can be switched on under conditions of stress, and switched off when the stress is over; and instances exist where cells are able to generate extreme variability in localized regions of their genome" (1988:145). It is thus now both possible and, given their own experiments, in fact warranted to consider a variety of mechanisms for "the inheritance of acquired characteristics" (p. 145).

The response of the biological community was quick, and largely predictable. The paper was sharply criticized by a chorus of respondents claiming, variously, experimental inadequacy, alternative (neo-Darwinian) accounts of the results Cairns and his colleagues described, and redescriptions of the phenomenon and mechanisms the authors had either inferred or posited. Many of the technical issues of this debate remain unresolved, but from a historian's perspective, two features stand out as worthy of particular note. First is its implication for our understanding of the function the Luria-Delbruck experiment has historically served, and second, the instability of meanings it reveals of the various concepts routinely employed in such debates—"spontaneous," "random," "induced," or "directed" mutation; "selection," "choice"; and relatedly, of course, "Darwinism" and "Lamarckism" (or, more accurately, neo-Darwinism and neo-Lamarckism).[1]

The first point is relatively straightforward. It pertains to the utter

[1] Indeed, Darwin himself worried a great deal about the origin of variation, and considered a wide range of possible mechanisms, including the Lamarckian notion of "use and disuse." The actual writings of Lamarck, on the other hand, may provide an even less useful reference point for these discussions given Lamarck's focus on organs rather than genes (a concept that was not available to him). In contemporary usage, the terms "Darwinian" and "Lamarckian" have come to take meanings more properly associated with discussions that followed both Darwin and Lamarck than with what these particular authors had to say on the subject.

lack of interest the respondents express in Cairns et al.'s opening refutation of the traditional interpretation of the Luria-Delbruck experiments. The authors observe that since the acquisition of resistance to viral infection is known (and has been known for more than thirty-five years) to require several generations to express itself, the original experimental design was not capable of registering the presence of such mutations as might have been induced by the selective agent. "So," the authors observe, "these classical experiments could not have detected (and certainly did not exclude) the existence of a non-random, possibly product-oriented form of mutation" (p. 142). This piece of "news" is not contested—indeed, it is widely acknowledged, though regarded as inconsequential. It is not mentioned in any of the published responses to Cairns et al., and informal inquiry suggests that to most readers, the fact remains that Luria and Delbruck were "right," even if for the "wrong" reasons. Furthermore, since the criticism leveled by Cairns and his colleagues is based on information that has long been common knowledge to molecular geneticists, it is not even "news."

This marked lack of concern with the accuracy of their own historical account, especially given the important place conventionally assigned to these experiments in the history of twentieth-century biological thought, invites examination. At the very least, it might tell us something about the attitude of working scientists toward historical narrative, their own or others'. In particular, it suggests a view in which history, unlike science, is not intended to be correct in a factual sense, but only in a moral sense, by which I mean correct in its overall moral—a view in which the function of history, again unlike science, is taken to be frankly edifying rather than informative.

But it is the instability of meaning of the relevant terms of the exchange on which I wish particularly to dwell here. Most of these terms have been subject to multiple meanings throughout their usage in biological literature, and it is almost invariably instructive to examine such conceptual multiplicity (see, for example, Keller and Lloyd 1992, especially the entries by Lennox, Bowler, and Ruse for an examination of some of the terms involved here). Typically, these multiple meanings are not separable in the discourses in which they occur, but coexistent and endemically oscillatory; in this way, they constitute effective reservoirs of meaning on which the overall

arguments tacitly depend. For the sake of specificity, however, I want in this paper to limit my focus to the instability of meanings of the terms "directed" and "spontaneous" mutation employed in the debate provoked by Cairns and colleagues[2]; to the consequent tension that has been generated between alternative descriptions and interpretations of their observations; and to the possibility of embedding these observations, alternatively, in a "Darwinian" or a "Lamarckian" framework.

Descriptive Latitude

To clarify the different levels on which redescription and reinterpretation are possible, it is useful to distinguish between (a) the observation(s) as reported, (b) the phenomenon inferred from this observation(s), and (c) the mechanisms hypothesized to account for such a phenomenon as each of these appears in the original paper by Cairns et al.

(a) The observation (for simplicity, I limit myself to the first of their experimental findings): The distribution of Lac— to Lac+ mutants appearing on plates in which lactose provides the sole energy source is at odds with the distribution expected from a population in which all of the mutants were preexisting, indicating the emergence of at least some of these mutations *after plating*. Similar increases in the frequency of valine resistant mutants were not observed. (None of the respondents discussed below questions this basic observation, and in a more recent paper, Cairns and Foster [1991] report an even stronger finding. They write, "Using the same battery of tests, we have studied two strains of *Escherichia coli* that constitutively express *lacZ* alleles bearing frameshift mutuations. Each test suggested that most of the Lac+ revertants detected on lactose plates arose after lactose had become the only source of energy. No revertants accumulated in the absence of lactose, nor

[2] In this paper alone, one finds the explicit invocation of seven different senses of the term "directed mutation," and three different senses of "spontaneous" mutation, used more or less interchangeably. Similar kinds of ambiguity can also be found in the responses this paper generated, but the sets of meanings deployed tend to vary with the orientation and particular commitments of each author.

did they accumulate in the presence of lactose if there was another, unfulfilled requirement for growth.")

(b) The phenomenon inferred from this observation is variously described by Cairns et al. as suggesting "the production of appropriate mutations in response to selection" (1988:144); "that populations of bacteria, in stationary phase, have some way of producing (or selectively retaining) only the most appropriate mutations" (p. 145); "that bacteria can choose which mutations they should produce" (p. 145). These various descriptions are subsumed by Cairns et al. under the term "directed mutation."

(c) To account for such a phenomenon of "directed mutation," Cairns et al. argue for "some *reversible* process of trial and error" (italics mine), suggesting a range of mechanisms, one of which effectively enables a transfer of information from protein to DNA. They speculate, for example, that "the cell could produce a highly variable set of mRNA molecules and then reverse-transcribe the one that made the best protein," or, more simply, "that made it able to grow." For this, the cell would need "some element that somehow monitors the protein product and determines whether the mRNA should go on being translated or should be transcribed into DNA . . . in effect," they conclude, "provid[ing] a mechanism for the inheritance of acquired characteristics" (p. 145).

Responses

In the volley of responses that quickly followed, redescription—primarily of the phenomenon and mechanisms suggested—provides the principal tool for managing the heresy of the original argument. With these redescriptions, the meaning of the basic observations is transformed.

The first, and perhaps friendliest, response appears in Franklin Stahl's recounting, published under "News and Views" in the very same issue of *Nature*. Here, the basic observations stand essentially intact, and the inferred phenomenon only slightly modified:

[The authors] show that these mutations to lac+ happen only if lactose is present on the plates. Mutations to other phenotypes, which confer no selective advantage, do not occur. Additional experiments further the

iconoclastic view that bacteria have mechanisms for making just those mutations that adapt the cell to an available energy source (1988:112).

But in his discussion of possible mechanisms, Stahl quickly moves to distance himself and the authors from the imminent threat of heresy. He writes:

> What's up? Can bacteria really direct their mutational processes? Did bacteria discover 'directed mutagenesis' before the genetic engineers did? Cairns et al. appear to eschew such an idea. . . . More attractive, the authors suggest, is some sort of trial-and-error mechanism that allows the selection of serendipitous molecular misconceptions that have an adaptive phenotype, with the selection operating at the molecular level rather than at the level of the cell (p. 112).

To account for the phenomenon (now distinguished from "directed mutagenesis"), Stahl himself proposes a "trial-and-error" mechanism that is an elaboration of one of Cairns et al.'s own, emphasizing its enabling of "selection" rather than its "reversibility"; although this "trial-and-error" mechanism is in fact also (at least transiently) reversible, it requires neither the presence of reverse transcription nor the repudiation of the central dogma. It merely requires the assumption (evidently more palatable) that the normal mechanisms of mismatch repair be impeded by starvation. The effect of such reduced efficiency of repair is an increased production of nonspecific mutants upon which selection can act. As Stahl (1988:113) explains, "Polymerase-catalyzed DNA synthesis has a mistake rate that is thousands of times higher than the observed mutation rate of freely growing cells. The fidelity normally observed is achieved by the action of post-replicative mismatch-correction enzymes . . . To a good approximation, we can say that mutations result only when these correction systems fail . . . In the lucky event that a synthesized DNA segment is adaptively mutant . . ., the resulting ability to utilize the lactose stabilizes the mutation by allowing the cell to replicate its chromosome"—and thus to fix the mutation in duplex DNA.

The key issue in these two readings does not revolve around the basic observation, nor even around the existence of the inferred phenomenon, but around its naming, and its meaning. The underlying question is whether one can encompass mutations that are preferentially induced or stabilized in a Darwinian framework, re-

lying solely on the language of chance and selection, or whether it is necessary to have recourse to a Lamarckian language of purpose and choice. For some authors,[3] a tacit equation is assumed between "Lamarckian" explanations and the violation of the "central dogma" of molecular genetics. For many of the other participants in this debate, the very phenomenon of preferential mutations—even when re-presented in Stahl's language of chance and selection—is seen as undermining the neo-Darwinian orthodoxy and as having "onerous implications for bacterial genetics" (Lenski, Slatkin, and Ayala 1989) and is, accordingly, itself put into question. Charlesworth et al., for example, write, "This conclusion is at variance with the neo-Darwinian orthodoxy that mutations occur strictly at random with respect to any challenge" (1988). And although Lenski et al. sharply distinguish this phenomenon (which they call "directed mutation") from "inheritance of acquired characteristics," they insist that "it is imperative to consider alternative hypotheses that might account for the same observations" before the hypothesis of directed mutation is accepted (1989). In pursuit of such alternative hypotheses, four of the respondees suggest differential growth or survival rates of these particular mutants as an alternative way of accounting for Cairns's observations (Charlesworth and Charlesworth 1988; Tessman 1988; Partridge and Morgan 1988; Lenski et al. 1989). In an effort to eliminate the need for supposing *any* form of selection-dependent mutation, they develop models premised on differentially growing mutants, fault Cairns et al. for omitting controls relevant to these alternative models, and propose experiments designed specifically to detect such differences. Cairns retorts that his own observations persuade him that these alternative explanations "are not very likely." More important, however, he notes that the special properties of the new mutants assumed in these models render them "just another way of describing the very anomalies we are seeking to explain" (1988). In conclusion, he registers a note of protest:

We now know that, in the processing of biological information, almost anything is possible. Sequences are spliced, rearranged, cast aside, res-

[3] See, for example, Davis (1989) and his proposal of a mechanism for preferential mutation through "selective transcription" as a way of accounting for the observations of Cairns et al. that does not require the transfer of information from protein to nucleic acid.

urrected, and to a limited extent may even be invented when the need arises, and so it should not be difficult for an organism to devise a way of testing phenotype before adopting the new genotype. It therefore seems almost perverse to maintain, as a matter of principle, that such a mechanism has never evolved (p. 528).

Clearly, more than one issue is at stake, as is more than one notion of "perverse." To the extent that the phenomenon inferred by Cairns et al. can be interpreted in terms of selection operating at the molecular level, one can detect in the resistance surviving even Stahl's re-presentation of that phenomenon at least a tacit preference for natural selection operating on individual organisms. Perhaps by virtue of its proximity to the idea of cellular agency (or "choice"), the very idea of intracellular selection, whether called "directed mutation" or not, seems to evoke distaste. Here as elsewhere, the primary concern that surfaces in virtually all the responses seems to be to avoid any language associated with intentionality, and more specifically, with Lamarckism.

This concern is identified explicitly by Lenski, Slatkin, and Ayala (1989). Although the main point of their paper is to argue against the "hypothesis of directed mutation" put forth by *both* Stahl and Cairns et al. (and now by Barry Hall as well 1988; 1989; 1990a and 1990b), and in favor of alternatives involving "selection at the level of individuals within populations," they "do not reject outright the potential for selection acting on molecular variation within cells to produce changes in gene frequency." "There is," they acknowledge, "an extensive literature in evolutionary biology concerning the potential for selection to act at different levels of organization" (p. 2777). But they are adamant on their "disagree[ment] with the assertion of Cairns et al. that directed mutation in bacteria (if it is demonstrated to exist) could 'provide a mechanism for the inheritance of acquired characteristics.' " They conclude, "Regardless of the outcomes of further research, the hypothesis of directed mutation should not be equated with the notion of inheritance of acquired characteristics" (Lenski et al. 1989:2778).

But just in case it should prove impossible to maintain this penultimate distinction, Bruce Wallace (1990) offers one further—and surely final—line of defense. He writes:

If, however, the complex organelle described by Cairns and his colleagues

169

were to be discovered, . . . an earlier argument reappears: such organelles do not arise de novo in response to novel challenges . . . [I]t would appear that the only Lamarckian mechanism that would function efficiently is one that must be assembled under Darwinian-style natural selection. . . . I, for one, consider it ironic that the postulated Lamarckian mechanism is one that . . . when perfected, illustrates the power of Darwinian selection (p. 332).

Before moving on to the discussion, however, it is important to note that Cairns et al. have also had their supporters. In a series of papers published since the original paper by Cairns et al., Barry Hall has described extensive experiments supporting their original findings. Hall insists, "The phenomenon that Cairns describes is real. Mutations that occur more when they're useful than when they're not: That I can document any day, every day, in the laboratory" (1990b). But the absence of a similar volume of response to his intervention may reflect a lesser interest rather than greater acceptance. A factor of major relevance here is that, in his scientific papers, Hall's interpretations are couched in the most cautious language possible and, for this reason, have largely eluded the emotional charge that the work of Cairns et al. triggered. (It is also likely to be relevant that Hall enjoys neither the same degree of seniority or of visibility that Cairns enjoys.) But whatever the reasons, the fact remains that, despite his more extensive evidence, Hall has still not succeeded in eroding the skepticism of the larger community for which he writes.

Discussion: Making Sense of the Debate

To properly understand the vicissitudes of this debate, it is of course necessary to embed it in the entire history of debate over the meanings, and place, of chance and purpose in modern biology. Such an embedding necessarily entails an analysis not merely of language, but of language in the context of scientific, political, and ideological developments. Clearly, that task goes well beyond the space of a single paper. Instead, my (only slightly more modest) aim here has been to focus on the deployment of these concepts in their contemporary scientific context. One relatively straightforward argument that I suggest can be made from even this limited focus is for the

operational inadequacy of any representation that issues from the assumption of a dichotomy between "chance" and "purpose." To make this argument, it is useful to begin by examining the various meanings of the term "spontaneous mutation."

Mutations described as "spontaneous" are generally understood to be mutations that would have arisen even in the absence of selection. Thus, for example, the Luria-Delbruck experiments are described as attempting to distinguish mutations "that arise after plating, in response to the attack by the bacteriophage," from those that "arise spontaneously" (for example, Cairns et al. 1988). As Delbruck himself wrote, "The question had never been settled whether these variants are produced in response to the action of the added virus or whether they occur spontaneously" (see Fisher and Lipson 1988). In their original paper, Luria and Delbruck (1943) in fact conflate "spontaneous" with "mutation," explaining that their purpose is to distinguish between the hypothesis of "mutation" to immunity (where by "mutation" they mean a change occurring "independently of the virus") and that of "acquired immunity." In a subsequent discussion, however, Delbruck, while not questioning their conclusion itself, did acknowledge the need for more careful delineation of the concept of "spontaneous" mutation.[4] There he points out that

> an obvious question to ask [is] whether [the selective environment] had an influence on the mutation rate, and as long as this has not been ruled out the designation 'spontaneous' would seem improper. In view of our ignorance of the causes and mechanisms of mutations, one should keep in mind the possible occurrence of specifically induced adaptive mutations of this kind, or should exclude their occurrence in a variety of specific cases (1946:154).

The criticism leveled by Cairns et al. (1988) at the conclusions initially drawn by Luria and Delbruck and perpetuated by subsequent generations of geneticists is based on the fact that their experimental design was incapable of recording mutants that might arise after plating, and therefore would not be "spontaneous." Yet, by another commonly accepted meaning of the term, mutants arising after plating, even in response to the selection pressure, could also

[4] I thank John Cairns for calling my attention to this reference.

be regarded as "spontaneous"—in the sense, now, of not being "product-oriented," or "directed."

Perhaps out of a tacit recognition of the insufficiency of the first definition, and out of the felt need to register this further distinction, "spontaneous" tends on other occasions to be taken to be synonymous with "random." The term "random" however has proven notoriously difficult to define with precision, even by mathematicians, and biological use of the term is inevitably colloquial. Indeed, William Wimsatt (1980) has argued that the use of the term in evolutionary biology suggests that randomness is largely "in the eye of the beholder." An attempt at a more precise, and workable, definition has now been made by Sahotra Sarkar (1991). Sarkar introduces a "weak notion of randomness" according to which "a mutation of a gene is random if and only if the probability of its occurrence in an environment has no correlation with the fitness of the phenotype induced by it in that environment." Here, however, the weight of ambiguity is inadvertently shifted to the term "mutation." In an attempt to resolve the difficulties that arise from this latter ambiguity, Sarkar, later in the same paper, introduces the helpful distinction between "variant" strands of DNA and RNA and "mutations."[5]

More generally, however, "random" is taken to mean, variously, fortuitous, accidental, or haphazard—in short, implying the "absence of fixed aim or purpose" (Webster). Such an opposition of "fixed aim or purpose" to "random" or "spontaneous" leaves a large domain of intermediate phenomena undescribed—in particular, all those mutations that might arise as a result of increased rates of overall mutation induced by specific kinds of selection pressure, but that are not themselves "product-oriented" (for example, stress-induced mutagenesis), as well as such mutations as would result from biased increases in mutation rates (resulting, for example, from a reduced efficiency of repair mechanisms in the presence of a selective agent). This intermediate domain is precisely the domain in which the debate about the origin of mutants tends to wreak havoc.

Instances of mutants arising only in the presence of a selective agent—for example, the mutations from Lac− to Lac+ which Cairns

[5] I am grateful to Sarkar for sending me his manuscript as I was preparing the final revisions of this paper.

et al. found to occur preferentially in media containing lactose as the sole energy source—clearly violate the first definition of "spontaneous" mutation, but they are nonetheless not in themselves assumed to be newsworthy. They become newsworthy only when coupled with the observation that other mutations, conferring no selective advantage, do not arise at the same time. In this way, phenomena of stress induced mutagenesis in which starvation increases the overall mutation rate are tacitly elided from the discussion, and debate over whether or not mutations are "spontaneous" is confined to the meaning of the preferential production of those mutants that carry a selective advantage.

To Cairns et al., such phenomena imply that bacteria "can *choose* which mutations they should produce." They suggest that molecular biologists have now documented so complex a dynamic of genomic instability that it is no longer implausible to consider (and actually look for) mechanisms by which cells could effect informational transfer from protein to DNA—that is, mechanisms that would enable the cells "to exercise some choice over which mutations to accept and which to reject."

In the context of modern biological discourse, this language is sufficiently heretical (or, in Mary Douglas's sense of the term, "dangerous") to jeopardize the very existence of the phenomenon. Thus, in an effort to save the phenomenon (and perhaps the authors as well), Stahl offers a crucial redescription of both the phenomenon and the mechanisms envisioned in which he replaces the terms of "choice" and "direction," by those of "trial-and-error," "luck," and "serendipity" and suggests a mechanism of "selection" based on the notion of "variable efficiency of repair mechanisms" in lieu of a process based on notions of internal "monitoring" and "reverse flow of information." Although both the mechanisms proposed by Stahl and by Cairns et al. depend on kinds of positive feedback that could be thought of as "reverse flow of information," their choice of language suggests otherwise. For example, in his thoughtful review of these papers, Sarkar (1991) writes of Stahl's mechanism that "the underlying genesis of variants is, *formally*, neo-Darwinian in the sense that there is random variation and natural selection. . . . However, it is not completely clear whether the same can be said about the mechanisms hypothesized by Cairns, Overbaugh and

Miller" (p. 258)[6]. It is precisely this doubt that Stahl seeks to lay to rest. The net effect of his redescription is thus to subtly but decisively draw the phenomenon—and with it, the authors—back into the Darwinian fold.

To others, however, the Darwinian mantle appears notably less commodious. For these, their very commitment to Darwinism thus prompts either a rejection of, or at least a principled disinclination toward, the very possibility of preferential mutation, and their efforts are accordingly directed toward a search for alternative ways to account for the basic observations. Cairns, in turn, regards such a stance as "perverse." He evidently believes that scientists should be more open to novel kinds of evidence, especially in a domain that has not already been foreclosed by decisive experiment. In short, to Cairns, the critics seem less than "objective." But even discounting Cairns's confidence in the possibility of a neutral stance, and even acknowledging the inevitable restrictiveness of all language and all categories, his intervention does bring to light the singular impoverishment of the particular categories that have traditionally been employed in this classic controversy.

In particular, for all authors, the opposition of "spontaneous" or "random" to "directed" or "purposive" removes the entire range of stress-induced but nonspecific increases in mutation rates from discussion, and the opposition of Darwinian to Lamarckian inclines at least some authors to exclude the more specific range of phenomena I am calling "preferential mutation" from investigation. Examples of stress-induced mutagenesis have been abundantly documented in the literature of molecular biology, and their elision from this particular discussion is notable. By contrast, the possibility of specifically induced adaptive mutations (for example, effected by preferential repair) is seen by most authors as explicitly destabilizing to the discussion.[7]

[6] The distinction is drawn even more sharply in a request by an anonymous referee for clarification. He writes, "[Stahl] postulates reverse flow of information only among nucleic acids and not from protein, as Cairns does; the difference is crucial."

[7] An exception is Bernard D. Davis (1989), who suggests that the "ability of potential substrates to selectively promote adaptive mutations" offers an "escape [from] an artificial dichotomy." He writes:

The meaning of randomness in mutations provides the key to this escape.

Perhaps the perception of preferential (or adaptive) mutations as theoretically problematic has had something to do with the fact that examples of such mutations have rarely been pursued; in any case, they are surely less well documented than instances of nonspecific increases in mutation rates. Cairns is undoubtedly right, however, in suggesting that they are readily imaginable within the larger phenomenological context of contemporary molecular biology, and some instances of context-dependent efficiency of repair have in fact now been observed (see, for example, Yamamoto and Fox 1990; Hanawalt 1989).

Given that at least some of the limitations of these particular categories can now be articulated, it would appear as if the moment has arrived when a shift in language is both possible and desirable. By way of illustration, I would like to propose one such representational shift, invoking a metaphor for evolution borrowed from the very different domain of bacterial chemotaxis.

The behavior exhibited by bacteria exposed to chemical gradients suggests a formal analogy to that observed by Cairns et al. (1988). In particular, it was noticed in the 1960s that bacteria tend to swim toward higher concentrations of certain substrates that are required for metabolism. The question that arose when this phenomenon first came to the fore was this: How could a microscopic single-celled organism, lacking in both sensory apparatus and significant spatial extent, possibly have the capacity to assess a macroscopic spatial gradient? Thus posed, the dilemma seemed unresolvable. Yet, by a shift in focus from the individual cell to the population, a surprisingly simple answer came readily into view: An individual bacterium does not need to "see" a gradient for a chemotactic response on the level of the population; it suffices for the individual to execute a "random" motion, as long as the efficiency of the mechanism re-

Used to mean an undirected process, occurring by chance in any gene, this term has become firmly embedded in classical genetics. But equally clearly, randomness in the strict mathematical sense, as equal probability, does not apply to the genome at the level of nucleotides or of short sequences surrounding a site of mutation. The notion of biased randomness is thus not a radical one; it has been with us since the discovery of fine-structure genetics, with its recognition of mutational hot spots. Here I am simply extending the notion to longer sequences, subject to influence by the environment (p. 5008).

sponsible for the motion of its flagella can be assumed to vary with the local concentration of substrate (see Keller and Segel 1971). In this redescription, bacterial chemotaxis appears as a form of "Brownian motion," in which a bias in individual motility (induced by spatial or temporal fluctuations in local concentration of substrate) translates into a net flux "upstream." Furthermore, once the notion that the bacterial cell must be able to assess the macroscopic gradient is abandoned, it becomes a trivial exercise to imagine, to look for, and even to observe successive refinements in this rudimentary mechanism that would increase the apparent "purposiveness" of bacterial motion without ever requiring "purpose" on the level of the individual cell.[8] The net effect of such a redescription is to displace the dichotomy between "chance" and "purpose" altogether, and replace it with a continuum of increasingly complex but entirely mechanistic networks of chemical interaction.

The analogy with mutation and evolution is as follows: If the motion of the individual flagellum is taken as a metaphor for mutation, and the net bacterial flux for adaptation, this system provides a model for thinking about an entire range of phenomena *between* "spontaneous" and "directed" mutation, and accordingly, *between* "Darwinian" and "Lamarckian" evolution. Even the nonspecific mutations arising in response to selection pressure (for example, stress-induced mutagenesis) find a place in this scheme. While neither "directed" nor adaptive on the level of the individual cell, they inevitably lead to an increase in the overall frequency of useful mutations, and thus could be said to be adaptive on the population level. Similarly, the phenomenon of preferential mutation would not require the supposition either of foreknowledge or intentionality on the part of the cell, but merely the dependence of mutation frequency on the functionality of the specific sequences involved.

[8] One such refinement that rapidly came into view suggests that the individual bacterium, through a rudimentary mechanism enabling a comparison between past and present, can actually "detect" a temporal (though still not a spatial) gradient in its immediate, local, environment (see Berg and Brown [1972];, Macnab and Koshland 1972).

Conclusion

Interpretations (or descriptions) are cashed out in experiments, with different interpretations leading to the design and execution of different kinds of experiments. When successful, they point the way to observations of different kinds of phenomena, which, in turn, are taken to lend credence to the interpretations that generated them in the first place. It is in this sense that, even under a realist view, one could say that language "constructs" knowledge. By simultaneously facilitating certain research trajectories, and foreclosing others, descriptions shape the construction (or articulation) of the edifice we call scientific knowledge (see, for example, Hacking 1988).

The developments of molecular biology were framed and guided by a representation of "chance" and "purpose" as opposing and mutually exclusive categories. For many years, that linguistic frame proved to be extraordinarily productive. It led to the observation of many phenomena that seemed to provide stunning confirmation of just such an opposition. Over the course of time, however, it led also to the exposure of other kinds of phenomena, less readily encompassed within the original frame. Not surprisingly, attempts to cope with these aberrant phenomena tend (thus far at least) to seek recourse to the original categories of "chance" and "purpose," with different readings relying on different demarcations between the two. Each such attempt points to particular kinds of experiments, prompting the search for phenomena appropriate to and subsumable under its own particular demarcation. In like manner, the alternative description I have outlined above also points to the search for phenomena subsumable under its categories.

In suggesting this alternative as in some sense an "improvement" over prevailing descriptions, I do so with the full realization that judgment can only be meaningful within the available theoretical and experimental context. "Between language and science" there is no empty space in which such a judgment, taken as absolute, could possibly reside. Between language and science there is only the world, constituted simultaneously and interactively by language and by experience. That such a judgment could have meaning at all derives not from the independence of language and experience, but from their coexistence. Only by their coexistence could one begin to notice the insufficiency of a particular language. Yet, so bound

are we by the interdependence of language and experience that we can only see and speak of alternative possibilities out of the congruences between the two that have already been forged by our preexisting categories. Nonetheless, within the very limited range of possibilities available to us at any particular point in time and place, we might still be able to recognize some as more expansive or less exclusionary than others, and in that sense alone, as more productive.

Epilogue

\blacklozenge

As the year 2000 draws near, apocalyptic strains abound at the outer edges of the academy on virtually all sides, though perhaps especially in the humanities and the natural sciences. At one extreme, the archtheorist of the postmodern condition, Jean Baudrillard, tells us that we live in an age in which the order of "simulacra" has displaced the real, in which "the whole environment becomes a signifier, objectified as an element of signification" (Kellner 1989:77). "Gone are the referentials of production, signification, affect, substance, history . . . [F]rom now on signs will exchange among themselves exclusively, without interacting with the real" (p. 63). If such entities as subjects, motivated by desire and intention, ever did exist, they clearly do no longer; the subject has been vanquished by "the sovereign power of the object" (p. 157).

At the other extreme of realist scientific discourse, human subjects are equally invisible, their material, embodied presence equally ephemeral and inconsequential. As the search of particle physicists for the building blocks of matter leads them into the realm of the vanishingly small and evanescent, the search of biologists for the building blocks of life leads them into the realm of pure information. The genes that "make us what we are" (for example, Watson 1990) are presented not only as having no need of the bodies in which they are housed for the processes of "reading" and "interpretation"; they no longer need even their own chemical structures for their existence. The substantive component of the gene is said to lie in

179

its nucleotide sequence, and that can be stored in data banks and transmitted by electronic mail.

For all the divergences between advocates of the autonomy of language and those of the autonomy of science, one cannot but be struck by their resonances, by their convergent embrace of the very romance of disembodiment (the hope, as Daniel Hillis has put it, that "human thought [may] live free of bones and flesh" [1988:189]) that has both prodded and pursued us through this entire millennium. The essays of this book have been written in opposition to that romance—as part of the effort to map, between language and science, the realm of embodied human actors without whom there would be neither language nor science. My starting proposition is self-evident: Science is a product of human actors, engaged in material interactions with the objects they encounter, and attempting to craft those interactions into a way of making sense of the world— especially, the kind of sense that will foster the dual prospects of agency and control. Equally self-evident is my assumption that if the experience of those interactions is to be cumulative, it must be encoded, interpreted, and communicated. In other words, scientists must be language users. Language provides them with the vehicle through which they "make sense" of their actions, and by which they communicate that sense to others. Necessarily, it is an imperfect vehicle—simultaneously limited and enabled by the very finitude and the material and social locatedness of its creators.

The imperfections and versatility of language on the one hand, and the finitude and locatedness of experience on the other, are both central concerns for many contemporary historians and philosophers of science. These concerns stand in striking contrast to some of the most traditional aspirations of modern science. From my own days in theoretical physics, I can still recall the immense appeal of the dream of a unified theory (a theory of everything), and of the closely kindred idea that one might deduce the entire structure of the universe from pure thought—free of the vicissitudes of either language or material or social experience. But if the history of physics has taught us anything, it has taught us that such fantasies of omniscience (or omnipotence) are just that, fantasies, yet at the same time, immensely powerful sources of motivation for their own nec-

essarily imperfect realization[1]. Today, even some theoretical physicists have begun to give up on the idea of a unified theory, and to settle instead for the acceptance of more local successes—pieces of theory inevitably rooted to their particular contexts, yet also ("always already") informed by all the other pieces of theory to which— thanks to the latitude of metaphor—they can attach, more or less consistently (see Cao and Schweber 1992).

Just because we are finite beings, located, situated, embodied, we can, and can only, muddle through—sometimes with more success than at others. Scientists muddle through with staggering success. Only their success is rather different than they imagine. It depends not on any possibility of translating thought into action, but on the conjoining practices of a colluding community of common language speakers. Our task as historians and philosophers of science is to make sense of the successes of science in terms of the particular linguistic and material conventions that scientists have forged for their sorts of muddling through.

Imperfect because fantasies in science (unlike in ordinary life) do not translate into action no more so than do theories.

References

Abir-Am, P. "Themes, Genres and Orders of Legitimation in the Consolidation of New Scientific Disciplines: Deconstructing the Historiography of Molecular Biology." *History of Science* 23:73–117, 1985.

Abugov, R. "Genetics of Darwinian Fitness: 1. Fertility Selection." *The American Naturalist* 121(6):880–86, 1983.

Axelrod, R. *The Evolution of Cooperation.* New York: Basic Books, 1984.

Beer, Gillian. "The Face of Nature." In *Languages of Nature*, ed. L. Jordanova, 212–43, New Brunswick, NJ: Rutgers Univ. Press, 1986.

Berg, H. C., and and D. A. Brown. Chemotaxis in *Escherichia coli* Analyzed by Three-dimensional Tracking. *Nature* 239:500–4, 1972.

Bernal, J. D. "Definitions of Life." *New Scientist* 3 January: 12–14, 1967.

Bernstein, H., H. C. Byerly, F. A. Hopf, R. E. Michod, and G. K. Vemulapalli. "The Darwinian Dynamic." *Quarterly Review of Biology* 58:185–207, 1983.

Bettelheim, B. *Symbolic Wounds, Puberty Rites and the Envious Male.* New York: Collier Books, 1955.

Birch, L. C. "Meanings of Competition." *American Naturalist* 91:5–18, 1957.

Bodmer, W. F. "Differential Fertility in Population Genetics Models." *Genetics* 51:411–24, 1965.

Bohr, N. "Light and Life." In *Atomic Physics and Human Knowledge*, New York: John Wiley and Sons, 1958.

Boucher, D. *The Biology of Mutualism*. New York: Oxford Univ. Press, 1985.

Boucher, D. H., S. James, and K. Keeler, "The Ecology of Mutualism," *Ann. Rev. Ecol. Syst.* 13:115–47, 1982.

Bowler, P. "Preformation and Pre-Existence in the Seventeenth Century." *J. Hist. Biol.* 4:221–44, 1971.

Boyle, R. *The Works of Robert Boyle*, ed. Thomas Birch, 5 vols. London: A. Millar, 1744.

Boyle, R. "An Invitation to a Free and Generous Communication of Secrets and Receipts in Physick." In *Chymical, Medicinal and Chyrurgical Addresses: Made to Samuel Hartlib. Esquire*, ed. Samuel Hartlib, pp. 113–50. London, 1655.

Brandon, R. "The Levels of Selection." In *P.S.A 1982*, ed. P. Asquith and T. Nickles. East Lansing, MI: Philosophy of Science Association, 1982.

Brandon, R. and R. Burian. *Genes, Organisms, and Populations*. Cambridge, MA: MIT Press, 1984.

Byerly, H. "Fitness as a Function," Paper presented at the P.S.A. meetings, Pittsburgh, 1986.

Cairns, J. "Response." *Nature* 336:527–28, 1988.

Cairns, J. and P. Foster. "Adaptive Reversion of Frameshift Mutations in the *lacZ* Gene of *Escherichia coli*," *Genetics*, 128(4):695–701, 1991.

Cairns, J. J. Overbaugh, and S. Miller. "The Origin of Mutants." *Nature* 335:142–45, 1988.

Cao, Tian Yu and Sylvan S. Schweber, "Conceptual Foundations and Philosophical Aspects of Renormalization Theory," to appear in *Synthese*, 1993.

Carlson, E. A. "An Unacknowledged Founding of Molecular Biology: H. J. Muller's Contributions to Gene Theory, 1910–1936." *Journal of the History of Biology* 4:149–70, 1971.

Cartwright, N. *Nature's Capacities*. Oxford: Oxford University Press, 1990.

Charlesworth, B. *Selection in Age-Structured Populations*, Cambridge Studies in Mathematical Biology, vol. 1, Cambridge, Eng.: Cambridge University Press, 1980.

Charlesworth, B. "Selection in Populations with Overlapping Gen-

erations; I. The Use of Malthusian Parameters in Population Genetics." *Theoretical Population Biology* 1(3):352–370, 1970.

Charlesworth, D. and B. Charlesworth. "Letter to the Editor." *Nature* 336–525, 1988.

Christiansen, F. B. "The Definition and Measurement of Fitness." In B. Shorrocks, ed., *Evolutionary Ecology; B.E.S. Symposium* 23:65–79, 1983.

Christiansen, F. B. and M. Feldman. *Population Genetics.* Palo Alto, CA: Blackwell Scientific Publications, 1986.

Churchill, F. B. "Sex and the Single Organism." *Studies in the History of Biology* 3:139–177, 1979.

Cohn, C. "Sex and Death in the Rational World of Defense Intellectuals." *Signs* 12(4): 687–718, 1987.

Cole, L. C., "Competitive Exclusion," *Science* 132:348–9, 1960.

Colinvaux, P. *Why Big Fierce Animals Are Rare.* Princeton Press, 1978.

Crick, Francis. *Life Itself.* New York: Simon and Schuster, 1981.

Crick, Francis. "Central Dogma of Molecular Biology." *Nature* 227:561–63, 1970.

Crick, Francis. *Of Molecules and Men.* Seattle: Univ. of Washington Press, 1966.

Crick, Francis. "On Protein Synthesis." *Symposium of the Soc. of Exp. Biology* 12:138–63, 1957.

Davis, B. D. "Transcriptional Bias: A non-Lamarckian Mechanism for Substrate-induced Mutations." *Proc. Natl. Acad. Sci. USA* 86:5005–09, 1989.

Dawkins, Richard, *The Extended Phenotype.* San Francisco: W. H. Freeman, 1982.

Dawkins, R. *The Selfish Gene.* Oxford: Oxford Univ. Press, 1976.

Deason, G. "Reformation Theology and the Mechanistic Conception of Nature." In *God and Nature,* ed. D. Lindberg and R. Numbers. Berkeley: Univ. of California Press, 1986:167–91.

Delbruck, M. "A Physicist's Renewed Look at Biology: Twenty Years Later." *Science* 168:1312, 1970.

Delbruck, M. "Discussion." *Cold Spring Harbor Symposium* 11:154, 1946.

Dennis, M. A. "Accounting for Research: New Histories of Corporate Laboratories and the Social History of American Science." *Social Studies of Science* 17:479–518, 1987.

Denniston, C. "An Incorrect Definition of Fitness Revisited." *Annals of Human Genetics*, Lond., 42:77–85, 1978.

Doolittle, W. F., "Is Nature Really Motherly?" *CoEvolution Quart.* 29:58, 1981.

Dulbecco, R. *The Design of Life.* New Haven, CT: Yale Univ. Press, 1987.

Dundes, A. "A Psychoanalytic Study of the Bullroarer." *Man* 11:220–238, 1976.

Dupree, A. H. "Government and Science in an Age of Scientific Revolution," *Science* 135:1119–21, 1962.

Eamon, W. "Arcana Disclosed: The Advent of Printing, the Books of Secrets Tradition and the Development of Experimental Science in the Sixteenth Century." *Hist. Sci.* xxii:111–150, 1984.

Easlea, B. *Fathering the Unthinkable: Masculinity, Scientists, and the Nuclear Arms Race.* London: Pluto Press, 1983.

Ehrenreich, Barbara, *Hearts of Men.* Garden City, NY: Doubleday, 1983.

Emerson, Alfred, "Dynamic Homeostasis: A Unifying Principle in Organic, Social, and Ethical Evolution," *Scientific Monthly* 78:82, 1954.

Emlen, J. M. *Ecology: An Evolutionary Approach.* New York: Addison-Wesley, 1973.

Engels, F. *Dialectics of Nature.* International Publishers, 1940.

Farley, J. *Gametes and Spores: Ideas about Sexual Reproduction 1750–1914.* Baltimore Johns P. Univ. Press, 1982.

Feldman, M., F. B. Christiansen, and U. Liberman. "On Some Models of Fertility Selection." *Genetics* 105:1003–10, 1983.

Feynman, R. "Los Alamos from Below." *Engineering and Science* 39(2): 19, 1976.

Fischer, E. P. and C. Lipson. *Thinking About Science: Max Delbruck and the Origins of Molecular Biology.* New York: W. W. Norton and Co., 1988.

Fisher, R. A. *The Genetical Theory of Natural Selection.* Oxford, Eng.: Oxford Univ. Press, 1930; Dover, NY, 1958.

Fleming, D. "Emigre Physicists and the Biological Revolution." *Perspectives in American History* 2:155. Cambridge, MA: Harvard Univ. Press, 1968.

Forman, P. "Behind Quantum Electronics: National Security as a Basis for Physical Research in the United States, 1940–1960."

REFERENCES

Hist. Studies in the Physical and Biological Sciences 18(1): 149–229, 1987.

Foucault, M., ed. *I, Pierre Riviere, Having Slaughtered My Mother, My Sister, and My Brother.* New York: Penguin, 1975.

Friedman, A. T. and C. C. Donley. *Einstein as Myth and Muse.* Cambridge: Cambridge Univ. Press, 1985.

Galison, P. "Between War and Peace." In *Science, Technology, and the Military*, edited by Everett Mendelsohn, Merritt Roe Smith, Peter Weingart. Dordrecht; Boston: Kluwer Academic Publishers, 1988. Mendelsohn, Smith & Weingart. (1988).

Galison, P. *How Experiments End.* Chicago: Chicago Univ. Press, 1987.

Gasking, E. *Investigations into Generation: 1651–1828.* London: Hutchison, 1967.

Gause, G. F. and A. A. Witt. "Behavior of Mixed Populations and the Problem of Natural Selection." *American Naturalist* 69:596–609, 1935.

Geertz, C. *The Interpretation of Cultures.* Basic Books, 1973.

Ghiselin, M. *The Economy of Nature and the Evolution of Sex.* Berkeley: Univ. of California Press, 1974.

Ginzburg, C. "High and Low: The Theme of Forbidden Knowledge in the Sixteenth and Seventeenth Centuries." *Past and Present* 73:28–41, 1976.

Golinski, J. V. "Robert Boyle: Scepticism and Authority in Seventeenth-century Chemical Discourse." In *The Figural and the Literal: Problems of Language in the History of Science and Philosophy*, ed. A. E. Benjamin, G. N. Cantor, J. R. R. Christie, pp. 58–82. Manchester; Manchester Univ. Press, 1987.

Gould, Stephen Jay, "Caring Groups and Selfish Genes," *Natural History* 86:20–24, 1977.

Hacking, I. *Representing and Intervening.* Cambridge: Cambridge Univ. Press, 1983.

Hacking, I. "The Participant Irrealist at Large in the Laboratory." *Brit. J. Phil. Sci.* 39:277–94, 1988.

Hacking, I. "Weapons Research and the Form of Scientific Knowledge." *Canadian Journal of Philosophy*, Supp. vol. 12:237–60, 1987.

Hadeler, K. P. and U. Liberman. "Selection Models with Fertility Differences." *Journal of Mathematical Biology* 2:19–32, 1975.

Hall, B. *Science News*, p. 391, June 23, 1990a.

Hall, B. "Spontaneous Point Mutations That Occur More Often When Advantageous Than When Neutral." *Genetics* 126:5–16, 1990b.

Hall, B. "Selection, Adaptation, and Bacterial Operons." *Genome* 31(1): 265–71, 1989.

Hall, B. "Adaptive Evolution that Requires Multiple Spontaneous Mutations, I: Mutations Involving an Insertion Sequence." *Genetics* 120(4): 887–97, 1988.

Hall, T. S. *Ideas of Life and Matter*, 2 vol. Chicago: Univ. of Chicago Press, 1969.

Hamilton, W. D. "Innate Social Aptitudes of Man: An Approach from Evolutionary Genetics." In *Biosocial Anthropology*, ed. R. Fox. London: Malaby Press, 1975, reprinted in R. Brandon and R. Burian, *Genes, Organisms, and Populations*, pp. 193–202. Cambridge, MA: MIT Press, 1984.

Hanalwalt, P. "Preferential Repair of Damage in Actively Transcribed DNA Sequences in vivo." *Genome* 31(2): 605–11, 1989.

Haraway, D. *Simians, Cyborgs, and Women*. New York: Routledge, 1991.

Harden, G. "The Competitive Exclusion Principle," *Science* 131:1297, 1960.

Harding, S. *The Science Question in Feminism*. New York: Cornell Univ. Press, 1986.

Hedrick, P. W. *Genetics of Populations*. Boston: Science Books, Int., 1984.

Herdt, G. *Guardians of the Flute*. New York: McGraw-Hill, 1981.

Hesse, M. "Models, Metaphors and Myths." *N. Y. Times* October 22, 1989, p. E24.

Hesse, M. *Revolutions and Reconstructions in the Philosophy of Science*. Oxford: Oxford Univ. Press, 1973.

Hesse, M. *Models and Analogies in Science*. London: Sheed and Ward, 1963.

Hillis, D. "Intelligence as an Emergent Behavior," *Daedalus* 117(1): 175–190, 1988.

Hollis, M. and S. Lukes. *Rationality and Relativism*. Cambridge, MA: MIT Press, 1982.

Hull, D. "Units of Selection: A Metaphysical Essay," In *Genes, Organisms, and Populations*, eds. R. N. Brandon and R. M. Burian. Cambridge MA: MIT Press, 1984.

Ingrao, B. and G. Israel, "General Economic Equilibrium Theory: A History of Ineffectual Paradigmantic Shifts," *Fundamenta Scientiae* 6:1–45, 1985.

Jacob, F. *The Logic of Life.* New York: Vintage, 1973.

Jacobus, M. "Is There a Woman in This Text?" *New Literary History* 14 (Autumn, 1982); reprinted in Jacobus, *Reading Woman.* New York: Columbia Univ. Press, 1986.

Jordanova, L., ed. *Languages of Nature.* New Brunswick, NJ: Rutgers Univ. Press, 1986.

Judson, H. *The Eighth Day of Creation: Makers of the Revolution in Biology.* New York: Simon and Schuster, 1979.

Jungk, R. *Brighter Than a Thousand Suns,* trans. J. Cleugh. New York: Harcourt, Brace & Co., 1958.

Kay, L. *The Molecular Vision of Life.* Cambridge: Cambridge Univ. Press, 1992.

Keller, E. F. "Origin, History, and Politics of the Subject called 'Gender and Science,' " to appear in *Handbook of Science, Technology, and Society,* ed. J. Petersen, Los Angeles: Sage Publications, 1992.

Keller, E. F. "Physics and the Emergence of Molecular Biology." *J. Hist. Biol.* 23(3): 389–409, 1990.

Keller, E. F. "Feminism, Science, and Postmodernism." *Cultural Critique* 13:15–32, Fall, 1989.

Keller, E. F. "Demarcating Public from Private Values in Evolutionary Discourse." *J. Hist. Biol.* 21(2): 195–211, 1988.

Keller, E. F. "Working Scientists and Feminist Critics of Science." *Daedalus* 116(4): 77–91, 1987.

Keller, E. F. "Making Gender Visible," in *Feminist Studies/Critical Studies,* ed. T. de Lauretis. Bloomington: Univ. of Indiana Press, 1986.

Keller, E. F. *Reflections on Gender and Science.* New Haven, CT: Yale Univ. Press, 1985.

Keller, E. F. *A Feeling for the Organism: The Life and Work of Barbara McClintock,* New York: W. H. Freeman, 1983.

Keller, E. F. "Gender and Science." *Psychoanalysis and Contemporary Thought* 1:409–33, 1978.

Keller, E. F. "Statistics of the Thermal Radiation Field." *Physical Review* 139, 1B, B202, 1965.

Keller, E. F. and Lloyd, E. A. (eds) *Keywords in Evolutionary Biology.* Cambridge: Harvard Univ. Press, 1992.

Keller, E. F. and L. A. Segel. "A Model for Chemotaxis." *J. of Theor. Biol.* 30:225–234, 1971.

Kellner, D., *Jean Baudrillard*. Stanford: Stanford Univ. Press, 1989.

Kendrew, J. "How Molecular Biology Started." *Sci. Amer.* 216:141–43, 1967.

Kittay, E. "Womb Envy: An Explanatory Concept." In *Mothering*, ed. J. Trebilcot, 94–128. Rowman and Allenheld, 1984.

Klein, M. *Envy and Gratitude*. New York Basic Books, 1957.

Knorr-Cetina, K. and M. Mulkay, eds. *Science Observed: Perspectives on the Social Study of Science*. London and Los Angeles: Sage, 1983.

Kropotkin, P. *Mutual Aid: A Factor in Evolution*. London: Heinemann, 1902.

Kuhn, T. S. "Possible Worlds in History of Science." In *Possible Worlds in Humanities, Arts and Sciences*, ed. A. Sture, Proceedings of Nobel Symposium 65. Berlin: Walter de Gruyter, 1989.

Kuhn, T. S. *The Structure of Scientific Revolutions*. Chicago: Univ. of Chicago Press, 1962.

Laqueur, T. *The Making of Sexual Difference*. Cambridge: Harvard Univ. Press, 1990.

Laqueur, T., "Orgasm, Generation and the Politics of Reproductive Biology," in *The Making of the Modern Body.*, eds. C. Gallagher and T. Lagueur, pp. 1–41. Berkeley: Univ. of California Press, 1986.

Lasch, C. *The Culture of Narcissism*. New York: Norton, 1979.

Latour, B. "Give Me a Laboratory and I Will Raise the World." In *Science Observed: Perspectives on the Social Study of Science*, ed. K. Knorr-Cetina and M. Mulkay, pp. 141–87. London and Los Angeles: Sage, 1983.

Lenoir, T. "The Discipline of Nature and the Nature of Disciplines," ed. J. Petersen, Sage, 1992.

Lenski, R. E., M. Slatkin, and F. Ayala. "Mutation and Selection in Bacterial Populations: Alternatives to the Hypothesis of Directed Mutation." *P.N.A.S.* 86:2775–78, 1989.

Levins, R. and R. Lewontin, *The Dialectical Biologist*. Cambridge, MA: Harvard Univ. Press, 1986.

Lewontin, R. "Organism and Environment." In *Learning, Development, and Culture*, ed. H. C. Plotkin. New York: Wiley and Son, 1982.

Lewontin, R. "The Units of Selection." *Ann. Rev. of Ecol. and Systematics* 1–18, 1970.

Lewontin, R. ed. *Population Biology and Evolution.* Syracuse, NY: Syracuse Univ. Press, 1967.

Lewontin, R. and L. C. Dunn. "The Evolutionary Dynamics of a Poly-morphism in the House Mouse." *Genetics* 45:705–22, 1960.

Limon, J. "*The Double Helix* as Literature." *Raritan* 5(3): 26–47, 1986.

Lloyd, G. *The Man of Reason.* Univ. of Minn. Press, 1984.

Luria, S. E. and M. Delbruck. "Mutations of Bacteria from Virus Sensitivity to Virus Resistance." *Genetics* 28:491–511, 1943.

MacKenzie, D. "Science and Technology Studies and the Question of the Military." *Social Studies of Science* 16:361–71, 1986.

MacKinnon, C. *Feminism Unmodified.* Cambridge: Harvard Univ. Press, 1988.

Macnab, R. M. and D. E. Koshland, Jr. "The Gradient-Sensing Mechanism in Bacterial Chemotaxis." *P.N.A.S.* 69(9): 2509–12, 1972.

Marcuse, H. *One-Dimensional Man.* Boston: Beacon Press, 1964.

Markus, G. "Why Is There No Hermeneutics of the Natural Sciences?" *Science in Context* 1(1): 5–51, 1987.

Mattfield, J. A., and C. E. Van Aiken, eds, *Women and the Scientific Professions.* Cambridge, MA: MIT Press, 1965.

May, R. *Stability and Complexity in Model Ecosystems.* Princeton: Princeton Univ. Press, 1974.

May, R. "Qualitative Stability in Model Ecosystems," *Ecology* 54:638–41, 1973.

Mayr, E. "The Unity of the Genotype," in *Genes, Organisms, and Populations,* eds. R. N. Brandon and R. M. Burian. Cambridge MA: MIT Press, 1984.

Mayr, E. *Animal Species and Evolution.* Cambridge: Harvard Univ. Press, 1963.

Mead, M. *Male and Female.* Dell Publ. Co., 1949.

Mendelsohn, E. "Physical Models and Physiological Concepts." *Brit. J. for Hist. of Sci.* 2(7): 201–18, 1965.

Mendelsohn, E., M. R. Smith, and P. Weingart. *Science, Technology and the Military.* Dordrecht: Kluwer Acad. Publ., 1988.

Merchant, C. *The Death of Nature.* New York: Harper and Row, 1981.

Merton, R. "Science, Technology, and Society in the 17th Century." *Osiris* 4:360–632, 1938.

Michod, R. E. "On Fitness and Adaptedness and Their Role in Evolutionary Explanation." *J. Hist. Biol.* 19:289–302, 1985.

Midgley, M. *Evolution as a Religion.* London: Methuen, 1985.

Miller, R. S., "Pattern and Process in Competition," *Adv. Ecol. Res.* 4:4, 1967.

Monod, J. *Chance and Necessity.* New York: Random House, 1972.

Moran, P. A. P. "On the Nonexistence of Adaptive Topographies." *Annals of Human Genetics,* Lond., 27:383–93, 1962.

Muller, H. J. "Physics in the Attack on the Fundamental Problems of Genetics." *Scientific Monthly* 44:210–14, 1936.

Muller, H. J. *Out of the Night.* New York: Vanguard Press, 1935.

Muller, H. J. "The Method of Evolution." *Scientific Monthly* 29:505, 1929.

Muller, H. J. "Artificial Transmutation of the Gene." *Science* LXVI No. 1699:84–87, 1927.

Muller, H. J. Presented before the International Congress of Plant Sciences, Section of Genetics, Symposium on "The Gene," Ithaca, New York, August 19, 1926. Published in *Proc. Int. Cong. Plant Sci.* I:897–921, 1929.

Olby, R. "Francis Crick, DNA, and the Central Dogma." *Daedalus,* Fall, 938–87, 1970.

Partridge, L. and M. J. Morgan. "Letter to the Editor." *Nature* 336:22, 1988.

Pauly, Philip. *Controlling Life.* New York: Oxford Univ. Press, 1987.

Penrose, L. S. "The Meaning of Fitness in Human Populations." *Annals of Eugenics* 14:301–04, 1949.

Perutz, M. *Is Science Necessary?* New York: E. P. Dutton, 1989.

Pickering, A. "Pragmatism in Particle Physics," presented at the History of Science Society Meetings, Bloomington, Ind., Oct. 31–Nov. 3, 1985.

Pickering, A. *Constructing Quarks.* Chicago: Univ. of Chicago Press, 1984.

Pollak, E. "With Selection for Fecundity the Mean Fitness Does Not Necessarily Increase." *Genetics* 90:383–89, 1978.

Pollak, E. and D. Kempthorne. "Malthusian Parameters in Genetic Populations, II. Random Mating Populations in Infinite Habitats." *Theoretical Population Biology* 2:357–90, 1971.

Potter, E. "Making the Gender Politics in Science." In *Feminism and*

Science, ed. N. Tuana, 132–46. Bloomington: Indiana Univ. Press, 1989.

Proctor, R. *Value Free Science? Purity and Power in Modern Knowledge.* Cambridge: Harvard Univ. Press, 1991.

Prout, T. "The Estimation of Fitness from Genotypic Frequencies." *Evolution* 19:546–51, 1965.

Pyle, A. J. "Animal Generation and the Mechanical Philosophy." *Hist. Phil. Life Sci.* 9:225–54, 1987.

Rhodes, R. *The Making of the Atomic Bomb.* New York: Simon and Schuster, 1986.

Ricklefs, R. E. *Ecology.* Newton, MA: Chiron Press, 1973.

Roger, J. *Les Sciences de la Vie dans la Pensee Francaise du XVII Siecle.* Paris: Armand Colin, 1971.

Roughgarden, J. *Theory of Population Genetics and Evolutionary Ecology: An introduction.* New York: Macmillan, 1979.

Rubin, G. "The Traffic in Women: Notes on the 'Political Economy' of Sex." In *Toward an Anthropology of Women,* ed. R. R. Reiter. New York: Monthly Review Press, 1975.

Ruddick, S. *Maternal Thinking.* Boston: Beacon Press, 1989.

Ruddick, S. and P. Daniels, eds. *Working It Out.* New York: Pantheon, 1977.

Salt, G. W., ed. *Ecology and Evolutionary Biology: A Round Table on Research.* Chicago: Univ. of Chicago Press, 1984.

Sarkar, S. "Lamarck *contre* Darwin, Reduction versus Statistics: Conceptual Issues in the Controversy over Directed Mutatagenesis in Bactera," in *Organism and the Origin of Self,* ed. A. I. Tauber. Princeton: Princeton Univ. Press, 1991, pp 235–71.

Schroedinger, E. *What Is Life?* Cambridge: Cambridge Univ. Press, 1944.

Segel, Hanna. "Silence Is the Real Crime." *Int. Ref. of Psychoanalysis* 14(1): 3–12, 1987.

Shapin, S. and S. Schaffer. *Leviathin and the Air-Pump.* Princeton: Princeton Univ. Press, 1985.

Smith, C. U. M., *The Problem of Life.* New York: John Wiley and Sons, 1976.

Smith, C. and N. Wise. *Energy and Empire: A Biographical Study of Lord Kelvin.* Cambridge: Cambridge Univ. Press, 1989.

Smith, M. R., ed. *Military Enterprise and Technological Change.* Cambridge: MIT Press, 1985.

Sober, E. *The Nature of Selection*. Cambridge, MA.: MIT Press, 1984.

Sober, E. and R. Lewontin. "Artifact, Cause, and Genic Selection." *Philosophy of Science* 47:157–80, 1982.

Soderqvist, T. *The Ecologists: From Merry Naturalists to Saviours of the Nation*. Stockholm: Almqvist and Wilzell, 1986.

Stahl, F. "A Unicorn in the Garden." *Nature* 335:112–13, 1988.

Stent, G. "That Was the Molecular Biology That Was." *Science* 160:390–95, 1968.

Taylor, C. "Rationality." In *Rationality and Relativism*, ed. M. Hollis and S. Lukes, pp. 87–105. Cambridge: MIT Press, 1982.

Tennyson, A. L. *In Memoriam*, LV–LVI.

Tessman, I. "Letter to the Editor." *Nature* 336:527, 1988.

Thompson, J. T., *Interaction and Coevolution*. New York: John Wiley & Sons, 1982.

Trebilcot, J. *Mothering*. Totowa, NJ: Rowman and Allenheld, 1984.

Tuana, N., ed. *Feminism and Science*. Bloomington: Indiana Univ. Press, 1987.

Vandermeer, J. H. and D. Boucher, "Varieties of Mutualist Interaction in Population Models," *J. Theoret. Biology* 74:549–58, 1978.

Wade, N. "Thomas S. Kuhn: Revolutionary Theorist of Science." *Science* 197:143–45, 1977.

Wallace, B. "Norms of Reaction: Do They Include Molecular Events?" *Perspectives in Biol. and Med.* 33(3): 323–34, 1990.

Watson, J. D. "Growing Up in the Phage Group," in *Phage and the Origins of Molecular Biology*, ed. J. Cairns, G. S. Stent, and J. D. Watson. Cold Spring Harbor: Cold Spring Harbor Laboratory of Quantitative Biology, 1966.

Watson, J. *The Double Helix*, New York: Atheneum, 1968.

Weinberg, S. "Reflections of a Working Scientist," *Daedalus* Summer, 33–46, 1974.

Westfall, R. "Newton and the Hermetic Tradition." In *Science, Medicine and Man in the Renaissance*, ed. A. G. Debus, New York: Science History Publ. 184, 1972.

Williams, G. *Adaptation and Natural Selection*. Princeton: Princeton Univ. Press, 1966.

Williams, G. "Comments." *Biology and Philosophy* 1(1): 114–22, 1986.

Williams, R. *Keywords*. Oxford: Oxford Univ. Press, 1983.

Wilson, D. S. "The Group Selection Controversy: History and Current Status," *Ann. Rev. Ecol. Syst.* 14:159–87, 1983.

Wimsatt, W. C. "Randomness and Perceived Randomness in Evolutionary Biology." *Synthese* 43:287–329, 1980.

Wright, S. "Genic and Organism Selection." *Evolution* 34:825–43, 1980.

Yamamoto, K. and M. S. Fox. "Localized Mismatch Repair by the *MicA/MutY* System of E. Coli," presented at the Gordon Conferences, 1990.

Yoxen, E. J. "Giving Life a New Meaning: The Rise of the Molecular Biology Establishment." *Sociology of the Sciences* 6:123–43, 1982.

Printed in the United States
by Baker & Taylor Publisher Services